spring into

Digital Photography

▬▮spring into▮▮ series

Spring Into... a series of short, concise, fast-paced tutorials for professionals transitioning to new technologies.

Find us online at **www.awprofessional.com/springinto/**

Spring Into Windows XP Service Pack 2
Brian Culp
ISBN 0-13-167983-X

Spring Into PHP 5
Steven Holzner
ISBN 0-13-149862-2

Spring Into HTML and CSS
Molly E. Holzschlag
ISBN 0-13-185586-7

Spring Into Digital Photography
Joseph T. Jaynes and Rip Noel
ISBN 0-13-185353-8

Spring Into Technical Writing for Engineers and Scientists
Barry J. Rosenberg
ISBN 0-13-149863-0

Spring Into Linux®
Janet Valade
ISBN 0-13-185354-6

YOUR OPINION IS IMPORTANT TO US!
We would like to hear from you regarding the Spring Into... Series. Please visit **www.awprofessional.com/springintosurvey/** to complete our survey. Survey participants will receive a special offer for sharing their opinions.

From the Series Editor
Barry J. Rosenberg

A few years ago, I found myself in a new job in which I had to master many new skills in a very short time. I didn't have to become an instant expert, but I did have to become instantly competent.

I went to the bookstore but was shocked by how much the publishing world had changed. At a place where wit and intelligence had once been celebrated, dummies were now venerated. What happened?

Photograph courtesy of Ed Raduns

Well, I made a few phone calls, got Aunt Barbara to sew up a few costumes, and convinced Uncle Ed to let us use the barn as a stage. Oh wait… that was a different problem. Actually, I made a few phone calls and got some really talented friends to write books that clever people wouldn't be ashamed to read. We called the series "Spring Into…" because all the good names were already taken.

With Spring Into…, we feel that we've created the perfect series for busy professionals. However, there's the rub—we can't be sure unless you tell us. Maybe we're hitting the ball out of the park and straight through the uprights, bending it like Beckham, and finding nothing but net. On the other hand, maybe we've simply spun a twisted ball of clichés. Only you can tell us. Therefore, if anything—positive or negative—is on your mind about these books, please email me at

barry.rosenberg@awl.com

I promise not to add you to any email lists, spam you, or perform immoral acts with your address.

Sincerely,
Barry

spring into

Digital Photography

Joseph T. Jaynes

Rip Noël

✦✦ Addison-Wesley

Upper Saddle River, NJ • Boston • Indianapolis • San Francisco
New York • Toronto • Montreal • London • Munich • Paris • Madrid
Capetown • Sydney • Tokyo • Singapore • Mexico City

The publisher offers excellent discounts on this book when ordered in quantity for bulk purchases or special sales, which may include electronic versions and/or custom covers and content particular to your business, training goals, marketing focus, and branding interests. For more information, please contact:

U.S. Corporate and Government Sales
(800) 382-3419
corpsales@pearsontechgroup.com

For sales outside the U.S., please contact:

International Sales
international@pearsoned.com

Visit us on the Web: www.awprofessional.com

Library of Congress Cataloging-in-Publication Data

Jaynes, Joseph T.
 Spring into digital photography / Joseph T. Jaynes, Rip Noel.
 p. cm.
 Includes index.
 ISBN 0-13-185353-8 (pbk. : alk. paper)
 1. Photography—Digital techniques. I. Noel, Rip. II. Title.
 TR267.J39 2006
 775—dc22

 2005017735

ISBN 0-13-185353-8
Text printed in the United States on recycled paper at Courier in Kendallville, Indiana.
First printing, September 2005

To Kim, Andy, Alex, Hugh, and Eleanor.
Your patience, support, and love illuminate me.

—Joe

To Jim Thompson, Hugh Lunsford, Charles Potts, Deborah, and all my family.
Your help and guidance have made all this possible.

—Rip

"People…light is life!"

—Charles Potts
The Art Center College of Design

Contents

Preface

Digital photography is only a fad. The images aren't as good as real photographs shot on film and printed with chemicals the way God intended. If you want to be a real photographer, you should drop this book like a spent flashbulb and stick with film. It was good enough for Alfred Stieglitz and Ansel Adams, and look how far they got. It was good enough for your dad at the Grand Canyon, for Pete's sake! What's with you kids today? Would you give all this digital foolishness a rest? Please?

[We interrupt this Preface to give the authors a moment to recapture control of their manuscript . . . hhmmphh . . . grrrrgnn . . . aacccckk! . . . OK, that's better. Let's try that opening again.]

Digital photography is more than just *the future* of photography. It's hands down the best way to take photographs for any and every conceivable purpose *today*. Film photography was revolutionary and powerful, and it created a medium for artistic expression that stood the art establishment on its head. Digital photography continues the revolution, putting even more creative power into the hands of even more people than film photography ever could.

Our hope in writing this book is to stir up some creative fervor among the masses. Are you ready to be stirred?

Who Should Read This Book?
Everyone on the planet should read this book.[1]

We've written this book for people who have a passion for photography and who want to improve their artistic sensibilities and skills using the exciting tools that digital photography provides. We don't expect you to be an expert or a prodigy or a guru. We do expect you to care about making great photographs.

Are you someone who has owned a camera for years and used it to shoot generally disappointing shots of friends and family that you really wish were better? (The shots, not your friends and family.) That lingering sense of disappointment means that this book is for you. Are you an avid photographer who's happy with the results you've been getting with film and now want to "make the leap to digital"? This book is for you. Are you a

1. Or at least *purchase* this book. How else can we expect to continue making the payments on our yachts?

student of photography looking to supplement your dry textbooks with a perky tome written by guys who have learned their lessons the hard way (by making mistakes) and who are willing to tell you the truth? This book is for you. Are you a professional shooter who suspects that the quality of digital photography has finally overtaken that of film but can't quite bring yourself to believe it? There are big chunks of this book that are for you, too.

How Is This Book Organized?

We've organized this book into four sections plus an appendix. The organizational scheme traces the chronology of making a photograph.

Section 1 teaches you how to capture a great image.

TABLE P-1 Section 1—Capture the Perfect Image

Chapter	Title	Teaches You How To ...
1	Let There Be Light	Understand and control the effects that light has on the shapes and colors of objects in a shot
2	Compose It	Observe and exploit the design elements and techniques that create great shots
3	Expose It	Use your camera's controls to capture images that express your creative intent

Section 2 addresses the thorny problems that managing color creates for digital photographers.

TABLE P-2 Section 2—Understand and Manage Color

Chapter	Title	Teaches You How To ...
4	Color Fundamentals	Understand the way color works and its profound implications for digital photography
5	Calibrate and Profile Your Monitor	Ensure that the colors you see on your computer screen are "true" and trustworthy
6	Profile Your Scanner	Ensure that your scanner produces scanned images whose color information is "true" and trustworthy
7	Profile Your Printer, Paper, and Ink	Ensure that the images you print contain colors that match what you see on your monitor

Section 3 teaches you how to optimize your images for viewing in a variety of contexts (on screen, in print, etc.), and presents tips and techniques for correcting common problems.

TABLE P-3 Section 3—Optimize Your Images

Chapter	Title	Teaches You How To ...
8	Optimize for the Screen	Optimize your images for best appearance on screens (computer monitors, TVs, projectors, etc.)
9	Optimize for Print	Optimize your images for best appearance in print
10	Fix Specific Problems	Correct common problems that occur in digital images

Section 4 discusses ways to optimize your workflow as a digital photographer. Work smarter rather than harder, in other words.

TABLE P-4 Section 4—Optimize Your Workflow

Chapter	Title	Teaches You How To ...
11	Manage Your Assets	Manage the huge volume of data that quickly overwhelms many digital photographers
12	Think Digitally	Adapt your habits and expectations to the rapidly changing world of digital photography

The Appendix gives you a peek inside our own personal gear bags to show the equipment and tools that we use ourselves. We also offer advice about how to upgrade your gear over time based on your photographic interests.

What's Unusual About This Book?

This book—like the other books in the *Spring Into* series—provides the following eccentricities:

- Each topic is explained in a discrete one-, two-, or four-page unit called a "chunk."
- Each chunk builds upon or complements the previous chunks in that chapter.
- Many chunks contain sidebars and "Quantum Leaps," which provide helpful, if sometimes digressive, ancillary material.

We assume that you are a very busy person for whom the time spent in the very act of buying this book was excruciating. To repay that incalculable opportunity cost, we've adopted the chunk style of presenting information so that you can learn as rapidly as possible.

Finally, we hope you'll find this book fun to read and the photographs a joy to behold. If you've paid good money for a book—no matter what the topic—boring text and ugly pictures are a slap in the face.

Where Can You Find Online Information About Topics in This Book?

This book has a companion Web site: PhotoGain.com. You'll find references to this site sprinkled liberally throughout the book.

We built PhotoGain.com for several reasons.

- Digital photography technologies evolve too rapidly for a printed book to stay current for very long. Although we've tried hard to make this book as timeless as possible, you'll want to visit the Web site often for the latest news and technical information.

- Some topics need to be discussed in greater technical depth than is appropriate for this book. Example: learning to light your shots using softbox lightbanks. You'll find that additional depth at the Web site.

- Some topics are of interest to a small subset of our readers. Example: optimizing images for commercial offset printing. Because most of you are probably not publishing images in books and magazines (yet!), we merely hint at that topic in the book and leave the complete discussion for the Web site.

Who Helped Us Write This Book?

We owe a big "thank you" to many people who help make this book possible. Barry Rosenberg and Mark Taub convinced us to write the book and offered encouragement and support throughout the process. Laura Westbrook and her sons Eric and Dillon Martin patiently modeled for many photos. Dennis Keeley at the Art Center College of Design in Pasadena gave much helpful advice and insight. Reviewers John Cowley, Ed Raduns, Mel Rosenberg, and Dr. Martin Liebling provided great suggestions on early drafts. Christine Yarrow at Adobe Systems coordinated early access to the latest releases of key products. Other vendors were extremely helpful in supplying both evaluation products and technical expertise, including Stan Hennigh at Chimera Lighting, Nicole Andergard and Dan Harlacher at Extensis, Susan Caballero at Lowepro, John Omvik at Lexar, Duane Sherwood and Dale Marks at Lowel, Norm Levy at MediaStreet, Scott Balmer at nik multimedia, Hilary Araujo at Tiffen, Kriss Brunngraber at Bogen, Tyler Andrew at X-Rite, Dawn Jones at Hart Graphics, Mark Rowlett and the staff at Thompson Photo Products, and Dustin Skartved at Vioplex. Finally, we thank our many friends and family who supported us throughout the project.

Acknowledgments

We gratefully acknowledge the assistance that we received from the following companies: Adobe Systems Incorporated; AlienBees (a division of Paul C. Buff, Inc.); BMW of North America; Bogen Imaging Inc.; Canon U. S. A., Inc.; Chimera Lighting; ColorBurst Rip; Eastman Kodak Company; Epson America, Inc.; Extensis, Inc.; Hart Graphics, Inc.; Lexar Media, Inc.; Lowel-Light Manufacturing, Inc.; Lowepro USA; Media Street, Inc.; Moab Paper Company; nik multimedia, Inc.; Nikon Corporation; The Tiffen Company; X-Rite–Monaco Systems, Inc.; and Vioplex Inc.

About the Authors

Joseph T. Jaynes is President of Abacus Arts, Inc., and Director of Customer Operations for Avilar Technologies, Inc. Joe has 25 years of experience in delivering information to computer users in creative and innovative ways. He has written numerous technical books on computer-related topics, including operating systems, digital imaging, programming, help-system development, and web development. He has taught college-level courses on technical publishing, information design, and computer usage. He is also an accomplished amateur photographer, actor and musician.

Rip Noël is Vice President of Media Production for Abacus Arts, Inc., and founder of Noël Studios, Inc. (a commercial photography, film, and video production company in operation since 1982). Rip was a contributor to Nikon's *Beginner's Guide to 35mm Photography* (composition and lighting chapters), and received one of only two annual scholarships upon entering his second year at The Art Center College of Design in Pasadena, CA. He has worked as a Hollywood studio manager, as a newspaper photojournalist, and for nearly 30 years as an award-winning commercial photographer and filmmaker for Fortune 500 clients. One of his most memorable assignments was producing a commissioned portrait of President Ronald Reagan.

About the Series Editor

Barry Rosenberg wrote the cult classic, *KornShell Programming Tutorial* (Addison-Wesley, 1991), which pioneered many of the chunk-oriented techniques found in the Spring Into... Series. He is the author of more than 60 corporate technical manuals, primarily on programming. An experienced instructor, Barry has taught everything from high-school physics to weeklong corporate seminars on data structures.

Most recently, Barry spent four semesters at MIT where he taught advanced technical writing. Barry is also a professional juggler who has performed more than 1,200 shows, including a three-week run in Japan. Juggling serves as the backdrop for his novel, *Cascade* (not yet published). Barry currently works as the documentation manager at 170 Systems.

Introduction

You have a great digital camera. Your computer and its image-editing software appears to be capable of magic. You know your printer is capable of producing knockout prints. Life as a digital photographer is good!

But is it as good as it can be? If you're the kind of photographer who really cares about the quality of your shots, who isn't satisfied to point and shoot and print and accept whatever emerges by default, who wants to get the most creative bang for the hard-earned bucks you've spent on gear, then this book is for you.

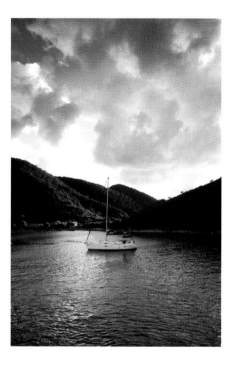

It doesn't matter if you're new to photography or you've been shooting film for years. What matters is your passion for producing great pictures and for getting the most you can out of the creative tools you own. That's what we're about here.

Do you want your digital images to look as fabulous as possible? Read on.

Artistry Requires Mastery

To be an artist, you must master your medium and its tools. Musician, sculptor, writer, or digital photographer, you must be comfortable enough with the tools of your discipline to use them easily and unconsciously. If you're worried about where your fingers go, you can't break free to be creative.

This is as true for photographers as it is piano players. So before we go any farther, we urge you to dig out the owner's manual that came with your camera and give it a thorough read-through. Then spend a few hours just working with the controls and shooting whatever you see.

Don't worry about getting great results. Worry about getting comfortable with your instrument. Most digital cameras are complex devices, with buttons, knobs, memory cards, display screens cluttered with icons, and menu systems that require patient navigation.

Practice until your fingers can perform the following functions while your eyes stay locked on the viewfinder or monitor.

- Change the focal length (zoom in and out).
- Change the exposure mode (automatic, aperture-priority, shutter-priority, manual).
- Change the shutter speed.
- Change the aperture (f-stop).
- Change the white balance setting.
- Override the camera's autoexposure control.
- Temporarily lock the exposure on one object and then reframe and shoot another.
- Change the weighting on the camera's light-metering scheme from center-weighted to spot metering.
- Change from auto focus to manual focus.

The Path to Perfection

This book takes the following approach to helping you create great digital images.

1. **Capture the image.**

 - Light correctly. It's all about the light. If you're outside, know where the sun is. If you're inside, make sure you use the ambient lighting and your on-camera flash or strobe light correctly.

 - Compose correctly. *See* what you're shooting. See the guy with the big gut at the edge of the frame? Zoom in! See that woman with her back to you? Move to a different camera angle, or ask her to turn around.

 - Capture correctly. Use the aperture and shutter speed that best suit your goal. Is your subject partially out of focus? Increase the f-stop. Is your subject moving? Increase the shutter speed. *And don't forget to set the white balance!*

2. **Understand and manage color.** Although getting color right seems much harder for digital photography, it's actually much easier when you have the right tools and digital workflow. This section lays the foundation for good digital color management.

3. **Optimize for the screen.** Viewing your images on a computer monitor, TV screen, or video projector? The characteristics of these devices have a huge impact on the images they display.

4. **Optimize for print.** Your printer, its ink, and the paper you're printing on all have inherent strengths and, more importantly, weaknesses when it comes to printing photographs. Don't expect more than your printer and paper can deliver.

5. **Manage your workflow.** You can add enhancements and fix many kinds of mistakes with your computer. But remember: No matter how good your tools and skills are, you cannot make pâté out of manure. You also need to manage your digital image assets effectively so that the growing mountain of images you have in storage remain accessible and useful as time goes by.

Capture the Perfect Image

C ome on, admit it. "Shoot-first-and-ask-questions-later" appeals to you, doesn't it? It's OK—we're that way, too. Acknowledging such a deep and abiding character flaw is the first step on the road to recovery. And your pictures will start coming out much better, too. Let the healing begin!

Our goal in these opening chapters is to help you dodge the "garbage in, garbage out" bullet. Acquire the perfect image to start with, and you'll save yourself a world of trouble down the road. In fact, there are some common mistakes that you just cannot fix later, no matter how great you are with your image-editing tools.

So don't skip this section. It will help you shoot smart and save you a ton of work.

Focus on the Fundamentals

Shooting smart means dealing with three things simultaneously while you're squinting through your viewfinder or at the tiny monitor on the back of your camera:

- Lighting
- Composition
- Exposure

Yikes! That sounds like a lot. But fear not: A little bit of practice will make these things second nature. Our goal is to help you master your camera so that acquiring great images becomes automatic and unconscious. When that happens, your creativity will begin to blossom.

Most of these fundamentals apply to any kind of photography: digital, analog, even video. Where there are special considerations for digital shooters, we'll make those plain.

So put the camera down and back slowly away. We have a couple of things to get straight first, before it's safe to shoot.

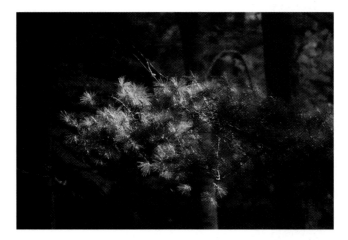

Let There Be Light

P hotography is all about capturing light. No light, no picture. That means the first thing you need to control (or at least acknowledge) is how your subject is lit (Figure 1-1). Use your light wisely, and the rest is easy.[1] Misuse your light, and you're done for.[2]

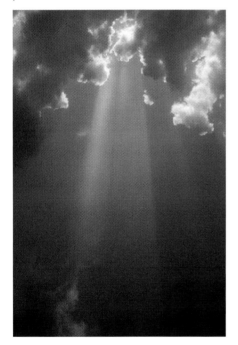

FIGURE 1-1 Light may seem mysterious, but you can master its use.

1. The portion of this statement about "the rest" being "easy" is what narrow-minded legal professionals technically refer to as a "lie," but bear with us for now.

2. Notwithstanding the utter falsehood of the preceding statement, this statement is absolutely true.

Qualities of Light

The qualities of light vary greatly. Not only bright and dim, but also hard and soft. Warm and cool. Flat and full. In-your-face direct, or bounced from above or below. And it all makes a profound difference in the way your photos look. Learn to evaluate the light around you.

Hard Versus Soft Light

Hard light travels straight to your subject without alterations like filtering or bouncing (Figure 1-2). Soft light travels a more winding route, perhaps passing through materials that change it (Figure 1-3).

FIGURE 1-2 Hard, direct light delivered straight from an on-camera flash

FIGURE 1-3 Soft, indirect light reflected from the misty morning sky

Flat Versus Directional Light

As Figure 1-4 shows, the direction of the light source relative to your camera lens can flatten your subject (if the light is in line with the lens); or it can create a full sense of three-dimensional depth (if the light arrives at an angle to the lens), as shown in Figure 1-5.

FIGURE 1-4 Flat strobe light in line with the camera lens, softened by softbox

FIGURE 1-5 Soft, natural, directional window light diffused by glass block panes and arriving off-angle to the camera lens

Cool Versus Warm Light

Light varies in "temperature" based on what produces it and what it travels through en route to your camera (Figures 1-6, 1-7, and 1-8). This has a huge impact on the perceived color of your subject.

FIGURE 1-6 Cool light from the predawn sky

FIGURE 1-7 Neutral light at midday

FIGURE 1-8 Warm light at sunset

Wrap-Up

You may think that light's only role in photography is to illuminate the subject you're shooting. That's certainly important, but light does a lot more than just illuminate. Light actually controls the *shape* and *color* of the objects that appear in your photographs. This is true whether you're shooting digitally or on film, still images or full-motion video.

Light helps us to perceive shape when it generates shadows. Because a photograph is a two-dimensional object, we can see those shadows only when the light arrives off-angle to the camera lens. When the light source is in line with the camera lens, any shadows that it produces are hidden from the viewer, and the resulting image looks flat. You can accentuate or suppress the "shapeliness" of objects in your photograph by being aware of how they are lit.

Light also creates the colors that we perceive. It seems like common sense to think that the color of an object is an inherent and unchanging property of the object, like its weight.[3] But color is a slippery, changeable thing. A "white" rabbit may appear blue one minute and red the next, depending on how it is lit and how your camera is configured to record "whiteness." By being more aware of light's effect on perceived color, you can create photographs that more accurately capture the "reality" of your subjects or that twist the viewer's expectations of "reality" in creative ways.

Let's look more closely at these fundamental principles of light.

3. Actually, "weight" is variable, too, according to the fundamental principles of space–time. But let's not go there.

Light Controls Shape

Shape is such a basic concept that it can be hard to see and analyze. "What's the big deal? Shape is shape!" But in photography, light reveals (or hides) shape.

A few examples make this clear. We start with the three fundamental, primitive solids (a cube, a sphere, and a cone) to illustrate some basic principles, and then we apply those basic principles to real-world objects. You may find the primitives a bit boring at first, but they illustrate our points about lighting without any distractions like beautiful bodies or busy backgrounds. We'll get to those soon enough.

PRINCIPLE

Light controls our perception of depth and therefore shape. Use light and shadow to strengthen or weaken the appearance of three dimensions in 2-D space.

The still life in Figure 1-9 contains primitive solid shapes. First, we light the group of objects with "flat" light, or light that is relatively diffuse and directly on-axis with the camera lens (Figure 1-10). Any shadows produced by the flat light are soft and lie directly behind the objects, hiding them from the viewer.

Lit flat, the cone appears as a simple triangle. The sphere is just a circle. The cube looks like a diamond.

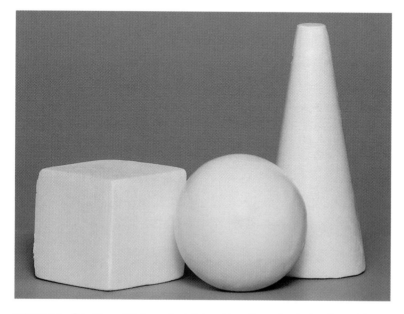

FIGURE 1-9 Primitive solid shapes look flat and two-dimensional when lit straight on.

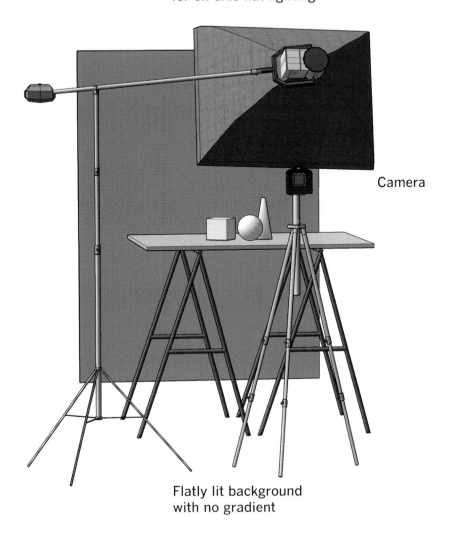

Main light: Directly above camera
for on-axis flat lighting

Camera

Flatly lit background
with no gradient

FIGURE 1-10 Lighting setup for Figure 1-9

Next, as Figure 1-11 shows, we light the objects to emphasize their three-dimensionality by moving the light source to the left, off-angle from the camera lens. We also add some light to the background to separate it from the foreground. The shadows from the solids are now clearly visible. See how much more depth, substance, and three-dimensional shape the objects have with this lighting setup?

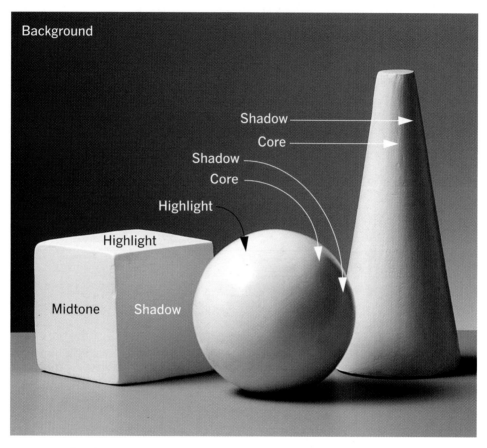

FIGURE 1-11 Primitive solid shapes look much more three-dimensional when lit off-angle to the camera lens.

The primary light source is a "daylight" flash unit inside a softbox diffuser positioned to the left of the objects; the background is lit from below with a secondary flash unit (Figure 1-12).

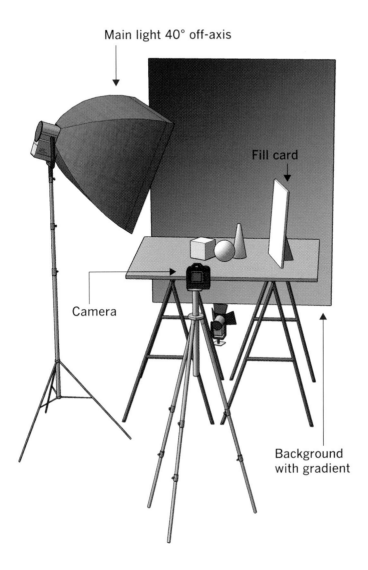

Main light 40° off-axis

Fill card

Camera

Background
with gradient

FIGURE 1-12 Lighting setup for Figure 1-11

Reflected Light: A Bit of Geometry

The *law of reflection* tells us that the angle at which light intersects a surface (the *angle of incidence*) is equal to the angle at which the light is subsequently reflected from that surface (the *angle of reflectance*).

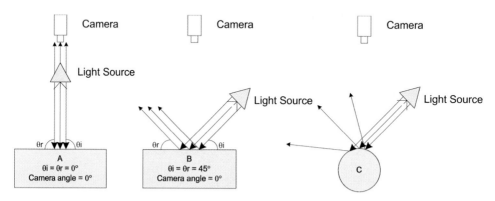

FIGURE 1-13 The law of reflection and its relationship to camera angle

The geometry in Figure 1-13 illustrates what seems like common sense, and indeed it is. But it's more than just common sense. The principle is directly relevant to photography, because the camera's job is to record reflected light.

The angle at which light strikes objects in a shot matches the angle at which the light gets reflected. If your camera's lens angle matches (Example A in Figure 1-13), it is on-axis with the light source. This is a recipe for trouble, especially if the surface is highly reflective like metal or glass.

In the case of a flat surface, the effect is simple to visualize and you've probably already encountered it. What happens when you use your on-camera flash to take a picture of a person standing in front of a window? The light from the flash unit bounces straight off the window and back into the lens, causing a huge exposure problem. Both the angle of incidence and the angle of reflectance are 0 degrees—and so is the angle of your lens relative to the window. But if you position your camera at a different angle to the window, so that the light from the flash unit bounces away from the lens, the glare goes away. You can also accomplish the same thing by using a flash that's detached from your camera and positioned at an angle (Example B). Your lens is no longer aligned with the angle of reflectance. Problem solved!

The issue is more complex (and much more interesting) when objects in a shot have curved surfaces (Example C). Curved surfaces reflect light at a multitude of angles. As those angles of reflectance grow more closely aligned with the camera angle, more and more light gets concentrated in those areas. This accounts for the incident highlights and the "core" between areas of light and shadow that give well-lit curved surfaces visual interest (see Figure 1-11 on page 10).

In the sections that follow, we illustrate the importance of this principle by starting with simple geometric shapes and a single source of light. We encourage you to apply this technique to your own shots. Start simply, and then gradually increase the complexity of the shapes. Next, start adding light sources one at a time, varying their position relative to the lens to create complexity and visual interest.

As you mature as a photographer, you'll find yourself growing more comfortable with the relationship between your camera's lens and the light sources in the shot. You'll understand the effect that the light is having on your subject. And your photographs will improve as a result.

Lighting a Cube

Light almost any object from the front, and it will appear flat and shapeless. This is the result you get when you shoot outdoors with the sun at your back, or rely on the flash that's built into your camera to illuminate your subject. Flat, flat, flat!

Perhaps your creative goal is to keep your subject two-dimensional. That's certainly a valid goal. But generally speaking, objects are much more interesting when they have depth and three-dimensional shape. To create that depth, you must use a light source that's angled away from the camera. The result: different planes of lightness and darkness. That's the secret of shape.

Look at the cube photo in Figure 1-14. Notice how the three surface planes of the cube have different light values and how the background clearly separates from the foreground.

This shot was taken with a light source positioned above and to the left of the cube (Figure 1-15). A fill card on the right side of the cube reflects light back on the shadow side to soften the darkness of the shadow a bit. Another strobe lights up the background from the bottom right. Notice how the background light varies slightly from left to right, to contrast with the planes of the cube that sit in front of it. This contrast also helps emphasize the shape of the object.

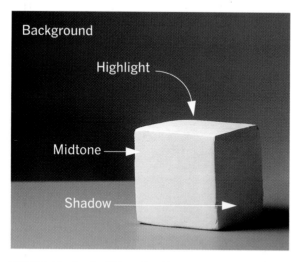

FIGURE 1-14 A cube, lit from the side to create shape

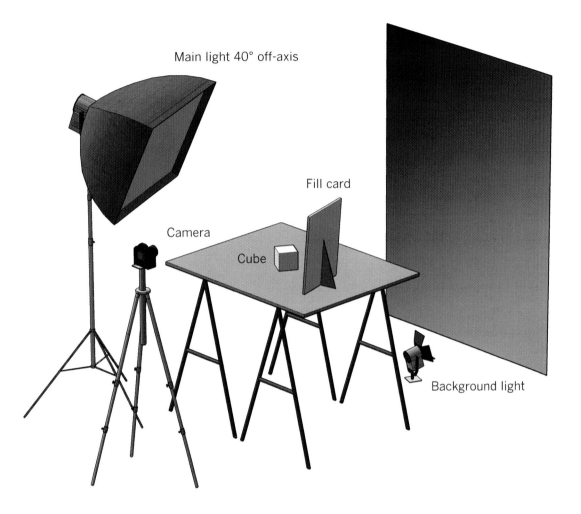

FIGURE 1-15 Lighting setup for Figure 1-14

Learning to "see" these lighting effects and apply them to real-world situations will help you become a better photographer. You'll get the results that you intended to get, rather than taking pictures by accident and being surprised by the results.

Cube Examples

FIGURE 1-16 Flat lighting turns 3-D geometry into a flat 2-D grid.

FIGURE 1-17 When the cube shapes are lit brightly from an angle off-axis to the camera, all three dimensions pop off the page.

In the examples in Figures 1-16 and 1-17, the light source is the sun. Of course, you cannot "control" the sun. But you can control its effects on your shot. For example, you can change your camera angle to get the correct light. Try scouting your shot ahead of time, and plan your shoot to occur when the light is best. You may need to shoot early in the morning or late in the afternoon, when the sun is in the best position in the sky or the fog and clouds disperse. You might even have to wait until the right time of year to get the correct sunlight, because the sun's angle and intensity vary considerably with the changing of the seasons. Our point is this: Take an active interest in lighting and its effects on your shot rather than passively accepting whatever lighting conditions you find.

Trying to sell your house? You'll need a great photograph to stand out from the crowd and get noticed. As shown in Figure 1-18, apply the principles of lighting a cube: Shoot your home slightly off-axis so that its planes are clearly visible, in the early morning or late afternoon when the light helps create 3-D shape and interest. The property will sell in a snap.[4]

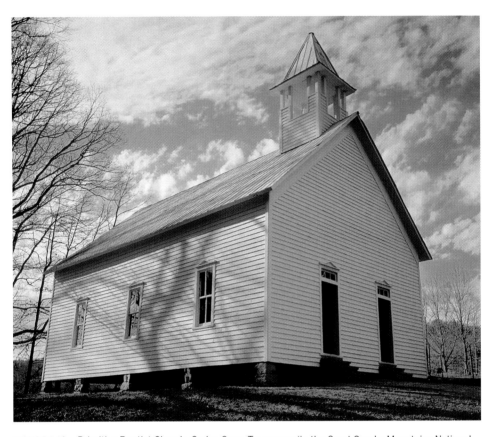

FIGURE 1-18 Primitive Baptist Church, Cades Cove, Tennessee (in the Great Smoky Mountains National Park)

4. Don't forget to price it right, too.

Lighting a Sphere

Lighting a sphere is similar to lighting a cube, although the highlight area is more prone to develop bright hotspots called *incident highlights*. Even so, an incident highlight within the highlight area can actually help to emphasize the shape of a sphere or a person's face. The lighting in Figure 1-19, coming from the top left, makes the sphere's boundaries very clear.

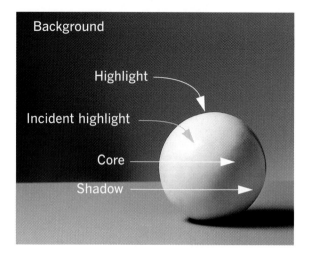

FIGURE 1-19 A sphere, lit from the side to create shape

Again, the varying light values of each area create the appearance of 3-D shape. The *core*, a transitional area that separates the shadow area from the highlights, appears as a dark band between the two. If you think of your sphere as the Earth, the core is the "twilight zone" separating daylight from nighttime.

Notice in Figure 1-19 that the background light again varies slightly from left to right to provide contrast with the foreground objects. This also helps emphasize the 3-D shape of the sphere.

Figure 1-20 shows the lighting setup for the photo in Figure 1-19.

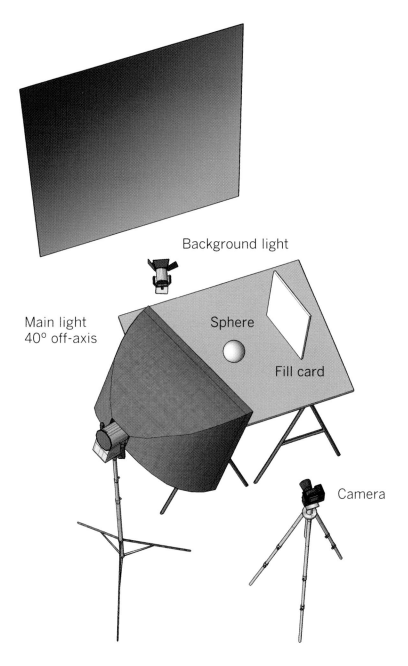

Background light

Main light
40° off-axis

Sphere

Fill card

Camera

FIGURE 1-20 Lighting setup for Figure 1-19

Sphere Examples

Figures 1-21 and 1-22 show examples of lighting a sphere.

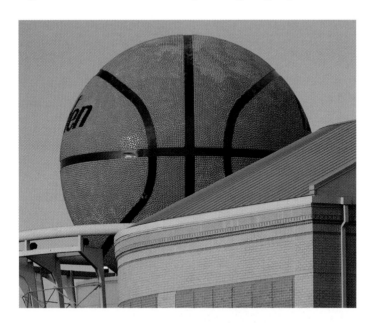

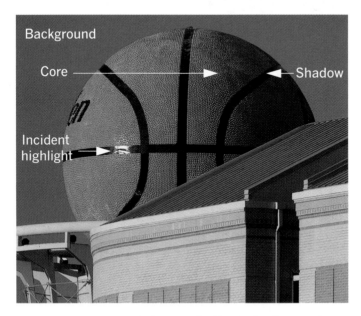

FIGURE 1-21 (Top) Ladies' Basketball Hall of Fame lit flat. (Bottom) The same subject lit for 3-D shape.

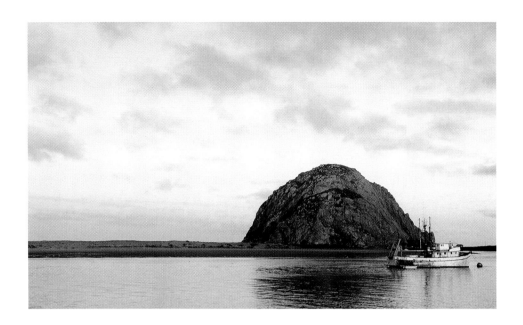

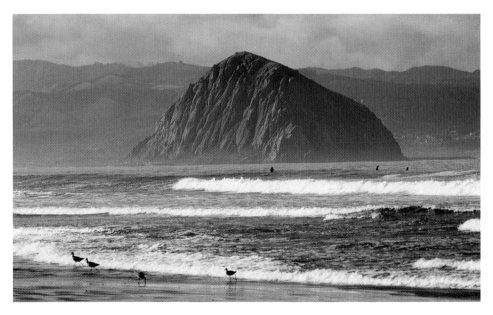

FIGURE 1-22 (Top) "Morro Rock" in Morro Bay, San Luis Obispo, California, lit flat. (Bottom) The same subject shot from a different angle and lit from the left to reveal its 3-D shape.

Lighting a Cylinder or Cone

Cylinders and cones combine the properties of cubes and spheres (Figure 1-23). Like cubes, these solids have top and bottom planes. Like spheres, they have curved rather than planar sides and thus offer core areas that create gradual transition zones between highlights and shadows.

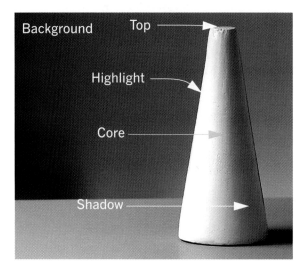

FIGURE 1-23 A cone, lit from the side to create shape

These primitive shapes appear in every picture you take. A person standing up straight is basically a cylinder. A mountain peak is basically a cone. Keep your eyes open for these shapes, and use lighting wisely to emphasize or diminish their three-dimensional shapes.

Figure 1-24 shows the lighting setup for Figure 1-23.

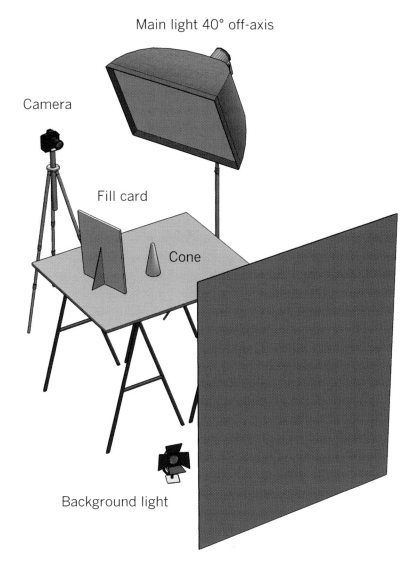

Main light 40° off-axis

Camera

Fill card

Cone

Background light

FIGURE 1-24 Lighting setup for Figure 1-23

Cylinder and Cone Examples

Figures 1-25 and 1-26 show examples of lighting cones and cylinders.

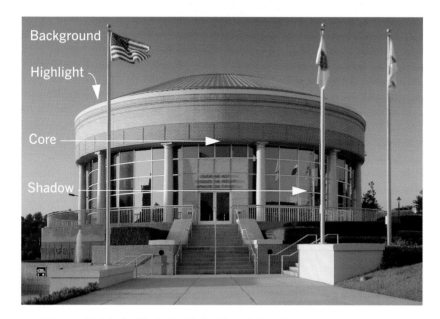

FIGURE 1-25 (Top) Ladies' Basketball Hall of Fame lit flat. (Bottom) Lit off-axis to maximize 3-D shape.

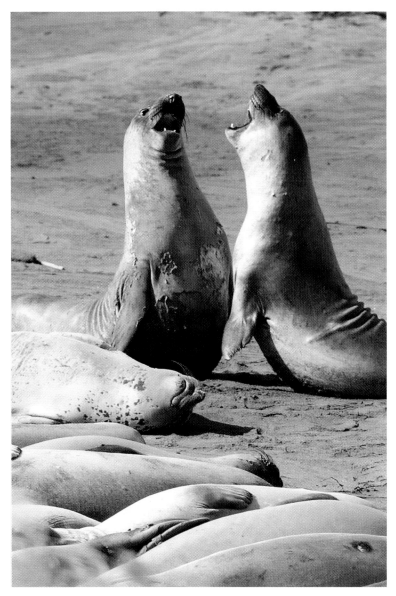

FIGURE 1-26 Elephant seals at Piedras Blancas Elephant Seal Rookery, lit off-axis to emphasize the cylindrical shape of their bodies

Softbox Lightbanks

Once you've started to see the effect that light has on your shots and are comfortable working with bare lights, using a *softbox lightbank* may be your next step (Figure 1-27). Softboxes are one of the most popular tools for controlling artificial light sources (strobes, tungsten lamps, etc.). A softbox does just what its name suggests: It softens and diffuses light and contains it to prevent unwanted spillover, thus giving you considerable control.

To hone your lighting skills, start with a single softbox and a continuous light source, such as a Lowell DP or a Tota Light. A continuous source (as opposed to a strobe) lets you see the subtle changes that occur when you set and adjust the light. Note that not all softboxes are alike. Some are designed to work with strobe lights, and others are designed for the higher heat produced by continuous tungsten lights like the Lowell DP. You can use a strobe light in a high-heat softbox safely, but you can't use tungsten lights in a softbox designed for strobes. Most of the top softbox vendors offer boxes for both applications.

We have used Chimera Lighting softboxes for years and have always been impressed by Chimera's quality and selection (www.chimeralighting.com). When you go shopping, look for a manufacturer that offers important add-ons like *egg crate* grids for further focusing your box light, *barn doors* to block lens flare, and so on (Figure 1-28). You'll soon be wanting to extend your lighting toolkit.

When you're using softbox lighting, remember three things.

- Choose as your main light source a softbox that is approximately the same size as your subject.

- Position the softbox first, and then aim it. When you first start working with these large light sources, it's tempting to concentrate on where to place the light and forget that aiming it slightly up or down, left or right can really enhance the lighting effect. For example, when you light a portrait shot, it's usually preferable to make the hands slightly darker than the face. Once you have the light placed properly, simply aim the light up and slightly away from the model's hands.

- Gain additional control by reaiming or refocusing the light source inside the softbox. These two simple adjustments can change the quality of your lighting dramatically. The bottom line is to learn to use your eyes.

When you're ready to move to the next level with your lighting, adding a softbox is the way to go. And it's not as expensive as you might imagine. Many manufacturers offer special packages targeted at photographers who are getting started with professional lighting. For more information on softbox lighting, check out PhotoGain.com.

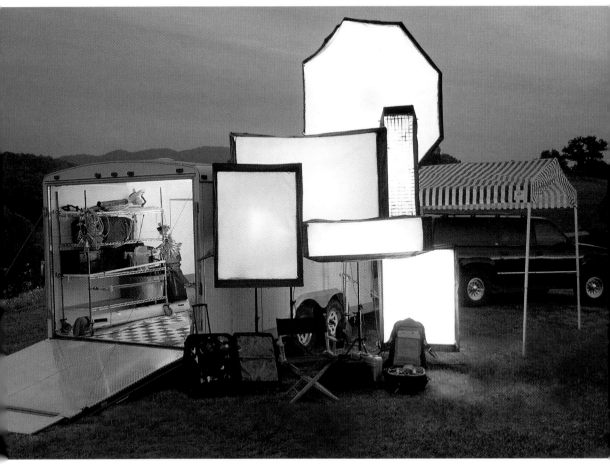

FIGURE 1-27 An assortment of softboxes beside Rip's grip trailer/mobile studio

FIGURE 1-28 (Left) A fabric grid insert diffuses light. (Right) Barn doors shape light.

Light Controls Shape: Wrap-Up

As you can see from the preceding illustrations, we've applied lighting techniques that work for the primitive solid shapes to objects that actually appear in photographs that you might take. The results are dramatic.

Real-world objects like people, pets, and panoramas are formed from various combinations of primitive solids. For example, a person standing up is basically a cylinder. If you apply the cylinder lighting techniques correctly, you'll get great results. (You can also break the rules and get great results, too. Just break them on purpose, for a good creative reason.)

For great real estate and architectural shots, recognize that houses and buildings are basically cubes (Figure 1-29). If you shoot them straight on at high noon, they'll have no shape at all. If you light them correctly by choosing the proper time of day and season when the lighting is best, they'll jump off the page or screen.

FIGURE 1-29 A combination of cubes, spheres, and cylinders lit to reveal their shapes

What's important in all this is to use your eye to recognize the basic elements of lighting rather than rely on a formula to achieve a result. Then you can adjust the lighting, or your camera position relative to the subject, to emphasize or deemphasize the subject's shape, depending on the results you want to achieve (Figure 1-30). Once you've learned how to "see" lighting in this fashion, you will be able to create whatever lighting results you need.

FIGURE 1-30 Directional light creates 3-D shapes in the rocks, waves, and hillside.

Portraits, with and without Shape

A portrait "head shot" is essentially a photo of a sphere. Figures 1-31 and 1-32 show two examples of using flat versus directional light to create dramatically different effects for "glamour" portraits.

FIGURE 1-31 Areas of highlight, shadow, and backlight create a powerful portrait.

FIGURE 1-32 Breaking the rules can also create a great shot. We lit this face with flat, soft, balanced light to remove shape, and then we created facial contours with makeup. Flat, soft light deemphasizes the nose; makeup strengthens eyes and lips.

Reflective Surfaces: Automobile

Reflective surfaces create special problems, because point-source light, like the sun, directed at the surfaces can sometimes reflect back to, or away from, the camera in problematic ways (Figure 1-33). The solution? Don't light the surface by aiming light directly at it. Instead, use what is reflected in the surface to draw the subject (Figures 1-34 and 1-35).

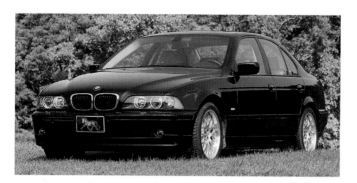

FIGURE 1-33 Shiny metal lit directly by the sun

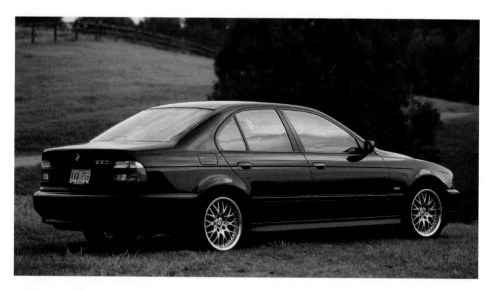

FIGURE 1-34 The best time to shoot great car shots is usually a few minutes before or after sunrise or sunset, when the entire sky becomes the light source. The metal is now being lit by sunlight reflected softly and evenly by the entire sky, creating dramatic, eye-popping results. This shot was taken 20 minutes after sunset.

FIGURE 1-35 Another illustration of shiny metal being lit by what it reflects[5]

5. © 2005 BMW of North America, LLC, used with permission. The BMW name and logo are registered trademarks.

Reflective Surfaces: Jewelry

Trying to sell Grandma's costume jewelry online? To fetch the best price, those shiny baubles must look great. Here's a great trick for lighting the perfect jewelry shot.

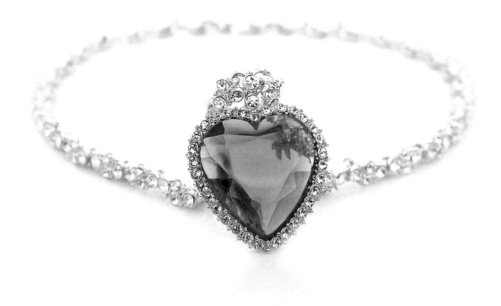

FIGURE 1-36 Jewelry has lots of shiny reflective surfaces that are tough to light well.

Lighting Details

Create a small, tentlike cone with a base diameter approximately twice the size of your object. Cut a small opening at the top for your camera lens.

Your shooting surface can be almost anything but must be slightly smaller than the diameter of the base of the cone. In Figure 1-36 we have used a piece of white coated paper approximately 3 inches smaller than the cone's base diameter. Then we set everything on top of a light box (the kind that you use to view slides or transparencies) and turned on the light (Figure 1-37). Because the paper is smaller than the base diameter of the cone, some of the light from the light box fills the inside of the cone. That's the light that the jewelry reflects.

By slightly varying the light source underneath your object or changing the angle of the cone, you can draw a tremendous amount of shape into your shiny object. Just remember the cube, sphere, and cone examples for creating the best shape possible. Also remember that you don't light shiny objects directly; you light what they reflect. Light the inside of your cone for maximum shape, and your jewelry will look great.

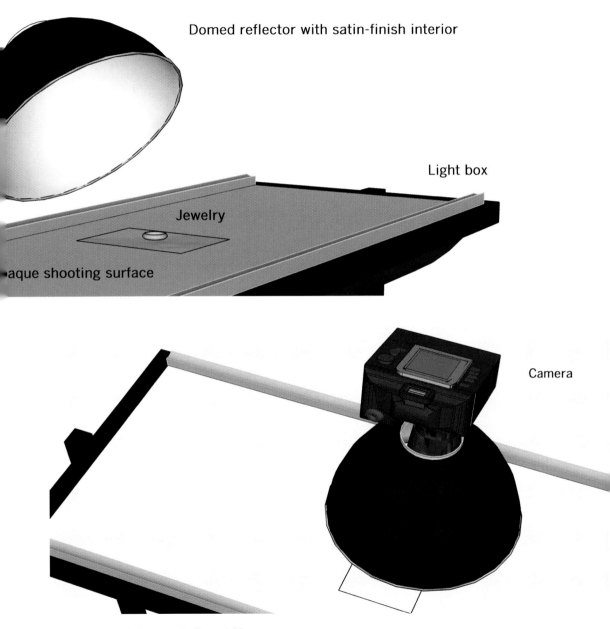

FIGURE 1-37 Lighting setup for Figure 1-36

Reflective Surfaces: Shiny Metal and Fabric

The still life of currency and a gold coin (Figure 1-38) was lit from above and slightly behind (*top-back lighting*) through a scrim (Figure 1-39). The light illuminates the scrim rather than the objects in the shot. The gold coin reflects the light diffused on the scrim, and the top-back directional light coming through the scrim maximizes the subtle textures in the currency.

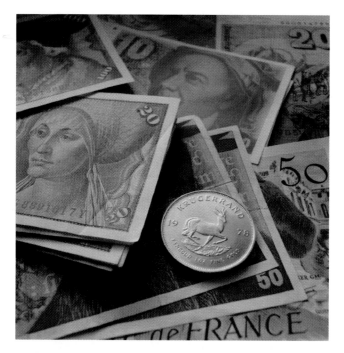

FIGURE 1-38 A tricky lighting problem: a reflective metal object along with paper or fabric

This shot combines two lighting principles:

- Shiny metal is lit best by reflected light rather than by direct light.
- Three-dimensional shape is enhanced when a light source is off-angle to the camera lens.

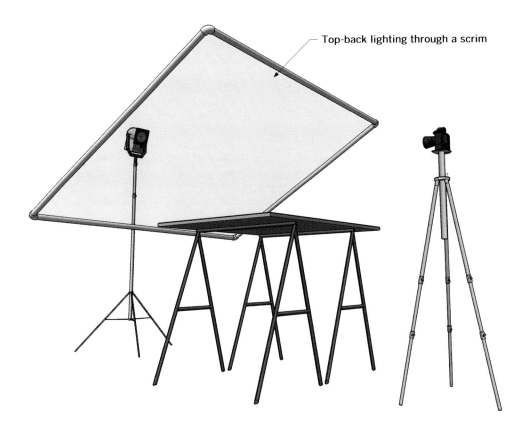

Top-back lighting through a scrim

FIGURE 1-39 Lighting setup for Figure 1-38

A scrim is a great addition to your gear collection and can be a boon to amateur photographers who cannot justify the expense of a professional softbox. See page 38 for instructions on building your own scrim for less than $50.

You'll find ways to use a scrim for all sorts of lighting situations. In this example, we're shooting close-ups. Direct light is often too harsh for such shots, creating too much contrast between light and dark areas, forcing your camera to make hard decisions about exposure levels, and so on. A scrim softens the strobe light and spreads it out over a wide area.

Build Your Own Scrim

You can build your own lighting scrim for less than $50.

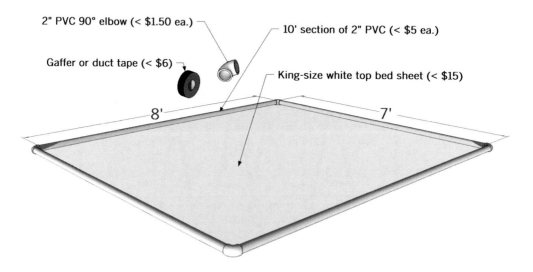

Inexpensive 8' x 7' PVC lighting scrim
Total cost < $47

2" PVC 90° elbow (< $1.50 ea.)

10' section of 2" PVC (< $5 ea.)

Gaffer or duct tape (< $6)

King-size white top bed sheet (< $15)

8'

7'

1. Cut the 10-ft. PVC pipe sections into four pieces (two 8-ft. lengths, two 7-ft. lengths).

2. Assemble the frame by fitting the PVC pipe sections together with the elbows. Secure the connections using duct tape or gaffer's tape.

3. Iron the bedsheet to remove as many wrinkles as possible.

4. Stretch the bedsheet tightly over the frame, and secure it with duct tape or construction clamps. If there are still wrinkles in the sheet, iron them out. Wrinkles create shadows, so the smoother the sheet, the better.

5. Position the finished scrim above, behind, or beside your photo subject. Then bounce light through or off of the scrim to get a soft, glare-free effect.

A scrim is useful for shots that require broad, soft lighting, such as portraits and still life shots, especially if they contain shiny objects (for example, food layouts with silverware).

Light Controls Color

PRINCIPLE

The apparent color of an object depends completely on the light that illuminates it.

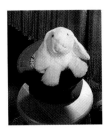 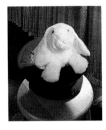 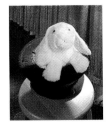 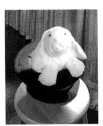

FIGURE 1-40 Same rabbit. Same light. Different results. How?

You can treat color like science, but it behaves like magic (Figure 1-40). Our goal in this section is to make you a magician. Otherwise, there's no telling what color the rabbit is likely to be when you pull it out of the hat. Now try this little experiment.

1. Find the gray squares printed on the white balance calibration card that is located at the back of this book.

2. Carry the card into a windowless room and turn on a lamp or overhead light that uses regular incandescent lightbulbs. Look at the squares. What color are they? [Write your answer here so that you don't think you're crazy later.]

 A: B: C:

3. Move to another room and look at the squares under fluorescent light. What color are they now?

 A: B: C:

4. Carry the squares outside and look at them in bright sunshine. What color are they now?

 A: B: C:

We told you it was magic. (Actually, it's *metamerism*.) What the heck is going on here?

The Temperature of Color

Objects in your photographs are illuminated by light sources of one kind or another. Indoor shots use *artificial light sources*: usually incandescent or fluorescent bulbs, often supplemented by the flash unit on the camera. Outdoor shots use a *natural light source*: the sun, whose light shines through—and is constantly altered by—the atmosphere.

Whatever the light source, we tend to refer to the light that it produces as "white." Sun, lightbulb, fluorescent tube, flash unit—they all emit light that looks "white" to us.

But they don't all look white to your camera, especially your digital camera. It's a fact: Not all whites are created equal. As you saw firsthand from our experiment with the squares on page 39, "white" lights of various kinds produce wildly different perceived colors to the human eye. Why?

QUANTUM LEAP

Every light source (sun, incandescent bulb, flash unit, etc.) produces light that has a specific color temperature (Figure 1-41). The physics explanation is complex. For now, it's sufficient to know that different light sources can make the same object appear to be different colors in your photographs.

| 1,800K | 4,000K | 5,500K | 8,000K | 12,000K | 16,000K |

1,200K: candle 6,000K: bright midday sun

 2,800K: ordinary incandescent bulb, 8,000K: hazy sky
 sunrise / sunset

 10,000K: heavy overcast sky

 5,000K: electronic flash, average daylight
 "D50" = standard photo light booths

FIGURE 1-41 Typical light sources and their color temperatures in Kelvins

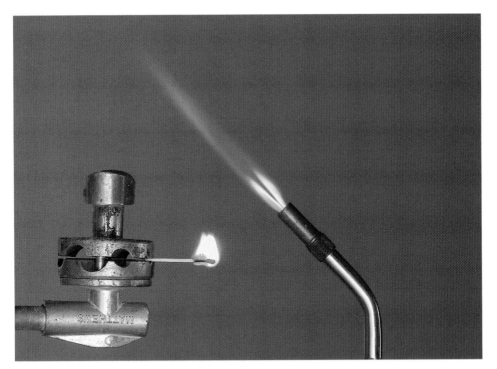

FIGURE 1-42 Heat and color temperature are inversely related.

Figure 1-42 shows clearly that heat and color temperature are inversely related. The blowtorch flame is hottest in degrees but coolest in color as the flame emerges from the head of the torch. As the flame cools farther from the head, the color becomes warmer. The match flame is cooler in degrees but warmer in color compared with the blowtorch.

The implications of color temperature for photography are profound. Whereas the human eye perceives "white" light of varying temperatures, the camera treats each "white" differently. You must control your camera's perception of "white" if you hope to control its rendition of other colors.

Color Magic

The photographs in Figures 1-43 through 1-47 were shot using the camera's default "factory daylight" color balance setting. The only thing that changes from shot to shot is the light source that illuminates the subject.

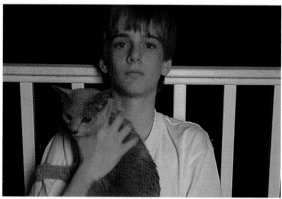

FIGURE 1-43 Incandescent light makes objects look warm.

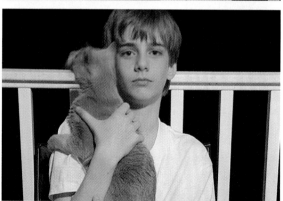

FIGURE 1-44 Fluorescent tubes create a cool, greenish light.

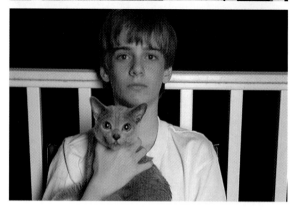

FIGURE 1-45 A camera flash unit is calibrated to approximate natural daylight.

FIGURE 1-46 The midday sun is what your camera's "factory daylight" setting is designed to match. (Midday sun directly overhead creates unpleasant shadows that can spoil portrait shots, so we don't recommend this lighting for shots of people!)

FIGURE 1-47 When your subject is outdoors but in the shade, it's being lit by sunlight reflected by the blue sky. This creates a "cooler," more blue light.

Do you see what a difference the lighting makes on the perceived color of the image? You must get this variation under control if you want to take great digital photographs.

Light in Landscapes

The key to using light effectively in landscape shots is patience, timing, and a little bit of luck. You must depend on the lighting that nature gives you, and this means that time of day, time of year, and weather play huge roles in determining what light falls on your subject. Getting the right light may be as simple as waiting for a cloud to pass.

If you have the luxury of visiting the shot location more than once, do so at different times of day. In particular, watch the light at early morning and early evening, when the sun's lower angle in the sky creates interesting shadows compared with the flat lighting that you typically get at midday.

Just be aware that the color of sunlight does vary as atmospheric conditions change, because the atmosphere is filtering the light before it reaches your camera. Use the color principles in this chapter to obtain your intended results.

White Balance Perfection

Digital cameras provide a great way to solve the color problems created by shooting with different light sources.[6] The secret to success is called *setting the white balance*. It's one of the most important things you must do before pressing the shutter release button.

When you set the white balance of a shot, you tell your camera what object in the shot looks truly white to you. Once the camera knows what white is, it can manipulate the data coming from its sensors so that the values it stores in memory create a final image whose colors are pleasing to your eye.

If you don't tell the camera what white is, it will guess. That's what you get if you set your camera to "automatic" white balance. Sometimes it will guess correctly. For example, if the flash unit fires, the camera knows that the subject has been illuminated by the flash and makes assumptions about what white is based on the characteristics of the light emitted by the flash unit.

But your camera can guess wrong, too. When it does, your images turn out too blue, or too red, or just plain awful. Don't make your camera guess. Give it a fighting chance.

Inexpensive digital cameras may not let you set the white balance completely. Instead, they offer general-purpose settings for "indoor," "outdoor," and "overcast" conditions, plus an "auto" setting. If that's all the control you have, then choose the setting that most closely matches your shot. That almost always yields more pleasing results to the human eye than the auto setting does, although automatic white balance is getting better all the time. Camera manufacturers are constantly improving this and many other camera features. The digital camera wars rage on!

But to get perfect control of color, set the white balance manually using the "manual" white balance setting on your camera and the white balance calibration card included with this book.

Consult your camera's instruction booklet for information about setting white balance manually.

6. Back in the old days, when photographers shot on film, you dealt with varying light sources using lens filters that altered the light entering the camera (see page 50) or by using film emulsions designed for specific lighting situations. Remember having to choose between "indoor" and "daylight" film? That was a crude attempt to address this issue.

White Balance Calibration Card

NOTE
If your camera captures images in the RAW digital photo format, shoot RAW. This allows you to adjust the white balance of your images later, on your computer. But if you're shooting JPEGs, then use the card.

The white balance calibration card included with this book provides both a standard white balance reference and graduated cool-white to warm-white targets that you can use with your digital camera to control color. Follow these steps to use it effectively.

1. Place the white balance calibration card in the same lighting situation as your subject.

2. Set your camera to the mode that allows you to preset the white balance. Refer to your camera manual for instructions. Note that some cameras allow you to preset the white balance only in certain shooting modes.

3. Zoom in or move in so that the area labeled "Neutral White" on our card fills the frame; then lock the white balance. Check the result on your camera's monitor. Does the card appear "white"? If it does, then your camera's preprogrammed white balance setting for this light source is OK. You can stop here and proceed to shoot with abandon!

4. If you want to shift the color, frame up the top or bottom of the card before locking in the setting. Move the card up toward the area labeled "Warmer" to create warmer shots, and down to create cooler shots. The numbered grid helps track where you are on the card so that you can produce similar results in future shots.

5. Some digital cameras that don't support manual white balance preset still allow you to adjust the programmed white balance settings somewhat. If that's the case with your camera, then make these adjustments.

 – If the card appears too red, increase (+) the white balance to add more blue.

 – If the card appears too blue, decrease (-) the white balance to add more red.

 – Shoot the card after each adjustment and check the results. When the card appears closest to "white," you're finished.

White Balance Creativity

Sometimes you can get interesting and creative results by setting your camera to the "wrong" white balance setting (Figure 1-49). For example, try taking some outside shots in direct sunlight with the white balance set to "cloudy" and notice how this warms the shot. Or set the white balance manually using a nonwhite object, such as the "warm" and "cool" target areas on the color calibrator card. The results can be amazing. Don't be afraid to experiment. Just be sure you've selected the wrong white balance setting on purpose!

QUANTUM LEAP

Some shots contain multiple light sources (Figure 1-48). What might you do with an interior room lit with incandescent lights that also has a big window full of sunlight? You could use daylight fill flash to match the sunlight coming through the window; in this case, the lightbulbs add a touch of warmth. Or you could set up a tripod to hold the camera still, then shoot the room twice using two different white balance settings (flash and daylight), and then combine the images on your computer using an image-editing program like Adobe Photoshop.

FIGURE 1-48 Multiple light sources (incandescent and daylight)

FIGURE 1-49 A shot taken in bright sunlight with the white balance set to "cloudy," which produced a warmer result

White Balance Examples

Figures 1-50 through 1-52 show examples of using white balance.

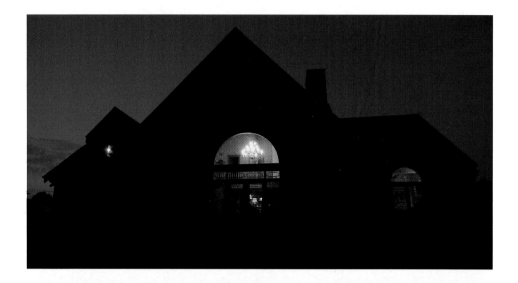

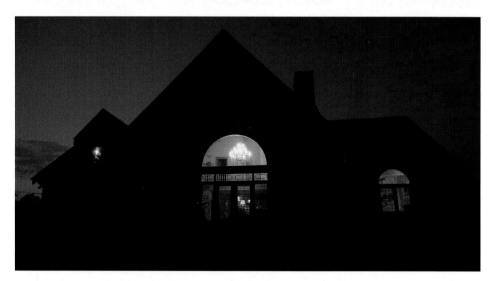

FIGURE 1-50 Same shot; different white balance. The top shot is balanced to 2,400K, and the bottom shot is balanced to 5,000K. Notice the effect not only on the "whiteness" of the incandescent lights but also on the apparent color of the sky.

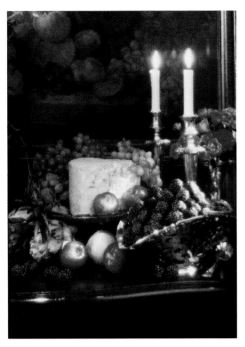

FIGURE 1-51 Still life with multiple light sources of varying color temperatures: natural daylight from the right; white fill card on the left; incandescent flames in the shot. Because the main light source was daylight, we used the daylight white balance setting, which added warmth to the overall shot and candle flames.

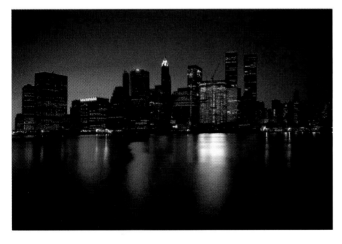

FIGURE 1-52 Playing with color balance presets at night can create interesting results. This shot uses the fluorescent white balance setting.

Physical Filters

Digital cameras and image-editing software can do amazing things with image data. Software filters can create effects that were not possible in film photography, as well as reproduce effects that photographers long relied on physical filters to create.

But even when you're shooting digitally, physical filters can still be useful and necessary. By altering the light that enters the camera, some physical filters let you create effects in-camera that you can't truly duplicate on the computer. For example, although you can simulate polarization using computer software, you can actually polarize light only by using a physical filter. The same is true for shooting infrared. And don't forget that in addition to removing haze, a $10 UV filter offers great protection to a $200 lens!

So shoot the shot in several different ways to give yourself the most creative options.

Does My Camera Accept Filters?
If your camera has a removable lens cap, then filters may be an option. If your camera has a sliding clamshell design with a lens that moves out when you turn the camera on, chances are filters won't fit because they would interfere with the lens cover. But don't despair; there are *software filters* that offer many of the same effects that physical filters do. To be sure whether or not your camera accepts filters, check your camera's owner's guide.

You can also look closely at the end of the lens itself to see whether it has screw threads. If you find threads, then your camera accepts filters. If not, you may be able to purchase a filter adapter that holds the filter on the lens, either from the camera's manufacturer or from third parties (see page 286).

What Physical Filters Do I Need?
If your camera accepts filters, you should add the following to your gear bag. If your goal is to achieve the particular effect that one of these filters provides, then using the filter saves time later in front of the computer. Of course when you shoot through a filter, there's no "undo"—only "delete" if you're unhappy with the results.

If you're saving your images as JPEG or TIFF (rather than RAW) when you shoot through a filter, be sure to set your camera's white balance first. Use the white balance calibration card for much greater control (page 45).

Clear ("UV Haze")
A *clear* (or "UV haze") filter reduces ultraviolet wavelengths to create sharper outdoor shots. Because UV is almost never desirable in any shot, this filter can go on your camera and stay there. That makes it a great lens protector, too. If the filter gets scratched, it's cheap and easy to replace—unlike the lens.

Infrared

An *infrared* filter blocks all visible light but allows infrared wavelengths to reach the image sensor (Figure 1-53). See page 124 for more about IR shooting.

FIGURE 1-53 A landscape shot in daylight with an infrared filter

Circular Polarizer

A *circular polarizer* filter is great for reducing glare in water and improving color saturation. It can also reduce haze in the sky and make it appear bluer (Figure 1-54).

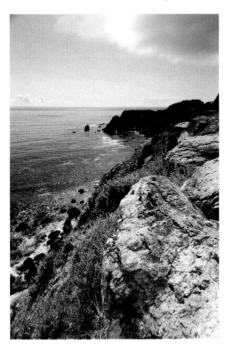 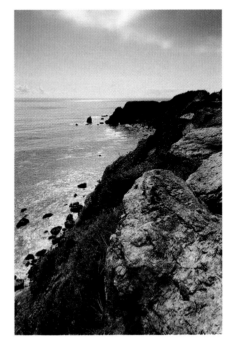

FIGURE 1-54 California coastline shot with a circular polarizer (left) and without a filter (right)

Soft Focus

There is a wide variety of *soft focus* filters designed to create different effects (Figure 1-55). They soften the overall image and create various glows (either lighter or darker) around highlights in the shot.

FIGURE 1-55 (Top) Autumn still life shot with Tiffen Pro-Mist 2 filter. (Bottom) The same shot unfiltered.

Neutral Density

Sometimes there's just too much light. In Figure 1-56, we wanted to blur the water in the mountain stream. That means shooting with a shutter speed no faster than ¼ second. But in full daylight, the shot would be overexposed at even the highest f-stop setting. You can use a *neutral density* filter (available in a variety of density values) to reduce the amount of light entering the lens without altering the color characteristics of the shot.

FIGURE 1-56 Mountain stream shot with a shutter speed of 1.5 sec. to blur the water. The smallest aperture available on the lens was f/22; a 2-stop full neutral density filter reduced the light to an acceptable level to allow the motion blur.

Graduated Neutral Density

Sometimes there's too much light, but only in one part of the shot. In Figure 1-57, the sunset sky was much brighter than the coastline in the foreground. If we had exposed the sky correctly the foreground would have been lost in darkness. A *graduated neutral density* filter was just what we needed. Like a full neutral density filter, a graduated neutral density filter blocks incoming light. But the effect is "graduated" or variable, and not uniform.

FIGURE 1-57 A Tiffen Clear No. 6 graduated neutral density filter held in front of the lens. The upper-left corner is unfiltered to show the original sky. The filter itself is shown at right.

Software Filters

If your camera does not accept physical filters, or if you prefer to filter your images on your computer rather than on your camera, the following software-based filtering products from nik Multimedia, Inc., are just the ticket. (Please visit PhotoGain.com for the latest information about software filtering products.)

- Color Efex Pro: Dozens of color and lighting effects (simlated polarization, sepia, solarization, graduated neutral density, etc.). For Adobe Photoshop and applications that accept Photoshop plug-ins. Provides powerful creative effects for dazzling results. Highly recommended!

- Dfine: Digital noise reduction and sharpening. For Adobe Photoshop and applications that accept Photoshop plug-ins. Purchase optional camera-specific profiles to work more quickly. Reduces noise caused by sloppy image compression to improve detail and image quality. Recommended.

- sharpener Pro: Digital sharpening for specific output targets (laser and ink-jet printers, commercial offset presses, computer monitors, etc.) For Adobe Photoshop and applications that accept Photoshop plug-ins. Recommended for beginners.

Figures 1-58 and 1-59 show the kinds of effects you can get using software filters.

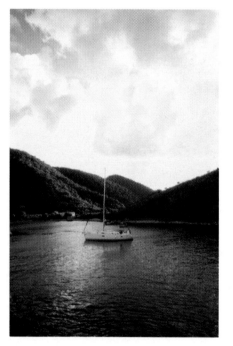

FIGURE 1-58 Original shot, in a cove on Peter Island, British Virgin Islands

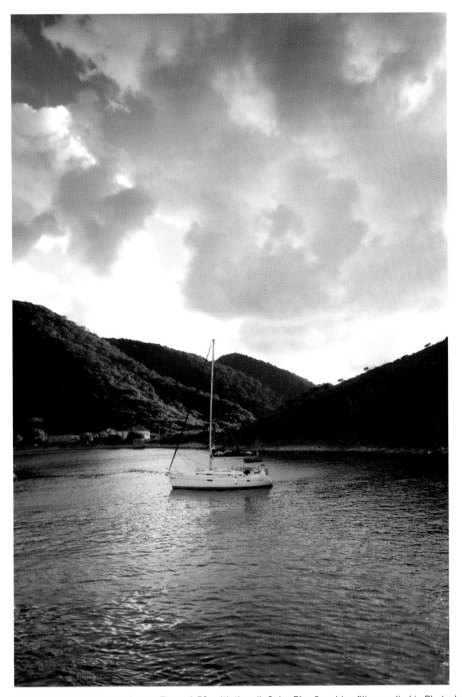

FIGURE 1-59 The same shot as Figure 1-58, with the nik Color Efex Sunshine filter applied in Photoshop

Underwater Photography

Underwater photography used to be an exotic undertaking that was open only to a select few. But the advent of digital cameras has made underwater shooting much more accessible to those looking for a bit of visual adventure (Figures 1-60 through 1-62).

Here are a few advantages that digital photographers who dive can expect to enjoy—even if their dives are in the swimming pool!

- Digital camera companies and specialty vendors offer a large (and rapidly growing) number of waterproof housings for underwater shooting.

- High-capacity memory cards mean more shots per dive and less time spent on the surface drying off and reloading film.

- Water is a natural filter for shorter wavelengths of light, giving shots a blue color cast that is constantly changing with water conditions and that increases with depth. Automatic white balance adjustments in-camera can help you get much truer colors much more easily than was possible with film.

- Instant feedback on the camera's monitor lets you know immediately whether you need to reshoot.

- Water refracts light and magnifies objects very differently than air. This means that photographers who focus manually must make special corrections when focusing. Auto focus cameras pull focus automatically, even under water. Although many film cameras offer auto focus, the feature is virtually universal on digital cameras.

FIGURE 1-60 Even underwater shots require decisions about depth of field and composition.

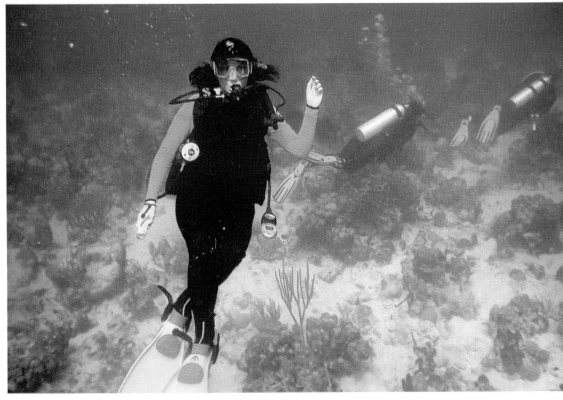

FIGURE 1-61 A diver in 50 feet of water off Peter Island, BVI. The shot was made using natural light. At this depth, the light is mostly blue, but auto white balance does a fairly good job of delivering true color without a flash.

FIGURE 1-62
Navigating reefs without the bulk of an external flash unit makes underwater shooting more pleasurable.

Summary

Light is critical to revealing shape and controlling color in digital photography.

- Light reveals shape in your subjects by casting shadows and creating highlights. If shape is important to your photographic intent, be sure the subject is lit off-angle to the camera lens. On the other hand, if your goal is to minimize shape, light the subject straight-on to the camera lens.

- When you're lighting reflective surfaces, it is best to light what the surface reflects rather than light the surface directly.

- "Color" in photography is not an intrinsic property of objects. It is an *effect* created by light reflected from objects and interpreted by the brain.

- The first step to getting the color you really want in your shot is to set the camera's white balance to match the light source in the shot. This defines what "white" means to the camera for that specific image.

- Shoot in the RAW format if possible, or use the white balance calibration card included with this book to set the desired white balance.

- Physical filters can be very useful for digital photographers because they alter the light reaching the image sensor in specific ways to create specific creative effects.

- You can use software filters to create many of the same effects later, when you edit the image on your computer. And there are many software filter effects that are impractical, if not impossible, to create with physical filters.

- After you have begun to see light and are comfortable handling simple lighting instruments, add a softbox lightbank for a slightly diferent quality of light and additional lighting control.

- Even if you're just a snorkler and not a diver, check out some of the new inexpensive underwater camera housings. Most great underwater subjects occur at a depth of 30 feet or less.

Compose It

ighting makes the subject of your photograph *visible*. Composition makes it *interesting*. We've all seen plenty of photographs that shout the question, "Why was this taken?" Perhaps you've even shot a few yourself. One of the benefits of digital photography is that you can delete pointless pictures easily, without having wasted money on film and processing. But why waste time and disk space at all? This section helps you focus[1] on what's important to tell the story inherent in every shot, and to tell it in an interesting and compelling way.

Sometimes the story is very short; sometimes it's longer and more complex (Figure 2-1). But the story is there, and, as the photographer, you're the storyteller.

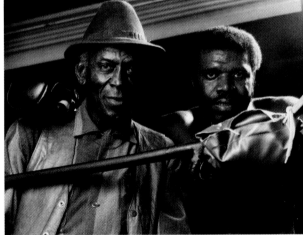

FIGURE 2-1 What stories do these pictures tell?

1. Pun intended.

Visual Push-Ups

Visual storytelling begins with the basics of design. Great photographs share a common set of visual design elements (Figures 2-2 through 2-6). Sometimes their use is overt and obvious. Sometimes the design elements are subtle or subconscious. When you begin to recognize these fundamental visual elements in the world around you and put them to creative work in your photographs, you will grow as an artist.

Most great images contain more than one fundamental element. The trick is to see them wherever you look, and then to exploit them in your photographs for all they're worth. Let's do some "visual push-ups." We want you to start seeing the world in a new way. Our goal is to exercise your eyes and your mind, so that you develop a habit of noticing the design elements that are all around you. The fundamentals are out there—go find them!

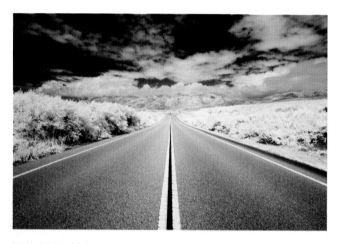

FIGURE 2-2 Line

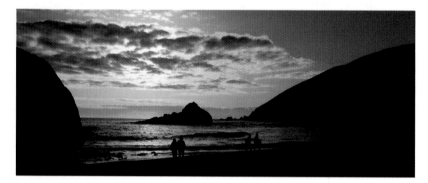

FIGURE 2-3 Shape and form

FIGURE 2-4 Pattern

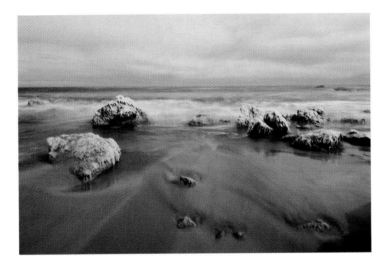

FIGURE 2-5 Texture

FIGURE 2-6 Color

Design Basics: Line

Line is the most fundamental visual element (Figures 2-7 through 2-9). Without line, there is nothingness. Lines are everywhere, in many forms: thick or thin, straight or curved, natural or man-made.

FIGURE 2-7 Sometimes the strongest lines aren't in front of you; they're above you.

FIGURE 2-8 Lines can be literal (the surf) or more subjective (the three pebbles).

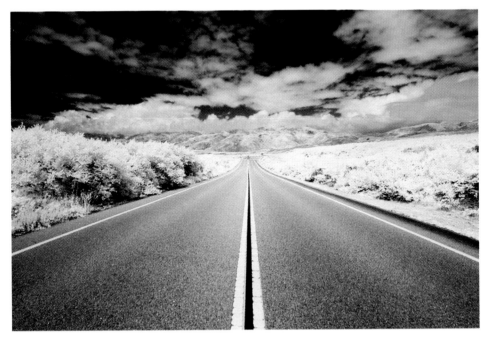

FIGURE 2-9 Lines can draw you from the foreground into the far distance. Strong diagonal lines create great energy and a sense of motion (see page 84).

Design Basics: Shape and Form

Basic two-dimensional shapes (often created by flat light or silhouettes) and three-dimensional forms (created by strong directional lighting) provide the next level of richness and complexity in visual design. Figures 2-10 through 2-12 illustrate the use of shape and form.

FIGURE 2-10 Strong backlighting provided by the setting sun creates stark, dramatic two-dimensional shapes

FIGURE 2-11 Whereas the hills are flat shapes, the clouds and waves have more body and fullness.

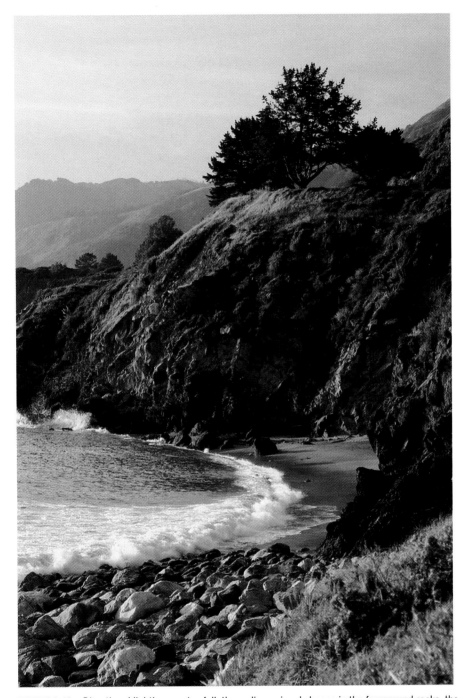

FIGURE 2-12 Directional lighting creates full, three-dimensional shapes in the foreground rocks, the curling waves, and the bulging hillside.

Design Basics: Pattern

As shown in Figures 2-13 through 2-15, patterns are everywhere. Sometimes they are purposeful; sometimes they arise from random associations that create fortuitous results. However they are formed, the predictability and repetitiveness of patterns reassure and comfort us. Without pattern, there is chaos.

FIGURE 2-13 Nature creates a wealth of patterns, like we see in the sand behind this strand of kelp.

FIGURE 2-14 Patterns appear in architectural and industrial contexts. The combination of pattern and line in this shot conveys both a sense of soaring energy and rock-solid stability.

FIGURE 2-15 Slow shutter speed coupled with a wide-angle zoom effect creates depth within the repeating patterns on a chessboard.

Design Basics: Texture

Texture, more than any other fundamental design element, has the power to convey strong emotion (Figures 2-16 and 2-17). It can also be the most subtle and most difficult element to see. You need strong directional lighting to reveal texture, so you'll need to seek it out in the early morning or late afternoon if you're shooting outdoors. If you seek texture when shooting with artificial light, be sure to keep your camera off-axis to the light source.

We often perceive textures when shooting very close-up (macro) shots. But texture is also revealed in sweeping landscapes.

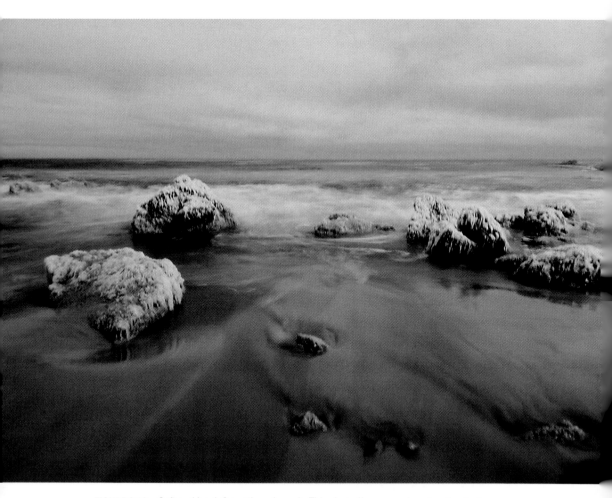

FIGURE 2-16 Soft and hard. Smooth and rough. This shot offers several contrasting textures.

FIGURE 2-17 You can almost feel the roughness of the sand between your toes. Consider the emotional response that this creates as you look closely at the image.

Design Basics: Color

The human response to color is varied and complex (Figure 2-18). Are you feeling blue? Was she green with envy? Does income tax time make you see red?

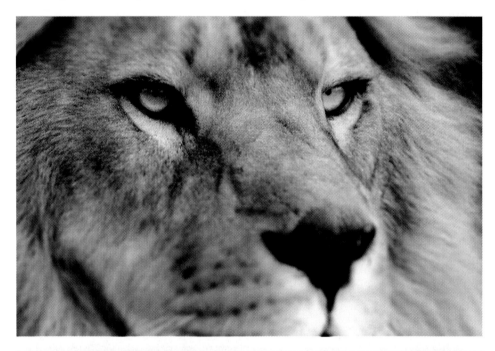

FIGURE 2-18 Isolated color in these monochrome shots grabs your attention forcefully.

Color carries enormous emotional power (Figure 2-19). Be aware, however, that the connotations of particular colors vary widely by culture. White can suggest both purity and death. Green connotes life and vigor, freshness and growth. Purple is the color of royalty to many. Red suggests love, anger, heat, and pain. Blue is cool, deep, and calm. Yellow can be lively or sickly, playful or cowardly.

Color can be a powerful storytelling tool.

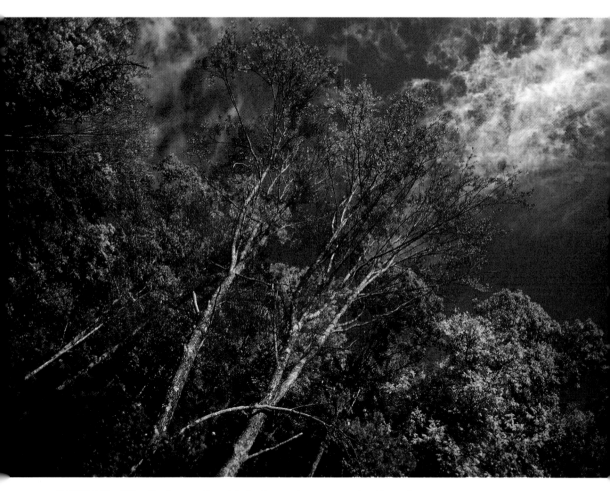

FIGURE 2-19 Filling the frame with a riot of color creates energy and excitement.

The Golden Section

Human beings have an innate preference for order over chaos. We are always trying to "make sense" out of what we perceive. The ancient Greeks codified this basic tendency into rules for the visual arts and architecture that eventually came to be known as the "golden section." The principles behind the golden section are a strong underlying design influence to this day.

Simply put, the golden section appears in rectangular shapes that are approximately two-thirds wider than they are tall. This 2×3 aspect ratio is generally pleasing to most viewers. (It's no coincidence that 4×6-inch prints are the most popular snapshot size.)

If you divide a golden section into nine equal parts, you create a grid (Figures 2-20 and 2-21). We'll use the grid in subsequent sections to guide your thinking about ways to make shots most pleasing. Remember, though, that the grid is only a guide, and not a rule that you must slavishly follow. Think of it as your personal design consultant, one who offers good suggestions that you should not hesitate to ignore if you have a valid artistic intent!

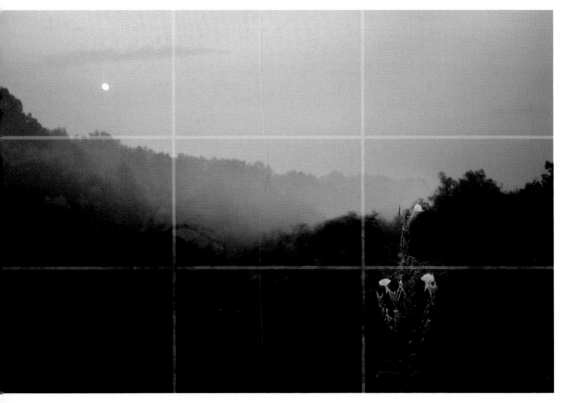

FIGURE 2-20 The golden section

FIGURE 2-21 The golden section applies to vertical images, too.

The Rule of Thirds

The Greeks observed that people prefer groups of three. As you saw on page 72, the golden section grid comprises three rows and three columns. If you use those rows and columns to organize a shot's elements, the visual design tends to be more pleasing.

The dominant elements in Figure 2-20 on page 72 are organized into three rows: the dark foreground (bottom), tree and ridge lines (middle), and sky (top). Figure 2-21 on page 73 aligns its elements to the grid almost perfectly, too, illustrating that the golden section works for vertical images as well as horizontal ones.

Look for boundaries and borders in your shots, and then imagine the golden section grid to guide you toward a pleasing layout (Figure 2-22).

FIGURE 2-22 Sidewalk and shadow boundaries lie near the golden section horizontal grid lines. Likewise, the tree and window are in the middle two columns.

Positioning the Horizon

In landscape shots, your first impulse is to put the horizon right in the middle of the image. If you place the horizon near the upper or lower horizontal grid line instead, the results will be more pleasing (Figures 2-23 and 2-24).

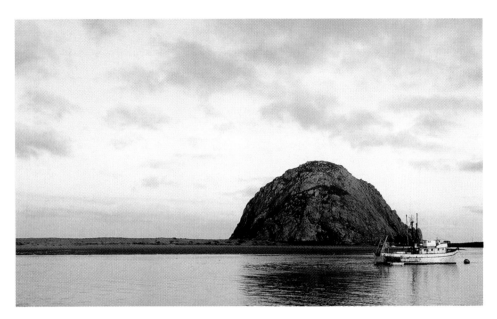

FIGURE 2-23 The horizon falls near the lower grid row.

FIGURE 2-24 Moving the horizon off the center improves this shot's balance (right).

The Power Points

The grid in the golden section is more than rows and columns. The intersections of the grid lines create *power points* that you can use to strengthen a composition. Consider placing dominant elements at one or more power points to give them extra thematic punch (Figures 2-25 and 2-26).

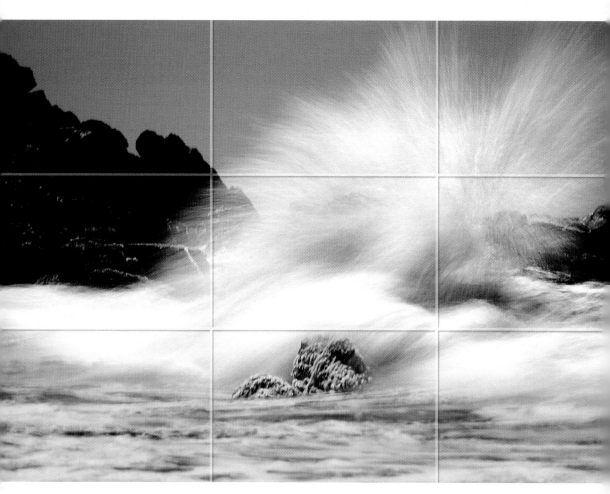

FIGURE 2-25 The splash is anchored at the upper-right power point, giving the whole shot an added pop.

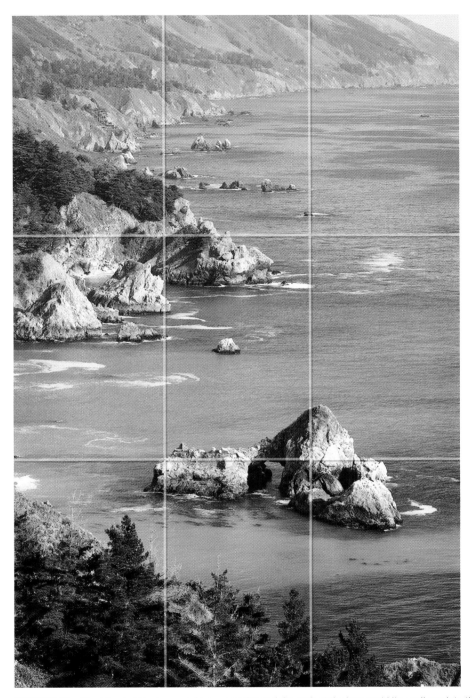

FIGURE 2-26 The island at the lower-right power point and the arch at the lower grid line pull you into the shot; the C curve in the upper row draws you into the distance.

Control the Frame

Sometimes, there's just too much in the shot. Consider Figure 2-27. The left and right edges distract from the main subject. It's time to crop, either by reframing the shot before you shoot it or later, on the computer. Imagine cutting a diamond, facet by facet, to transform a lump of carbon into a dazzling gem.

In Figure 2-28, the clutter at the edges is gone, allowing us to concentrate on the main subject without distraction.

FIGURE 2-27 The edges of this shot distract from the main subject.

FIGURE 2-28 Ahhhh . . . that's better.

It sounds obvious, but it's critical. The viewfinder or monitor shows roughly what you'll get in your shot.[2] Learn to see clearly what's in the frame of the shot, and not what you see when you look outside the camera. Treat your frame as an artist treats a canvas, and be aware of all that lies inside it.

See What's in the Shot

One of the most common errors you can make is to overlook objects that are right there in your shot—especially objects in the foreground that seem invisible but then appear as if by magic later. You're concentrating so hard on the primary subject that you fail to see extraneous objects cluttering the frame. Don't be surprised by what shows up in your shot. Check each shot immediately after you take it, and reshoot it if necessary.

Likewise, don't miss a critical story element that you've inadvertently cut out of the shot by poor framing. Change angles, or zoom a bit if necessary.

FIGURE 2-29 A classic (bad) landscape shot

Consider Figure 2-29. There may have been a pretty view of the mountains when the shot was made. But you can't tell it from this shot: The horizon is dead center; the light poles in the foreground obscure the view; the baseball fields (?) are awkwardly cropped. What other problems can you diagnose?

2. Most viewfinders on digital cameras match only about 90 percent of what you can expect to see in your final image. The small electronic monitors on the back are a bit better. You'll need to practice with your camera to get a good sense of how closely the camera's viewfinder and monitor match the final image.

Fill the Frame

Fill the frame with your subject. Eliminate clutter and noise and large expanses of nothingness that distract from or weaken the story. Ask yourself, "What's most important in this shot?" Resist the common urge to go for a wide shot to "get everything in." Zoom in on what's important.

FIGURE 2-30 It's tempting to shoot wide.

Figure 2-30 is pretty, but there is a lot of empty sky. Now, empty sky is not necessarily bad. Perhaps your visual story is about loneliness or feeling lost. In that case, a single balloon alone in an empty sky might have been a better choice.

Now consider Figure 2-31. The zoomed shot is much more powerful. It offers pattern and color and texture that grab the eye and won't let go. Fill the frame with your subject, and the results will be far more interesting.

FIGURE 2-31 Zoom in, and the shot becomes much stronger.

"Optical" Versus "Digital" Zoom—Caveat Emptor!

Having a digital camera with a zoom lens gives you more flexibility in framing interesting shots than is possible with fixed-focal-length lenses. But not all zooms are created equal. *Optical* zoom is really all that matters for serious photographers. Optical zoom measures a lens's ability to magnify an image using the optical elements inside the lens itself, without sacrificing image resolution (quality). *Digital* zoom does nothing more than crop the image in-camera so that it looks as if it's bigger. But it's not really. The cropped image has the same resolution as the original, so the image that you eventually print or display will typically be of lower quality.

Cameras that proclaim "30× Zoom! (3× optical, 10× digital)" really only offer 3× zoom before image quality begins to suffer. Spend your money on a camera with the most optical zoom that you can afford, and don't fool with digital zoom. If you can't zoom in enough with the optical zoom, take the shot at the highest possible resolution and then crop it on your computer. The results will be much better.

Shoe-Leather Zoom

One more tip: Use your feet! It's perfectly fine to walk toward or away from your subject if your lens won't zoom in or out enough. In these days of remote control everything, it's easy to forget that we have functioning legs.

Shot within a Shot

Great shots often contain other great shots lurking within them. If you've taken the time to frame a great shot, take one more minute to explore. Look for shots within your shots (Figures 2-32 and 2-33).

FIGURE 2-32 This wide shot tells of a mother's love for an ailing child.

FIGURE 2-33 The shot within the shot is all about the cuteness of the infant and tender touch conveyed by the hands.

The Power of Diagonals

Diagonal lines suggest motion and energy. They can breathe life into what might otherwise be a conventional, uninteresting shot (Figure 2-34).

One simple way to harness the power of diagonals is to frame strong horizontal elements and then just tilt your camera. You can create the same effect with your image-editing tool by selecting a rectangular region and then rotating it. Be careful not to skew or deform the rectangle when you rotate it unless the deformation is for a specific creative reason.

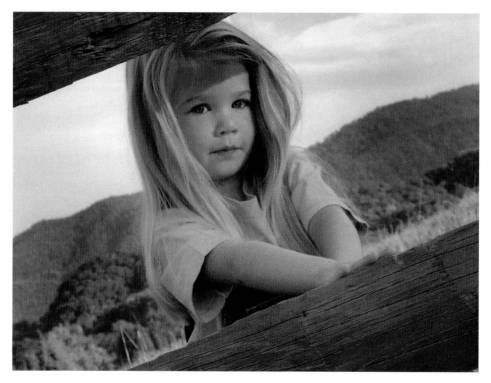

FIGURE 2-34 Strong diagonals heighten the playful energy. This shot also uses the "frame within the frame" technique (see page 94).

Diagonals may be artificial or natural. You may not notice strong natural diagonals until you frame a shot and see them in the viewfinder or monitor. In Figure 2-35, the contours of the hillsides, riverbank, and roadway combine to create powerful diagonals that give the shot considerable power and energy.

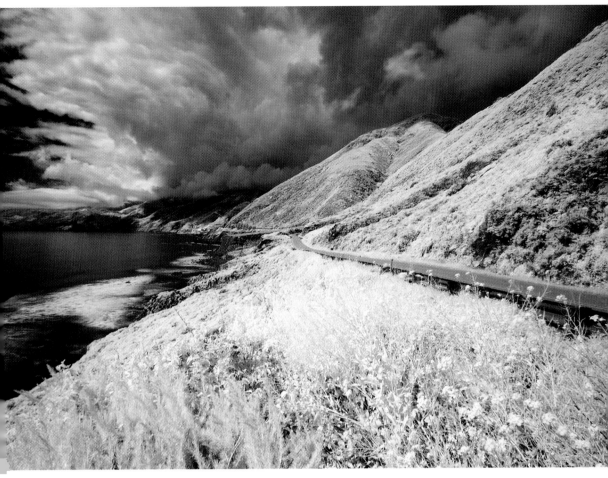

FIGURE 2-35 Natural elements unite to form astonishing diagonal lines.

The Power of Eyes

If there are people in a photograph, the first thing you look at is their eyes. It's basic human nature. Great photographers consistently use this principle to their advantage (Figure 2-36).

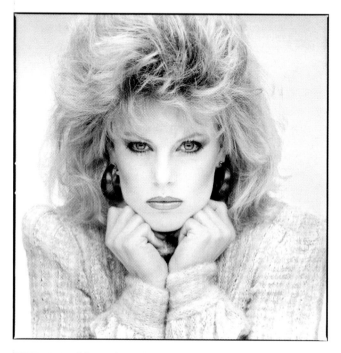

FIGURE 2-36 What makes this portrait so irresistible? It's the eyes, baby!

The attraction of eyes transcends age, culture, gender, and race. By gazing directly into the camera, the little boy in Figure 2-37 demands our attention. It doesn't hurt that he's cute, too.

Perhaps your shot contains a group of people rather than a single individual. If there are lots of eyes to choose from, as in Figure 2-38, your gaze is drawn first to the eyes that are looking back at you.

FIGURE 2-37 Eyes are irresistible.

FIGURE 2-38 Where do you look first? Despite this shot's many shortcomings, you can't help looking at the young man staring right at the camera.

It's no accident that even beginning photographers shout at their subjects, "Look here and smile!" A photograph is strongest when the people in it make eye contact with the people viewing it.

It's OK to talk to your subjects and encourage them to look at you. You may even need to wait for a few extra moments until the person or people most important to the shot turn to the camera (Figure 2-39). That's OK, too. Patience usually pays off.

Consider Figure 2-32 on page 82. Even though the mother is much larger and more thematically dominant than the child, our attention is drawn first to the infant's eyes.

But there are lots of great photographs that contain no eyes. The next several sections discuss other compositional tools you can use to guide the viewer's gaze into your shots.

FIGURE 2-39 Even when your subject is not of your own species, eyes are hard to ignore.

The Power of Contrast

FIGURE 2-40 Areas of highest contrast attract the most attention.

If a shot is devoid of people and eyes, then the next most attractive property of an image is *contrast*. In other words, our attention is drawn first to the objects that contrast most with their backgrounds or with adjacent objects in the shot.

Here's how your eye tends to travel through Figure 2-40:

1. You're immediately drawn to the area of highest contrast: the bright background oval surrounded by dark spaces and objects.

2. Next, you look down and left to the area of next highest contrast: the daisies. Although people from Western cultures tend to read left to right, the contrast in this shot pulls leftward.

3. Finally, your gaze moves rightward along the tabletop to the black telephone, which contrasts sharply with the light background.

FIGURE 2-41 Low contrast tends to saturate color.

You don't have to have a blue sky to get a beautiful outdoor shot. Overcast or foggy conditions are great opportunities to showcase colorful subjects. Low-contrast lighting makes whatever color there is stand out. If Figure 2-41 had been shot beneath a cloudless sky, the yellow in the flowers would have been washed away.

The Power of Focus

Focus is a powerful tool for directing the viewer's attention. Objects that are in focus attract much more attention than objects that are out of focus (Figure 2-42).

FIGURE 2-42 This shot draws attention to the product logo by throwing the surrounding objects out of focus. The high contrast between the brilliant white square and the dark background also grabs your attention. Contrast and focus—a double dose!

Dealing with Auto Focus

Professional-level digital cameras, especially those with interchangeable lenses, still offer obvious manual focus options like focus rings on the lenses. But many consumer-level cameras do not appear to give you that option. Those cameras pull focus automatically on whatever lies at the center of the image using a variety of techniques, with varying degrees of success. That may seem like a blessing in most circumstances, but if you really want to be in charge of the results, you'll need to take control.

One technique is to exploit *depth of field*, which derives from the size of the lens aperture that you're using. We talk more about this on page 109. The next section discusses other ways to control focus yourself.

Spot Focus and Manual Focus

There are alternatives to auto focus for those willing to dig into their camera manuals. Most digital cameras offer both spot focus and manual focus features. Using those features takes a bit more work, but gives you the control you may need.

Spot Focus

If your camera offers *spot focus*, you'll be able to move a focus-targeting box around the viewfinder. The camera then focuses on the highlighted target rather than on the center of the image. This can be useful if you position your main subject off-center—perhaps at a power point (see page 76). Then you use spot focus to get the main subject in focus.

Refer to your camera's user manual for instructions on using spot focus.

Manual Focus

Your camera may give you complete focusing control, too. This is true *manual focus*. The procedure varies, but typically it involves changing a camera setting to manual focus mode and then adjusting the focus with a cursor, control knob, or rocker switch. Check your user manual for specific instructions.

NOTE
You'll need quite a bit of practice to focus "by eye." We advise using a tripod to hold the camera steady for repeated shots.

Unless your camera's viewfinder offers a *through the lens* image, you won't be able to use it to judge whether or not you've focused correctly. You'll have to rely on the monitor to make a judgment. Unfortunately, the monitor is often too small, too dim, or too dirty to provide enough useful feedback to make an intelligent focusing decision.

That's where the tripod comes in handy. Pull focus and shoot; then use the monitor's zoom feature to zoom in on the shot you just took. With the image zoomed big enough, you can finally see for sure whether or not the shot's focus is what you intended. If it's out of focus, just smile, delete, and reshoot.

A More Interesting Angle

You don't have to settle for the same old, straight-on shot that you've shot a jillion times before. A simple shift in your point of view can add drama and spice to an otherwise conventional image (Figures 2-43 through 2-46). Try kneeling or lying on your belly to get a new view of the world. Or get above your subject and shoot down. Don't just stand there and shoot at eye level. It's been done!

FIGURE 2-43 A typical group portrait shot at eye level (yawn . . .)

FIGURE 2-44 The same group shot from the top of a staircase. Changing the point of view creates a much more interesting and dramatic shot.

FIGURE 2-45 Here's a different angle (left) on a common subject.

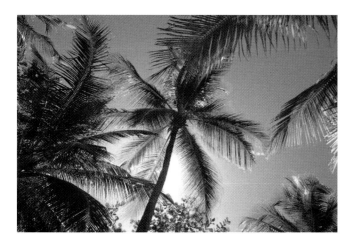

FIGURE 2-46 Look up and down, and not just side to side. You'll be surprised and delighted at the shots you'll discover.

Frame within a Frame

The physical borders of a shot form the most obvious "frame" around your subject. To add interest, you can also use foreground elements within the shot to frame more distant objects and draw greater attention to them (Figures 2-47 and 2-48).

FIGURE 2-47 Cactus frames Dead Man's Chest island in the British Virgin Islands.

See Figure 2-34 on page 84 for another example of a frame-within-a-frame shot.

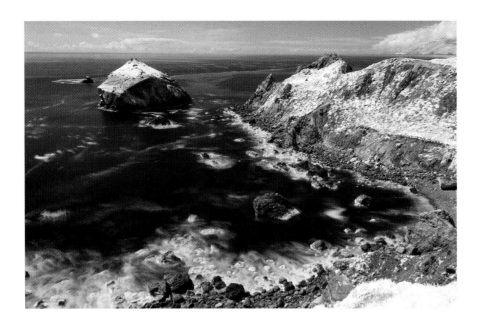

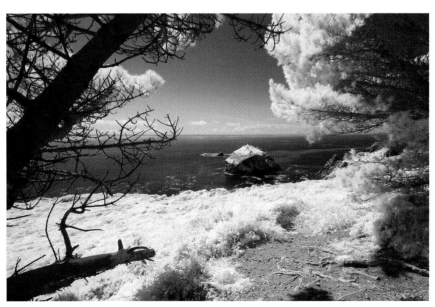

FIGURE 2-48 Here is a distant subject treated with two different techniques. (Top) The island lies at the upper-left power point of the golden section. (Bottom) The island is framed by the trees and branches in the foreground. Both shots are strong, but in different ways.

The Power of Altered Perspective

You can use your camera's ability to shoot at relative extremes of wide angle and telephoto to create unusual effects. For example, you typically use the lens's widest angle to capture a wide scene. By shooting wide and then pushing the camera in tight on your subject, you force a different perspective on the shot or emphasize a different portion of the shot and thus violate the viewer's natural expectations. The results, if handled effectively, can create an eye-catching effect (Figures 2-49 through 2-51).

FIGURE 2-49 A wide-angle shot pushed in tight from above makes the man's head and fingers appear too large for his body.

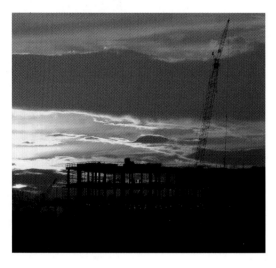

FIGURE 2-50 A telephoto shot of this construction scene compresses the foreground objects against the infinitely deep horizon. The sunset appears far bigger than it really was.

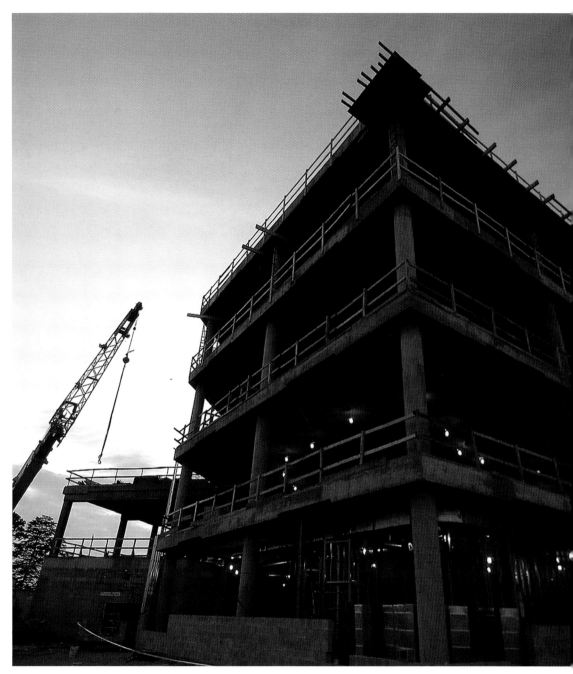

FIGURE 2-51 Another wide-angle shot pushed close to force an alternative view of reality. 12mm lens, f/4, $^1/_8$ sec.

The Power of the Foreground

You often shoot landscapes at wide angles to capture sweeping vistas. Sweeping vistas are good. But they're often even better when you add an interesting element to the foreground (Figure 2-52). It creates an exciting visual tension as your eye moves back and forth between foreground and background. It also helps to establish a sense of *scale*—a frame of reference to give the viewer a better understanding of the size and scope of the landscape.

When you shoot at wide angles, you get greater apparent depth of field at a given aperture (Figure 2-53). That means more of the shot is in focus. When the focal length is 24mm or less and the aperture is at least f/8, essentially everything is in focus—from a few inches to infinity.

This vast depth of field makes it easier to keep all objects in the close foreground and the distant scenery in sharp focus.

FIGURE 2-52 The foreground rocks and pensive iguana add scale and a bit of humor to this beautiful harbor landscape.

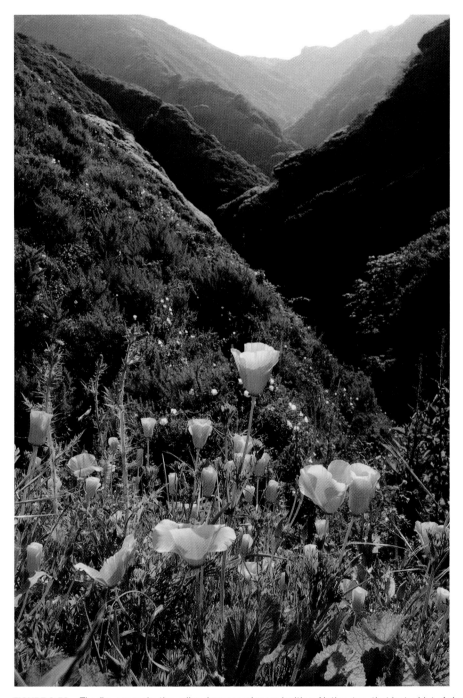

FIGURE 2-53 The flowers make the valley deeper and more inviting. Notice, too, that just a hint of sky at the top is all the sky the shot needs.

Get Vertical

The vast majority of the shots taken are horizontal (Figure 2-54). That's due in large part to the way we're forced to hold our cameras in our hands. But it doesn't have to be that way. After you've taken a great horizontal shot, turn your camera sideways and shoot vertical (Figure 2-55). There are great vertical shots just waiting to be taken, if you'll only take them.

And who knows? You may wind up with a great piece of stock. After all, almost every book and magazine cover in print is vertical!

FIGURE 2-54 A typical horizontal composition

FIGURE 2-55 A vertical treatment of a shot similar to Figure 2-54

Bring It Into Balance

The shot in Figure 2-56 combines several of the fundamentals of composition to create a compelling image:

- Even though the horizon is centered, the elements of sand, sea, and sky are organized into three strong rows.

- The driftwood, sand, and rocks offer distinct and interesting textures.

- Dramatic lines and areas of sharp contrast create excitement.

- The foreground driftwood frames the horizon.

FIGURE 2-56 Line, texture, form, and contrast . . . all working together

Summary

Composition makes a photograph interesting by clarifying the story within the picture. Your shots will tell their stories more effectively if you follow these guidelines:

- Do your "visual push-ups" to begin seeing the fundamental visual design elements that are all around you: light (Chapter 1), line, shape and form, pattern, texture, and color.

- Use the golden section and the rule of thirds as guides for creating a pleasing composition.

- Power points in the golden section offer great places to position the main subject of a shot.

- Control the frame and fill it with your subject. Resist the wide shot; zoom in on the main elements.

- Be on the lookout for great shots that may be lurking within the main shot.

- Diagonals can breathe life into an otherwise static shot.

- Eyes are irresistible. They draw our attention immediately, even if the subject is not a human being.

- Areas of contrast (relative difference in light and dark values) pull the viewer into the shot.

- Areas in sharp focus draw more attention than areas of soft focus.

- An unusual camera angle can add interest to an otherwise ho-hum shot. We see the world every day from eye level. Show us the world in a new light and at a different angle, and you will be on your way to stronger creativity.

- Use a frame within a frame to add drama and emphasis to the main subject.

- Alter or force the perspective to create an unusual twist.

- Foreground objects can make background vistas more interesting.

- Don't forget to "get vertical."

Expose It

C hoosing the best exposure setting is the last decision you make before you press the shutter release button (Figure 3-1). Notice we said "best" setting, not "correct" setting. That's because you can often achieve the same results with different combinations of settings, and unusual or creative results using what might normally be considered "incorrect" settings. Obviously, the trick is to know what you're doing so that the results you get are the ones you intended to get.

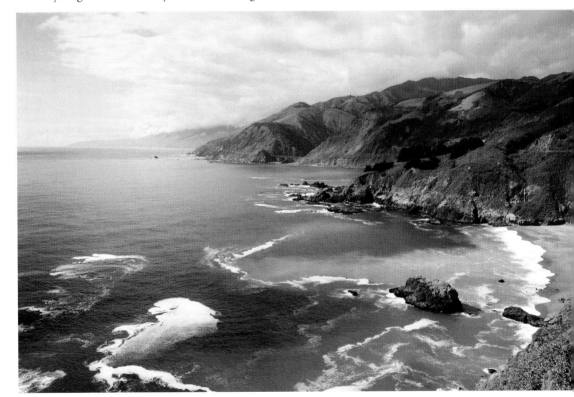

FIGURE 3-1 The Bixby Bridge, far in the distance, along California's Big Sur coastline

Measure the Light

Digital cameras contain powerful computer chips that analyze the incoming image and make smart decisions about what to do with it. You can help your camera produce great results by telling it which part of the picture is most important for its analysis.

Sometimes, everything in the frame is equally important (for example, a landscape shot from the rim of the Grand Canyon). At other times, one thing in the frame may be more important than other things (for example, a person standing on the rim of the Grand Canyon).

Use your camera's various *metering modes* to indicate which part(s) of the frame are most important.

- **Matrix or averaging (default)**. Matrix metering (sometimes called "averaging") measures light in several discrete areas of the frame[1] to compute an average light value for the whole frame. Use matrix metering when everything in the shot is equally important.

- **Spot metering**. Spot metering measures light in one small area of the frame, typically indicated by a target in the viewfinder or monitor. This ensures that the metered area will be correctly exposed, but other portions of the frame might not. This can be especially useful if your shot has high contrast (light versus dark), whether or not the most important object is in the center of the frame.

- **Center-weighted**. This setting is a compromise between matrix and spot metering. It measures light in the entire frame but gives priority to the central one-fourth of the frame. Your shot retains some detail in the background. You typically use this setting for portraits, because the most important object (the person's face) is in the center of the frame.

After you've told the camera how best to measure the light in the frame, you're ready to set the exposure.

TIP

Sometimes it's hard to find an object in your scene to meter for the best exposure. When this happens, find something outside the frame to measure. Then lock the exposure, reframe, and shoot. You can even aim straight up and meter the sky, which is usually fairly consistent; then adjust the exposure appropriately before shooting.

1. Exactly which areas get averaged varies from camera to camera.

Set the Exposure

Setting the exposure means controlling how much light reaches the camera's image sensors. In this regard, digital cameras offer the same choices that analog cameras have provided for years. Light enters the camera through the lens but then stops when it reaches the shutter. When you press the shutter release, the shutter opens and light passes through the *aperture* to reach the image sensor (or film, in days of yore).

You have two options for controlling how much light reaches the image sensor.

- You can make the opening through which the light passes (the aperture) bigger or smaller.
- You can make the shutter stay open longer or more briefly (the shutter speed).[2]

By varying the size of the aperture or the amount of time that the shutter remains open (or both), you control how much light reache; metering schemes: s the camera's image sensor (Figures 3-2 and 3-3). The following sections help you decide which settings to use under which conditions.

FIGURE 3-2 A fast shutter speed freezes motion.

FIGURE 3-3 A large aperture creates interesting focus effects.

2. The term *shutter speed* is actually a bit of a misnomer. The shutter always moves at the same speed. Shutter speed actually refers to *how long* the shutter stays open rather than how fast it moves.

Automatic Exposure Mode

All digital cameras offer an Automatic Exposure mode, and this setting is typically the default. Choose this setting to remain one of the vast herd of mindless shot snappers, disavowing all responsibility for results and placing the ultimate fate of your final image in the icy virtual hands of an image-processing chip that couldn't care less about you and the people you love. Also, return this book to the store and get your money back.

OK, perhaps that was a bit harsh. The point is, you can usually get better results when you understand what your camera is capable of doing and then use that understanding to control the process. When you can select an exposure mode, you gain more creative control of, and responsibility for, the outcome of your shot.[3]

3. Illustration by Danny Wilson, Satellite Studio (www.dannywilson.com)

Aperture Priority

Choose Aperture Priority exposure mode to give preference to the size of the aperture that admits light to the image sensor. The camera then computes the appropriate shutter speed to get the best results. Why would you choose Aperture Priority?

Aperture priority gives you more control of depth of field in your shot. Simply put, *depth of field* is how much of your shot appears in focus relative to its distance from the camera. The higher the aperture setting, the greater the depth of field and the more of your shot that is in focus, foreground to background (Figures 3-4 and 3-5).

FIGURE 3-4 Shot at f/16 **FIGURE 3-5** Shot at f/2.5

In Figure 3-6, both the color and the crisp focus pull your eye to the leaf. Note that as you move in for close-up photography, you lose depth of field. You must compensate accordingly by shifting to a higher f-stop. To hold the red leaf and spider web in focus in this shot required an aperture setting of f/8.

FIGURE 3-6 The leaf in the foreground is sharp, while the background is softly blurred.

Aperture Priority Examples

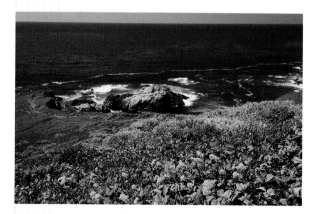

FIGURE 3-7 Wide-angle lenses provide greater depth of field than telephoto lenses. Although the f-stop setting in this shot was wide open, the wide-angle lens still kept everything in focus.

What's the "right" aperture setting? That depends on what you want to achieve in the shot. For portraits, you probably want a narrow depth of field (low f-stop/wide aperture): The person's face will be in focus, and the background will be blurry. This increases the psychological "pull" of the face. For larger group shots with several rows of people, choose a higher f-stop number to expand your area of focus so that all faces are in focus.

For landscapes like the one in Figure 3-7, choose a high f-stop setting to broaden your area of focus.[4]

SECRET REVEALED

Depth of field changes as you change the focal length of the shot (i.e., when you zoom in and out). If you shoot the same subject with different zoom settings, take a practice shot after zooming to make sure your depth of field is still OK (Figure 3-8). You may need to adjust the aperture setting to a different value to get the focus effect you want. For example, suppose you've set up a wide shot, and then want to zoom in for a closer look. To hold the same amount of focus after you have zoomed in, you will need to *stop-down*, or use a higher f-number.

4. The size of the aperture and f-stop numbers are inversely proportional. The higher the f-stop number, the smaller the physical size of the aperture.

FIGURE 3-8 A low f-stop setting (wide aperture) creates narrow depth of field.

SECRET REVEALED

Each increase in f-stop setting (for example, f/8 to f/11) results in half as much light reaching the image sensors. The camera (or you) must compensate by making a corresponding decrease in the shutter speed (for example, $^1/_{60}$ to $^1/_{30}$ second) to maintain the correct exposure. The settings for both shutter speed and f-stop follow the inverse square law and are directly proportional to each other, doubling or halving the light that reaches the image sensor.

Shutter Priority

Choose Shutter Priority exposure mode to give preference to the amount of time (measured in seconds or fractions of a second) that the shutter remains open. The camera then computes the appropriate aperture to get the best results. So why would you choose Shutter Priority?

Motion blur is just what it sounds like: Objects moving in your shot will be blurred if the shutter stays open too long. The longer the shutter stays open, the more likely you are to get motion blur. Sometimes blur is a good thing, as in Figure 3-9.

FIGURE 3-9 Slow shutter speed causes objects in motion (the water) to blur.

TIP

Use a tripod for shutter speeds slower than $1/60$ second. Otherwise your shot may be a little more "artsy" than you intended. It's impossible for most people to hold a camera steady enough by hand to avoid motion blur below $1/60$ second.

TIP

The more you zoom in, the harder it is to hold the camera steady. A handheld shot that is steady at $1/60$ second may require a shutter speed of $1/125$ second, or possibly $1/250$ second if you zoom in tight.

At other times, what you really want is to stop time in its tracks, as in Figure 3-10.

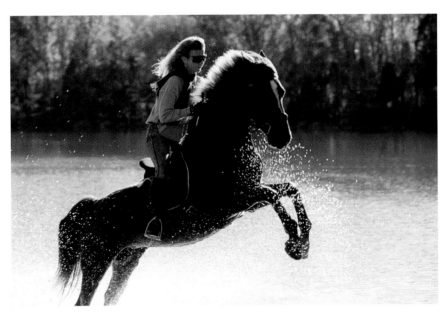

FIGURE 3-10 Fast shutter speed freezes motion, eliminating blur. Now the water droplets are frozen in place.

What's the "right" shutter speed setting? Again, that depends on what you want to achieve in the shot. If your subject is stationary, like a portrait or landscape, then shutter speed doesn't really matter. If you're holding the camera in your hand, then most people need to use a shutter speed of $1/60$ second or faster to eliminate motion blur caused by your breathing or hand jitters. Otherwise, use a tripod to keep the camera really still.

If your subject is moving, you'll need to use a shutter speed that is fast enough to freeze the motion. How fast is directly proportional to the speed of the subject. A shutter speed of $1/60$ second may be enough to freeze your infant daughter crawling across the floor. But you'll need $1/1000$ second to freeze your NASCAR entry at the checkered flag.

Shutter Priority Example

Figure 3-11 shows an example of motion blur as a creative effect.

FIGURE 3-11 Motion blur can help you be creative, too. To convey an impression of speed, you may want your subject to be a blur of light rather than in sharp focus. In this case, choose a slower shutter speed.

SECRET REVEALED

Each increase in shutter speed (for example, $^1/_{30}$ to $^1/_{60}$) results in half as much light reaching the image sensors. The camera (or you) must compensate by making a corresponding decrease in the f-stop setting (for example, f/11 to f/8) to maintain the correct exposure. The settings for both shutter speed and f-stop follow the inverse square law and are directly proportional to each other, doubling or halving the light that reaches the sensor.

Manual Exposure

Choose Manual Exposure mode to control both the aperture and the shutter speed settings for a shot. This gives you complete creative control over depth of field and motion blur (if any).

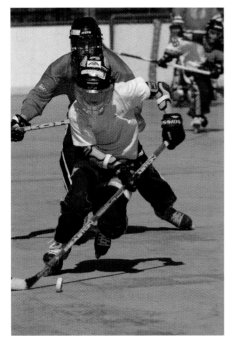

FIGURE 3-12 A fast enough shutter speed freezes the players in the foreground, and a wide enough aperture (small f-stop setting) blurs the players in the background. This helps freeze and isolate the main action in a busy sports scene.

Manual Exposure Versus Exposure Override

Your digital camera gives you two ways to take control of an exposure: its Manual Exposure mode, and the Automatic Exposure mode with Exposure Override.

Use Manual Exposure mode when your lighting is relatively constant and your subject is changing rapidly (as in Figure 3-12). This allows you to adjust aperture and shutter speed as needed to get the desired results.

On the other hand, if you're shooting the same subject repeatedly under changing lighting conditions, let your camera do more of the work. Set an auto exposure level, and then just tweak its exposure override up or down to correct for proper exposure.

Dealing with Contrast Extremes

OK. You've chosen a metering option (matrix or spot or center-weighted) that's appropriate for your shot, and an exposure mode (Aperture Priority or Shutter Priority or Manual) that will produce the right combination of depth of field and focus. The camera's ready to take a great picture, right? You can feel free, even empowered, to press the shutter release button, right?

Well, almost. In 90 percent of the cases, we're finished with the blasted preliminaries. Go ahead—knock yourself out. Shoot!

But there are still a few situations when, despite your best efforts to prep the digital imaging marvel that you hold in your hands, it *still* produces an image that looks as if it's exposed wrong. Why?

The problem is probably caused by extremes of contrast in the shot. You'll need to override the camera's logic to get the perfect results you seek. That's right. You must be smarter than your camera!

Here's a perfect example of a shot that presents extreme contrast problems.

Your three-year-old child, dressed in a white snowsuit, is standing proudly next to the snowman that the two of you built together in your snow-covered front yard. Your white house is in the background, with a white picket fence poking up out of the snow. You point . . . you shoot . . . and the shot turns out way too dark, as if there wasn't enough light. But there was plenty of light! What's wrong?

You know where we're headed, right? The shot was filled with too much white. The camera's exposure computation must have gone haywire. The question is, how do you fix it?

Here's the answer: Digital cameras assume that images contain objects whose combined relative contrast averages 18 percent gray, which is what a typical landscape shot contains on a sunny day. If the average contrast in your shot is substantially different, you'll have to override the camera's assumptions (Figure 3-13).[5]

5. Professional shooters call this "pushing" the exposure in one direction or another.

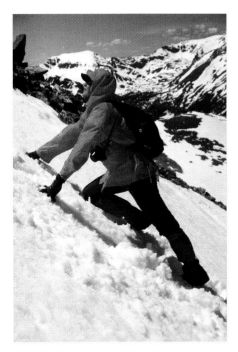

FIGURE 3-13 Lots of bright white creates a high-contrast shot.

Let's return to our white-on-white-on-white example and fix it. **The problem:** Because almost everything in the shot is white, the camera assumes that white is actually gray. **The fix:** Identify for the camera something in the shot that really is gray.

1. Spot meter on a rock, a tree branch, or something else in the shot that is middle gray rather than white. By "middle gray" we mean something that is roughly halfway between completely black and completely white if this were a black-and-white image.

2. "White" to your camera is typically 2½ to 3 stops above middle gray. So increase your exposure by 2 or 3 stops. You can do this by choosing a slower shutter speed or smaller f-stop number (wider aperture), or a combination of the two. This lets more light into the sensors, and the picture that was too dark comes out beautifully.

Contrast Extremes Examples

Here's another example at the opposite extreme: a black automobile parked in front of a dark background, with bright highlights.

The problem: Because much of the shot is black, the camera assumes that black is actually gray. **The fix:** As before, identify for the camera something in the shot that really is gray.

1. Spot meter on the windows or something that is near middle gray.

2. "Black" is typically 2½ to 3 stops below middle gray. Choose a faster shutter speed, a higher f-stop number (narrower aperture), or a combination of the two, to adjust the exposure downward by 2 or 3 stops. This reduces the amount of light hitting the sensors. The gray, washed-out car becomes black, and the too-bright highlights are exposed correctly.[6]

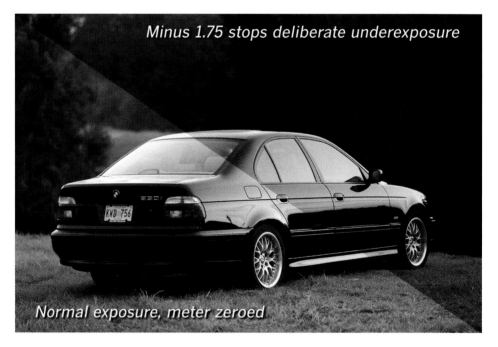

Minus 1.75 stops deliberate underexposure

Normal exposure, meter zeroed

6. © 2005 BMW of North America, LLC, used with permission. The BMW name and logo are registered trademarks.

On Location

Use the 18 percent gray swatch on the white balance calibration card to help control your exposure in extreme subject or lighting situations. Place the card in the scene, spot meter on it, and then set your exposure manually.

SECRET REVEALED

Most advanced digital cameras have an Exposure Override button that lets you spot meter on one area in your shot, and then lock in that area's exposure setting while you reframe the shot. This is another way to correct an exposure that turns out wrong.

Tonal Range

When light strikes the sensor array inside a digital camera, each spot in the array records a numeric value in the range between 0 and 255. The camera's logic then figures out what to do with those values to create a pleasing image. But the point is that there are only 256 possible values. This defines the *tonal range* of the camera at every given exposure setting.

In effect, varying the exposure moves the tonal range up or down the spectrum to match the incoming light. The incoming light may still exceed the limits of the camera's tonal range, even after you adjust it. If that happens, you'll lose information in the digital image. It's essentially invisible to the camera if it falls outside the 0–255 range of available values. In general, it's better to err toward underexposure (images too dark), because it's often possible to retrieve data in the black areas using Photoshop or other image-editing tools. Areas that are too white, however, represent data regions that are lost forever.

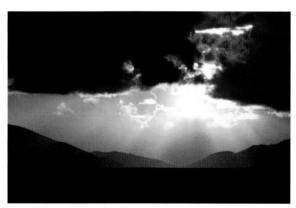

Some higher-end digital cameras allow you to adjust contrast in a shot digitally, thus effectively expanding or compressing the camera's tonal range in addition to varying exposures up or down. These cameras effectively allow you to capture more (or less) than 256 possible values for each pixel in the sensor array, even though the sensors really can't exceed this limit in an absolute physical sense. That means you get more information in the shot—information that you can play with in Photoshop to achieve your creative goals. Such adjustments are simply impossible in analog cameras, so digital cameras with contrast control features offer a decided advantage over their analog predecessors.

Digital ISO Equivalency

If you've been shooting film for even a short time, you know that film is manufactured with a variety of ISO (or ASA) "speed" values. The faster (higher) the ISO rating, the less light is required to take an acceptable shot. So you use slow film (ASA 64) when shooting outdoors in bright sunlight, and fast film (ASA 400) when shooting indoors without a flash unit.

Your digital camera lets you adjust its *ISO equivalency* to achieve the same effect as shooting film of different speeds. One big advantage of digital, of course, is that you don't have to shoot an entire "roll" at each speed. You can use a different ISO setting for every shot if you want to. Not that you'd want to.

Check your camera's user manual to find out how to change the ISO equivalency setting.

Higher ISO = More Grain = More Noise

Your film-shooting days may also have taught you that shooting faster film results in more "grain" in your shots. Too much grain becomes distracting and can spoil a shot.

A similar effect happens when you boost the ISO setting in a digital camera. Boosting the ISO setting to shoot in lower light causes increasing amounts of digital noise in the resulting image, especially in the shadows and darker regions of a shot.

Many digital cameras offer *noise reduction* features in an attempt to combat digital noise. We recommend leaving noise reduction disabled, if possible. As we write this, most in-camera noise reduction algorithms are less sophisticated than third-party filters and plug-ins for image-editing applications like Adobe Photoshop. Shoot in the RAW format and address any digital noise issues on your computer. See "Reducing Digital Noise" on page 240 for more information. On the other hand, you may choose to add digital noise deliberately for artistic effect, as in Figure 3-14.

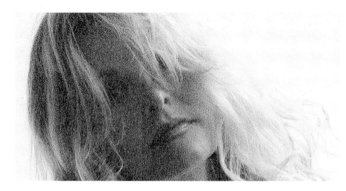

FIGURE 3-14 We boosted the ISO +4 stops in this shot to add an extreme level of noise for effect.

Digital File Formats

Most digital cameras offer a choice of formats in which to save your images. The formats allow you to make trade-offs between file size (and thus the number of shots you can store in your camera before running out of space) and image quality.

Making the right choice of file format is a bit like deciding on which type of film to use in the days of analog shooting.

JPEG

JPEG images (named after the Joint Photographic Experts Group that defined the format) offer a nice balance between file size and image quality. JPEG is a *lossy* format, meaning that image data is discarded by your camera when it compresses the image. For most images this is OK, because the software in the camera (and later, in your computer) makes pretty smart choices about what data to discard without doing visible harm to the image.

The downside of JPEG is that it's impossible to get *better* image resolution out of a shot later if you need it. A JPEG file that looks fine on a computer monitor when you e-mail it to Grandma may look awful if you try to make an 8×10 print to hang on the wall. So even though JPEG gives you the ability to save lots of images on your memory cards, we recommend this format only as a last resort. Memory is cheap; spend a few extra dollars to buy a memory card that's big enough to let you shoot RAW (see below). You'll be much happier with the results.

TIFF

A Tagged Image File Format (TIFF) image consumes much more disk space than an equivalent JPEG file because the TIFF format is uncompressed and *lossless*. As a result, image quality is higher, but you pay for it by being able to store fewer images in a given amount of disk space. Choose TIFF if you anticipate wanting to do more with your images than e-mail them or post them on the Web. TIFF is the format that is most widely supported by image-editing and design applications for high-quality postproduction. However, if your image editor supports the RAW format that your camera produces, we recommend choosing RAW.

RAW

RAW images are slightly smaller than TIFFs in terms of disk space—and best in terms of image quality and control. If your camera can store RAW files and you can afford enough memory to make shooting practical in the field, then RAW is definitely the format to use.

A RAW image is unprocessed data saved straight from the image sensor at the highest possible bit rate. Each pixel on the CCD records a light value.[7] When the camera saves an image in a format like JPEG, it applies a variety of filtering and compression algorithms to the pixel data. But not with RAW: The camera stores exactly what the sensor sees. No data gets discarded by the in-camera compression algorithms. What you shot is what you got.

Why is RAW so desirable? The reason is that it gives you complete creative control on your computer when the time comes to optimize your shots for viewing or printing. If you made mistakes when you shot the image, you have a much better chance of fixing them later if you have the RAW data. And even if the shot is "perfect," you'll be able to do more amazing things with it as your image-editing skills—and imaging technologies—improve.

Camera manufacturers support their own proprietary RAW formats. Here is a partial list of popular formats available at the time of publication. Check PhotoGain.com for the latest information.

- Nikon NEF5
- Canon CRW3
- Fuji RAF digital camera format
- Olympus ORF
- Kodak PDC (Digi Back)
- Minolta MRW
- Sony DCF
- Casio DCF

When you select software products, make sure they support the RAW file format that your camera produces. See page 278 for our opinion about the benefits and risks of proprietary data formats.

TIP

Repeat after us: "I won't be a cheapskate. I'll use a camera and memory cards that allow me to shoot RAW."

DNG

In late 2004, Adobe Systems Incorporated announced the Digital Negative Specification, which is designed to provide a camera-vendor-neutral RAW format (Figure 3-15). Current releases of Adobe Photoshop and Photoshop Elements support the DNG file format.

7. CCD refers to *charge-coupled device*, the detector used in digital cameras.

According to Adobe, "The Digital Negative Specification [is] a new unified public format for raw digital camera files."

Raw files, which contain the original information captured by a camera sensor prior to any in-camera processing, have become popular due to their promise of greater flexibility and image quality. Until today there has been no standard format for these files, which vary between manufacturers and individual cameras. The Digital Negative Specification solves this problem by introducing a single format that can store information from a diverse range of cameras.

Serious photographers want to store raw files in long-term image archives, because—unlike standard JPEGs and TIFFs—these files represent the pure, unaltered capture. Current raw formats are unsuitable for archiving because they are generally undocumented and tied to specific camera models, introducing the risk that the format will not be supported over time. The unified and publicly documented Digital Negative Specification ensures that digital photographs can be preserved in original form for future generations. The new .DNG file format also simplifies digital imaging workflows for creative professionals who today have to juggle multiple file formats as they bring raw images, from different cameras, into print and cross-media publishing projects.[8]

FIGURE 3-15 The Adobe Photoshop DNG dialog box

8. See http://www.adobe.com/aboutadobe/pressroom/pressreleases/200409/092704DNG.html for the complete text of the DNG announcement.

Infrared Imaging

The sensors in most digital cameras respond to light in the infrared portion of the electro-magnetic spectrum, which is invisible to the human eye.[9] This means that you can easily capture infrared images using your digital camera, with fascinating results (Figures 3-16 and 3-17). All you need is an infrared filter and the appropriate white balance setting.

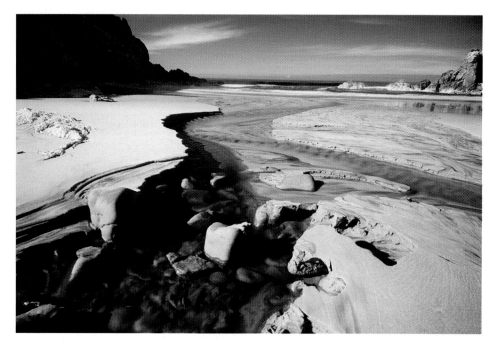

FIGURE 3-16　Creek and ocean at Pfeiffer Beach, California, shot with a Tiffen No. 87 infrared filter

TIP

Here's an easy test to see whether your camera is "infrared-ready." Point your TV remote control at your camera; then press and hold any button on the remote (such as the volume control). Now look at your camera's monitor to see whether the IR beam appears. These beams are fairly bright and should be quite visible in your camera's monitor. If you don't have a monitor on your camera, just take a picture of the remote's IR beam and see whether it comes out.

9. It's possible that your camera may have a built-in filter (sometimes called a "hot mirror" filter) that blocks infrared light. That would be the exception rather than the rule, though. Most consumer digital cameras do not have hot mirror filters installed by default.

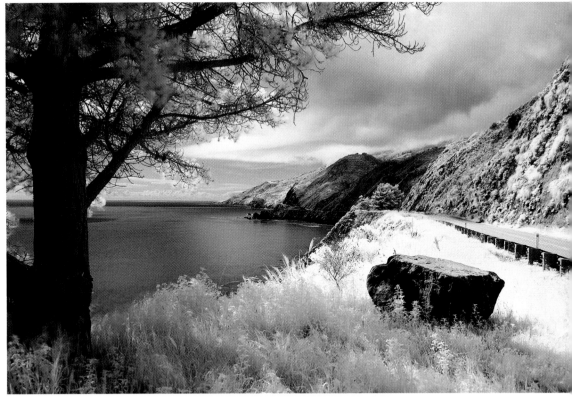

FIGURE 3-17 View north along Pacific Coast Highway 1 near Big Sur, California, shot with the same Tiffen No. 87 infrared filter as in Figure 3-16

Infrared filters are available in varying strengths. Because a full infrared filter blocks all visible light, it looks opaque when you try to see through it. If your viewfinder displays a through-the-lens image, this presents a challenge when you're framing a shot, to say the least. Your viewfinder and monitor will be too dark to use in framing the shot.

Follow these steps to shoot infrared photos.

1. Install the IR filter and preset the white balance with the filter in place. Consult your camera user manual for instructions on setting white balance.

2. Mount your camera on a tripod and remove the filter.

3. Compose the shot.

4. Reinstall the IR filter and use the camera's auto focus to refocus the shot. Remember that the IR spectrum focuses at a different focal length than visible light.

5. Shoot and check the results in your display. Make any necessary corrections; reshoot.

Rear Curtain Synch

Film cameras that employ focal plane shutters actually use two shutters (or *curtains*). The front curtain opens to expose the film, and then the rear curtain closes to end the exposure. When you use a flash unit with such cameras, the flash typically fires to illuminate the shot when the front curtain opens.

Rear curtain synch refers to triggering the flash when the rear shutter closes instead of when the front shutter opens. When you're shooting with a long exposure time (slow shutter speed), this can create an interesting special effect.

For example, imagine you're shooting in a theme park at night. It's dark, so you use a slow shutter speed to get an adequate exposure. If there is a brightly lit Ferris wheel turning in the background, its moving lights will be blurred by the slow shutter. That's normal.

Now suppose there are people standing in front of the Ferris wheel, and you use your flash to illuminate them. You'd normally set the shutter speed to $1/_{60}$ sec. (the standard for flash shots). That shutter speed is fast enough to freeze the motion of the Ferris wheel. However, if you set your camera's flash exposure mode to Rear Curtain Synch and use a slow shutter speed, the flash will fire at the very end of the exposure to illuminate and freeze the kids, while the turning Ferris wheel blurs in the background.

Figure 3-18 uses Rear Curtain Synch to create an artistic effect for a CD album cover.

FIGURE 3-18 A combination of slow shutter speed and zoom creates the blur in the background, while the flash delayed by rear curtain synch illuminates and freezes the figures in the foreground.

The Histogram

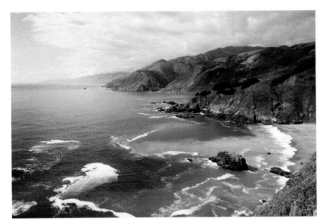

FIGURE 3-19 How could we be sure this shot was exposed correctly when we took it?

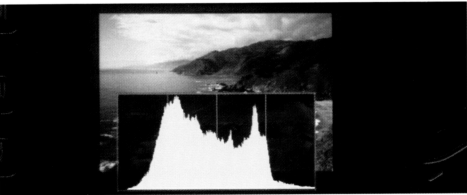

FIGURE 3-20 Histogram of the shot shown in Figure 3-19

There appears to be a big contrast range in Figure 3-19. If your camera has a histogram feature, you can use it to be sure that the exposure was metered correctly. The histogram is an invaluable tool once you discover it. It's hard to judge the quality of an exposure visually in the camera's tiny monitor, especially when the monitor brightness is adjustable.

The *histogram* graphs the RGB (red, green, blue) data in the pixels in your shot, showing the distribution and intensity of the color data. The horizontal axis ranges from 0 (black) to 255 (white). The vertical axis is the number of pixels in the shot at each intensity level.

Figure 3-20 shows that the exposure setting was great. Lots of data was captured in the midtones, and there were no sharp peaks at either extreme of black or white to indicate data loss. If you see spikes at either edge, that's a warning that you need to nudge the exposure settings up or down or else lower the camera's contrast setting.

Summary

Exposure involves setting your camera's aperture and shutter speed appropriately to achieve your creative goals.

- *Matrix/Averaging* metering (sometimes called "averaging") measures light in several discrete areas of the frame to compute an average light value for the whole frame. Use matrix metering when everything in the shot is equally important.

- *Spot metering* measures light in one small area of the frame, typically indicated by a target in the viewfinder or monitor. This ensures that the metered area will be correctly exposed, but other portions of the frame might not. This can be especially useful if your shot has high contrast (light versus dark), whether or not the most important object is in the center of the frame.

- *Center-weighted metering* is a compromise between matrix and spot metering. This setting measures light in the entire frame but gives priority to the central one-fourth of the frame. Your shot retains some detail in the background. You typically use this setting for portraits, because the most important object (the person's face) is in the center of the frame.

- *Aperture Priority* gives preference to depth of field in your shot. Depth of field is how much of your shot appears in focus relative to its distance from the camera. The higher the f-stop setting (the narrower the aperture), the greater the depth of field and the more of your shot that is in focus, foreground to background.

- *Depth of field* changes as you change the focal length of the shot (i.e., when you zoom in and out). If you shoot the same subject with different zoom settings, take a practice shot after zooming to make sure your depth of field is still OK. You may need to adjust the aperture setting to a different value to get the focus effect that you want.

- *Shutter Priority* gives preference to the amount of time (measured in seconds or fractions of a second) that the shutter remains open. Use this to create motion blur and stop action in your shot.

- *Manual Exposure* gives you control of both the aperture and the shutter speed for complete creative control over depth of field and motion blur (if any).

- *Extremes of contrast* in a shot may require you to override the camera's logic to get the results that you seek. Spot meter on something in the shot that is middle gray rather than white. Then adjust your exposure up or down 2 or 3 stops.

Understand and Manage Color

Y ou have captured great images by lighting, composing, and exposing them well. Now it's time to enjoy them: to view them on your computer or TV; to e-mail them to your friends and family or post them on the Web; to print them and display them proudly.

But there's trouble in paradise. It starts one day when you notice that the rich green grass in that shot of your golfing buddies looks pale and washed-out when you print it. The skin tones in the faces of the kids around the birthday cake that look great on your Mac appear dark and dreary when Aunt Jane opens them on her PC. And why does the red in the company logo in that great shot of the trade show booth, which you spent *hours* slaving over on your laptop at home to get just right for your PowerPoint presentation to the boss, look so *wrong* when you project it the next day at work?

The challenge is *color*—specifically, *digital color*. You saw the tip of the iceberg on page 44, when we introduced the issue of white balance in lighting. In this section, we'll raise the iceberg a little higher to expose more of the underlying color issues for digital photographers. Floating the entire iceberg is beyond the scope of this book, but we give you enough information to get great results in the most common circumstances.

We examine the following:

- How the fundamentals of color affect your digital imaging workflow

- How to calibrate and profile your computer monitor so that you can believe the colors it displays while you're working on your images

- How to profile your scanner (if you have one) so that you can digitize prints and slides accurately

- How to profile your printer so that the colors in your prints are consistent with those you see on your monitor

CHAPTER 4

Color Fundamentals

C olor is critical to our enjoyment of photographs. If the colors of objects in a shot are wrong, then we typically consider the image to be spoiled. Often, we want the color to be "true": The grass should be as green as real grass; the sky should be as blue as real sky; the skin tones should look like real human skin. But even when your creative goal involves using colors that are "false" (for instance, a red sky to symbolize anger), you still want the colors in your images to be consistent and predictable, no matter where you view them. That means you need *color management*: techniques you use to ensure consistent, predictable color no matter where the image appears—camera, computer screen, projector, or printer.

In the days of film-based photography, color management was relatively simple for photographers. You captured color images on film using exposure, lighting, filters, and different types of film to create the color results you wanted. Then you depended on the operator at the photo-processing lab, or the person doing color separations at your print shop, to create printed output whose colors were faithful to the negative or transparency that you handed them.

In other words, analog color management was an art practiced by artisans.

In the digital world, the playing field is dramatically different. All the color issues lie squarely on *your* shoulders. You may already have noticed that maintaining consistent, predictable color as an image moves from camera to computer monitor to video projector to printer seems like more trouble than it should be.

"Wait a minute!" you may object. "Cameras, computers, and printers are smart enough to manage color for me, aren't they?"

A Simple Test

To get a taste of the size and scope of the color management problem, close your eyes for a moment and visualize the last time you were in your favorite electronics superstore, standing in front of a wall of TVs or computer monitors (Figure 4-1). Remember the images on those screens? The colors on the screens were consistent and identical, right?[1] Every TV was tuned to the same channel, and this means every TV was receiving the identical input signal. It stands to reason that the output (screen images) should be identical, too.

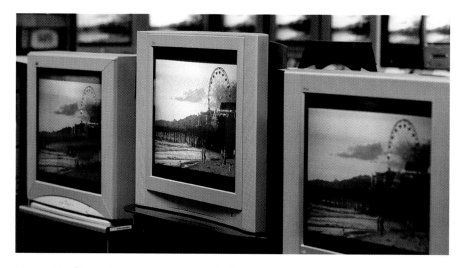

FIGURE 4-1 The need for color management is all around us.

Now imagine that you are the TV show's producer, and your boss is demanding that you guarantee that the colors seen on every TV screen are identical. And not only identical, but "true." Starting to feel suicidal? Welcome to the exciting and challenging world of color management!

As a digital photographer, you face the same daunting challenge as our imaginary TV producer. Fortunately, you've purchased this book. Consistent digital color management is not necessarily easy. But neither is it impossible, and it's getting easier all the time. Just as TV producers have a wide variety of tools and techniques to help them do their jobs, photographers also have many options for controlling and managing color. We'll show you the way.

1. It's OK to laugh out loud at the absurdity of this notion. We're being sarcastic.

RGB Versus CMYK

Colors reach your eyeballs in two ways (Figure 4-2).

Primary colors

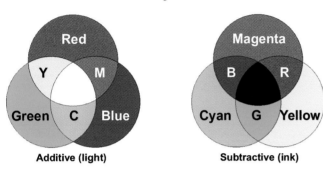

FIGURE 4-2 Additive and subtractive colors

Additive colors come from transmitted light, such as the light from a flashlight or a pro-jector or a computer monitor. We begin with darkness and then add light. When the three primary additives—red (R), green (G), and blue (B)—mix, they produce "white." Remem-ber white light shining through a prism to create a rainbow? That's additive color. Moni-tors, TVs, projectors, and other devices that *emit* light create additive color. They are RGB devices.

Subtractive colors come from substances that *absorb* light, such as inks on paper. We begin with a white canvas and then add ink to absorb all the colors except the ones we want to see. Our eyes see whatever colors remain. When the three primary subtractives—cyan (C), magenta (M), and yellow (Y)—mix, they produce "black"—at least, in theory.[2] Printers produce subtractive color. They are CMYK devices (the *K* stands for black).

Additive (RGB) and subtractive (CMYK) colors are much more than an academic curios-ity. The two color systems raise profound practical issues for every digital photographer. When you shoot, edit, and print an image, you're dealing with *both* types of color. As the image moves from camera (RGB) to computer (RGB) to printer (CMYK), the color infor-mation in the image gets processed and changed along the way. If you don't understand what's happening behind the scenes, you can't possibly control the end results.

2. In reality, impurities in inks and interactions between inks and paper tend to create a muddy brown instead of pure black. That's why most printers use a separate black ink to print pure black.

Digital Color: 256 Choices for "Reality"

Every digital device that you use—camera, computer, projector, scanner, printer—represents images in exactly the same way. An image is just a big bunch of dots, or *pixels* (short for "picture elements"). Think of each pixel as a tiny spot of light. But *how much* light does that pixel represent? And *what color* is the light at that spot in the image?

Because we're talking about digital devices, it should come as no surprise that the information about the light stored in each pixel is just numbers—three numbers, to be precise, in the range 0–255 for "8-bit" color images.[3] Each pixel consists of a red value, a green value, and a blue value (Figure 4-3). For example, a pixel storing information about "pure red" holds an RGB value of 255,0,0 (full red, zero green, zero blue).[4]

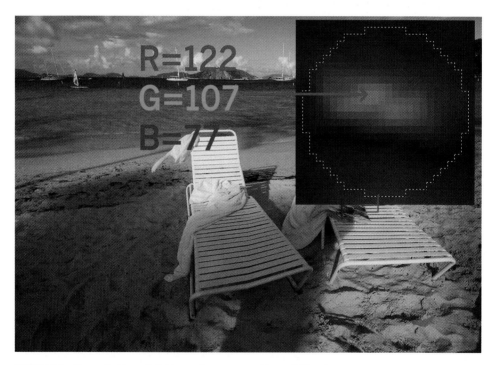

FIGURE 4-3 Every pixel in a digital image is represented by an RGB value.

3. Technology advances may allow a wider range of values—for example, 0–1,023 in 16-bit color—but the principle remains the same.

4. Again, new technology may introduce additional values, such as a fourth number representing the level of transparency, but that doesn't change the basic point we're making.

OK. Every pixel is a triplet of RGB values. So what's the problem?

First, we know that the visible color spectrum has an essentially infinite number of possible colors. But digital devices allow only 256 values for each of the three primary colors. Right away you can see that we're excluding *a lot* of possible colors. Digital devices can't handle infinity. Their reality is highly constrained.

Next, what does an RGB value of 255,0,0—or any other triplet of numbers, for that matter—actually mean to your camera, and your computer monitor, and your printer? You and I can say it's "red." But how red? Really, really, really red? Or just red?

In fact, "255,0,0" means something completely different to every digital device on the planet. That's because no two devices can reproduce exactly the same results. (Remember that wall of TVs at the electronics store?) There are many reasons for this, starting with the fundamental differences between RGB and CMYK devices, and continuing to minute inconsistencies in manufacturing processes between similar devices.

In other words, what "255,0,0" actually means to any specific digital device such as *your* camera and *your* monitor and *your* printer is all a matter of interpretation. It's up to you, the owner and user of those devices, to be sure that their interpretations of those abstract RGB values are all the same.

You need color management.

Color Spaces and Gamuts

The human eye can see many more colors than any device can produce. And color perception varies from individual to individual. Some people are "color blind" to one or more colors.

Wouldn't it be great if every digital device dealt with color in the exactly the same way that the human eye did? In that ideal world, we wouldn't need color management. But they don't, so we do.

A device's *color space*, or *gamut*, defines how that device interprets color values. Think of color space as the container of colors that a device is capable of handling.

Every device's gamut is a different size and shape, and much smaller than the space of all possible colors (Figure 4-4).

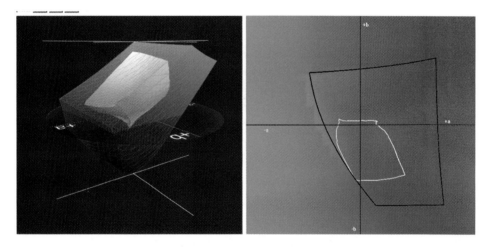

FIGURE 4-4 (Left) A 3-D representation of the color spaces of two devices: a typical CRT monitor (outer) and an ink-jet printer (inner). (Right) A 2-D slice through the same spaces.

Examine Figure 4-4. The typical CRT monitor's color space (the large form) is a different shape and far larger than the typical ink-jet printer's color space (the small form). The good news is that the monitor can display everything the printer can print. The bad news is that the printer cannot print everything you see on the monitor. Highly saturated greens and reds are particularly troublesome. And the problem gets even worse with offset printers (the big commercial presses that print books and magazines). Commercial presses have some of the smallest gamuts and cannot reproduce huge swaths of the human visual range.

When a color lies outside the color space of a particular device, it is said to be *out of gamut*, meaning that the device cannot reproduce that color. So what's a poor device to do? How should your printer respond if you tell it to print a green that it simply cannot print?

The device can either ignore the out-of-gamut color or try to approximate it. In either case, the colors in the resulting image may look dramatically different from what you started with, and from what you intended the end result to be.

You have three options for dealing with gamut differences between devices.

- You can make sure that all the colors in your images stay inside the smallest common gamut (an approach that is terribly limiting, and thus not truly an option if you're striving to produce the best possible image).

- You can trust your camera, computer, and printer to make the necessary adjustments to the image as it passes along the digital imaging workflow. The trouble with this option is that, *by default,* your camera, computer, and printer share almost no information about themselves with each other, so they can only make sweeping assumptions about what's going on in the workflow. Those assumptions often do more damage to the image than good, and can result in the loss of precious image data that you cannot recover later.

- You can use color management techniques to get the results you want. We like this option best.

Color management works by creating a standard way for devices to communicate with each other about their color spaces. Armed with that information, computer programs like Adobe Photoshop and Photoshop Elements can take the necessary steps to ensure consistent color throughout your workflow.

Device-Independent Color Spaces

If every device has its own unique color space, then which one should you use when you're viewing and editing your images on your computer? The answer is, none of them. As imaging professionals gained experience with optimizing digital images using computers, they quickly realized how inconvenient it was to work within device-specific color spaces. Every time they switched devices, they had to switch color spaces. What a pain! It's easier, faster, and better to work in a color space that's independent of the quirks and characteristics of any one device.

Adobe RGB (1998) and sRGB

Adobe Systems created the Adobe RGB (1998) color space for release 5.0 of its flagship Photoshop product (Figure 4-5). It is significantly larger than the SWOP (standard web offset press) gamut, but not so large that images become unwieldy to edit. Since its introduction, this color space has become the de facto standard for computer-based image editing.

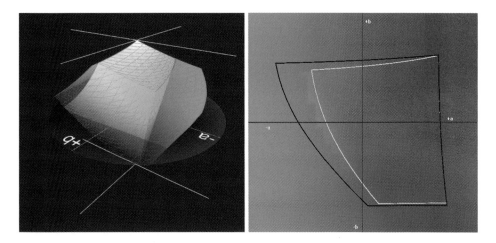

FIGURE 4-5 Adobe RGB (1998) (outer) versus sRGB (inner) color spaces

sRGB was defined by Hewlett-Packard and Microsoft in 1996 to represent the color space of a (then typical) computer monitor. Notice that sRGB is much more limited than Adobe RGB (1998). Nevertheless, sRGB has become the color space of the Web, and the color space to which most digital cameras default. If you edit *and save* your images in this smaller color space, you'll be sacrificing color data that may come in handy later. Even if you plan to share your images only via e-mail or on the Web, someone somewhere may want to print them. More on this in a moment.

ICC and ICC Profiles

The International Color Consortium (ICC) was founded in 1993 by eight companies to define a device-independent method by which cameras, scanners, computers, monitors, and printers could exchange color data with consistent results. Since 1993, ICC membership has grown to include all the major players in digital imaging. (Visit www.color.org to find out what the ICC is doing right now.)

An *ICC Profile* serves as the medium for communicating a device's color capabilities. The profile describes the color space of a specific device (monitor, printer, etc.) and defines how that *specific* device renders RGB values. Note that we said *specific*. To be effective, an ICC profile *does not* describe all monitors of a certain model made by a certain manufacturer. The profile describes *your specific monitor*—the one that's attached to your computer, right now, as you read this sentence in print or online.

Profiles are typically files stored on your computer's hard drive. They can also be embedded inside image files, so that when you pass the images around between programs on your computer, or send them to other people, the color space information that defines how the image's color data is to be interpreted rides along with the image. Such embedded data is often called *metadata*.

To do proper color management, you need an ICC profile for every device in your imaging workflow. That includes, at a minimum, your camera, your monitor, and your printer, paper, and ink setup. If you own and use a scanner, then it should have an ICC profile, too. If you're sending your images to a commercial printer or outside service to create prints, then you should ask it to give you an ICC profile for the device that it will use to create the prints.

Creating ICC Profiles

ICC profiles come from a variety of sources (Table 4-1). The chapters that follow describe how to create your own profiles. You may also choose to use the services of companies set up to create profiles for you. Even if you choose to have someone else do it, it's helpful to understand the process.

TABLE 4-1 Sources for ICC Profiles

Device	Where to Get an ICC Profile
Camera	The profile comes with your camera. Most cameras use a variant of sRGB (see page 138) and embed it in the metadata of each image. If your camera does not declare its own profile, most image-editing programs assume sRGB if the image comes from a camera.
	You can create a custom profile for your camera using products like monacoEZcolor, but this is practical only if you're shooting under consistent, controlled lighting conditions such as in a studio. The profile changes as the lighting changes, so you'll need to depend on the manufacturer's default profile for most shots.
Monitor	You should create a monitor profile yourself, as described in Chapter 5. The operating characteristics of your CRT or LCD monitor change as the device ages. You need to create a profile for your specific monitor and then update it periodically to ensure that it correctly characterizes the device that you're staring at every day.
Printer	You can have a service bureau create a profile for you, or you can do it yourself as described in Chapter 7. Profile each combination of output resolution, ink, and paper that you use for printing photographs.
Scanner	Create a scanner profile yourself, as described in Chapter 6.

Summary

You must apply color management techniques to ensure consistent, predictable color as images move through the digital imaging workflow: from camera to computer to projector or printer.

- There are two fundamental color models: additive color (RGB) and subtractive color (CMYK). Devices that emit light, like monitors and projectors, use the RGB model. Devices that rely on pigments or inks, like printers, use the CMYK model.

- Digital devices represent the color information in an individual picture element (pixel) as a triplet of RGB values (255,0,0). Every device interprets those values uniquely.

- Every digital device has its own unique color space, or gamut. Although there is substantial overlap between device gamuts, the overlap is never 100 percent. This means that a specific color that one device can handle may be beyond the capability of another device (i.e., the color is "out of gamut" for the second device). And the color space of the human visual system is bigger than that of all digital devices.

- Digital devices use ICC profiles to inform each other about the way they interpret RGB values. Each profile is unique to a particular device and its operating environment (lighting, media, age of device, etc.).

- You can create ICC profiles for your monitor, scanner, and printer, paper, and ink combination using profiling tools designed for this purpose.

 CHAPTER 5

Calibrate and Profile Your Monitor

The first and by far the most important step in managing color in your digital imaging workflow is to calibrate and profile your computer monitor. It's critical to get the colors on your monitor right before going any further. Think of it this way: If you cannot trust what you see on the screen, everything else you do with your images is a waste of time.

The good news is that this process is fast and easy, and you may even find it to be fun. That's because the benefits are immediately obvious and dramatic. Even if you spend only a little time looking at pictures on your computer, the images will look so much better after you calibrate and profile your monitor that you'll wonder how you ever got by before.

Calibration

The process of adjusting the brightness, contrast, and white point of your monitor to their optimum settings. Who knows what the correct values are? The one thing you can depend on is that the values were wrong when you first unpacked the monitor and plugged it in. Now it's time to get them right.

Profiling

The process of creating an ICC profile that describes how your monitor produces color at this exact time in its life span.

Recalibrate your monitor whenever you create a new profile. Monitors change as they age; people (not you, of course—other people) fiddle with the brightness and contrast settings trying to get the screen to look "better." You need to recalibrate periodically to put things right again.

Display Types

Computer displays ("monitors") fall into two broad catagories: *cathode-ray tube* (CRT) devices and *liquid crystal display* (LCD) devices. CRTs represent the bulk of traditional computer displays. LCD devices are the thin displays found on laptop computers and increasingly offered as "flat-panel" displays for desktop systems.

CRT monitor Laptop LCD monitor Desktop LCD monitor

If you're using an LCD monitor for imaging work, be sure to view your images straight on. LCDs are much more susceptible to color distortion caused by increased viewing angles. You'll notice this when you adjust your laptop display to get the best view. Adjust the screen so that your line of sight is 90 degrees (perpendicular) to the image plane.

A third type of display device is also gaining popularity: the digital projector. This device projects its image onto a white surface, typically a projection screen. Projectors create their images using light that is reflected from the screen, so the screen material, coating, and color have a huge impact on the colors you perceive. See page 150 for more about profiling projectors.

Although devices in these broad categories create their screen images using very different technologies, the calibration and profiling process for color management is pretty much the same across the board.

Viewing Environment and Ambient Lighting

Be sure to adjust the lighting in the room before you create your monitor profile(s). The ambient lighting has a big impact on the colors that you perceive on your computer screen. In general, the darker the room is, the better your colors will look on the screen. You may have noticed that imaging professionals often use black hoods to shield their monitors (Figure 5-1). Those hoods are not there for dramatic effect. They block stray light from hitting the screen and distorting the colors that appear there.

FIGURE 5-1 A hood blocks ambient light for improved color perception on this high-end monitor at a professional service bureau. Note the washed out image on the unhooded monitor at right.

Pay particular attention to the following:

- Ambient light *levels* (bright versus dark). In general, darker is better. As the ambient light increases, the effective gamut of your monitor decreases. In lay terms, the brighter the room, the more colors will appear washed-out on your monitor.

- Ambient light *sources* and their differing color temperatures (daylight from windows versus incandescent bulbs versus fluorescent bulbs)

- Direct and indirect *glare* on the screen

- Brightly colored *objects* near your workstation. See that bright yellow poster hanging on the wall over your monitor? Lose it.

Note, too, the color and pattern of the computer *desktop background* and other *windows* that may be open. For best color results, close all windows, remove dekstop wallpaper, and set the desktop background color to a neutral gray. We're concentrating on your images now, not on the virtual fish tank that normally occupies your screen. Current versions of Microsoft Windows and Mac OS allow you to save and restore several desktop color schemes, so create a nice neutral one that you can use when you're doing your imaging work. Save the bright, busy backgrounds for paying bills and surfing the Web.

Profiling Setup

You'll need to use a combination of software and hardware to calibrate and profile your monitor accurately. Purchase a monitor profiling product that includes a *colorimeter*: a mouse-sized device that hangs on your monitor and measures the light that the monitor produces, feeding that data to the calibration and profiling software. Colorimeters are fast, dependable, and far more accurate than you can ever hope to be with your eyeballs. If you're going to bother with this process at all, you might as well do it right.[1]

We'll walk you through the process using the MonacoOptixXR product made by X-Rite, Incorporated (www.xrite.com), running on a Windows PC.

1. Set the ambient lighting and desktop color scheme (see page 145).

2. Let your monitor warm up for at least one hour. Its color characteristics change as the components inside the monitor warm up. While it's warming up, find the monitor's instruction manual and review how to use the controls for adjusting brightness, contrast, and individual red, green, and blue settings. (If your monitor does not offer all these adjustments, then your ability to calibrate it will be limited. But it's still better than nothing.)

1. It's possible to profile a monitor "by eye" without a colorimeter. Adobe Photoshop and Photoshop Elements, for example, install a Windows Control Panel applet called Adobe Gamma that you can use to characterize your monitor by responding to a series of prompts and questions about color patches that the applet displays on the screen. But if you're serious about your work, invest in a colorimeter. You'll be glad you did.

3. Check your computer's current color management settings. Right-click on the desktop and then pick Properties. Click the Settings tab (Figure 5-2) and then click the Advanced button. Click the Color Management tab (Figure 5-3). Chances are good that the list of color profiles is empty, meaning that the monitor has never been profiled. If a profile is listed, it's still a good idea to create a fresh one.

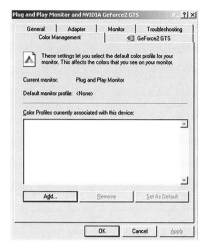

FIGURE 5-2 Display Properties dialog **FIGURE 5-3** Color Management tab

4. Exit all running programs.

5. Install the monitor profiling software according to the manufacturer's instructions.

6. Reboot.

Profiling Process

1. Install the colorimeter according to the manufacturer's instructions. Note: If the colorimeter plugs in to a USB connection, we recommend using a dedicated USB port on the computer rather than a separate USB hub. Hubs sometimes introduce a lag in data transmission that can interfere with the operation of the colorimeter.

2. Launch the monitor profiling software. If given the option to calibrate and profile, do both. To calibrate, you'll need to set the colorimeter on a flat black surface so that it can get a good initial black level reading.

3. Position the colorimeter 4–5 inches from the top of the screen (Figures 5-4 and 5-5).

FIGURE 5-4 Colorimeter positioned on a CRT monitor

FIGURE 5-5 Colorimeter positioned on a laptop monitor

4. Follow the profiling instructions.

 – Set the white point to 6,500K.

 – Set the gamma to 2.2 for PC, or 1.8 for Mac. (Although there's no physical difference between PC and Mac monitors, the Mac OS applies built-in gamma correction algorithms that must be taken into account.)

 – Set the white point manually if possible. The software will guide you through the procedure. Just be sure you can access your monitor's adjustments for red, green, and blue settings. If the monitor's on-screen menu gets in the way of the reader, you'll need to hide the menu to get accurate readings, or reposition it on the screen so that it does not interfere with the colorimeter.

 – Adjust the red, green, and blue values until they fall within the acceptable range. Notice that adjusting one color affects the others. Give the monitor time between adjustments to "settle in." Set brightness and contrast to 100% and measure.

5. Run the color patches to establish the profile (Figure 5-6). Don't bring up the monitor control menu during this process. Just be patient and wait for it to finish.

FIGURE 5-6 Colorimeter reading color patches

6. Save the profile to a file of your choice. Include the system, monitor, and date in the file name to help you identify this profile accurately.

7. *Repeat the calibration and profiling once a month or after 60 hours of monitor usage.* The settings drift as the monitor ages.

Profiling a Projector

Getting accurate color from digital projectors adds several special challenges compared with conventional computer monitors. The color and angle of the projector screen can have a huge impact on image quality; a smudged or dirty screen can throw colors completely out of whack, even when the projector itself is working perfectly. Ambient lighting has a much greater impact on perceived colors in a projected image, too.

Even so, it is possible to calibrate and profile projectors, and we encourage you to do so if accurate color is important to your projected presentations.

The calibration and profiling process is very similar to that described on page 146, with one important exception. The colorimeter device cannot hang on the screen, because the light that it needs to detect comes from behind.

What you need is a colorimeter that sits on or behind the projector and can detect the light reflected from the screen at a distance.

The Eye-One BEAMER is such a device: a long-distance colorimeter with a special holder that allows it to be positioned near the projector. (See www.i1color.com.) Use it along with the company's profiling software to create a projector profile.

Ambient Light

When you calibrate and profile the projector, be sure to duplicate the ambient lighting conditions that will be in use during presentations. If the room lighting changes, your profile will be wrong. Remember that the darker the room is, the better. Even though modern projectors emit enough light to view presentations when the room is fully lit, the effective gamut of the projector shrinks as the ambient light increases.

Not only the light *brightness*, but also the light *source* is an issue. Remember that sunlight from windows, incandescent lightbulbs, and fluorescent lights all have different color temperatures that directly affect our color perception (see "The Temperature of Color" on page 40). That's another reason to turn off the room lights and close the window shades if possible. You're reducing problems by reducing ambient light.

Summary

Calibrating and profiling your monitor are the first and most important steps in color management. You must be able to trust the colors that you see on your monitor before worrying about other devices in the digital imaging workflow.

- Calibration is the process of adjusting the brightness, contrast, and white point of your monitor to their optimum settings. Calibrate early and often.

- Profiling is the process of creating an ICC profile that describes how your monitor produces color at this exact time in its life span.

- Although output devices like CRTs, LCDs, and projectors use very different technologies to display images, the profiling process is basically the same for all of them.

- Ambient lighting is critical to our perception of color. Be sure to set the ambient lighting conditions as dark and neutral as possible before you calibrate and profile your monitor or projector.

- Use a colorimeter to measure light during calibration and profiling to achieve the best results. Don't rely on subjective human judgments about color values.

- Use a commercial calibration and profiling tool to build an accurate ICC profile for your monitor or projector, and update the profile regularly to account for changes in the device and in your viewing environment.

CHAPTER 6

Profile Your Scanner

We realize that not everyone owns a scanner. After all, we're talking digital photography here, aren't we? A *scanner* is a device for transforming analog images (prints, slides, transparencies) into digital form. What's the point of owning a scanner if you're shooting digital images?

Well, if you've been shooting more than a year or two, chances are that you have an archive of analog shots sitting around in shoeboxes or photo albums. Wouldn't it be wonderful to get those into digital form so that you can edit and share them more easily?[1] That's a great reason to own a scanner.

Another great reason to own a scanner is that you must have one in order to profile your printer yourself. What!? That's right; you need a scanner to profile your printer yourself. The reason will become obvious in Chapter 7.

So if you do not own a scanner, you can skip this chapter. However, you absolutely need to profile your printer, so don't skip Chapter 7. You can get a printer profile from a service bureau. It just takes longer than doing it yourself.

1. Not to mention the importance of protecting the images from damage and decay.

Scanner Types

A scanner works very much the way a digital camera does: Light shines on an object, and a detector records the results.

Scanners fall into two broad categories, depending on whether the object being scanned (the *target*) is opaque or transparent.

Reflective Scanners

Reflective scanners scan *opaque* targets, such as sheets of paper and photographic prints. Such scanners are often called *flatbed* scanners because the imaging surface is a flat sheet of glass. You lay the target on the glass; then a light illuminates the target and a CCD detector records the reflected image. The image is then converted to digital form (typically an RGB file) and saved in the device's memory. Fax machines, photocopiers, and multifunction devices that combine printer, scanner, copier, and fax—all use reflective scanners to capture and digitize images of their targets. Figure 6-1 shows a typical multifunction device.

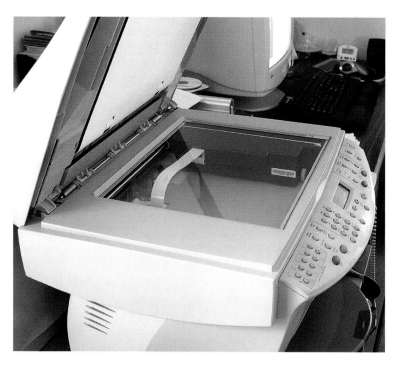

FIGURE 6-1 A typical multifunction device that includes a reflective flatbed scanner

Transparency Scanners

Transparency scanners are less common than reflective scanners, because they perform a more specialized function. As the name suggests, this type of device scans transparent targets, such as 35mm slides, film negatives, or film transparencies (Figure 6-2). Light shines *through* the target onto the detector; from there, the process is the same. Transparency scanners have special adapters to hold their targets in place, and these vary depending on the type of target (e.g., slide versus transparency) being scanned.

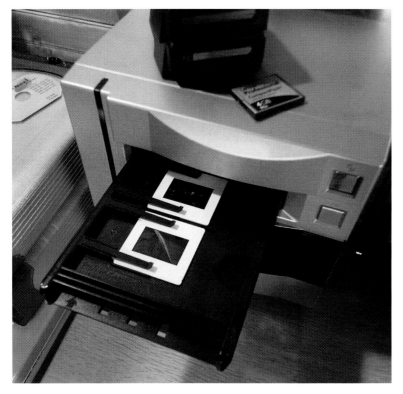

FIGURE 6-2 Transparency scanner with 35mm mounted film holder ready to scan slides

Standard Scanner Targets

To profile your scanner, you must scan a target whose color properties are known in advance. That allows the profiling software to compare the image of the target that your scanner produces with a set of known color values. The results of that comparison produce your scanner profile.

Standard scanner targets are available from a variety of sources for both reflective and transparency scanners. These targets conform to the American National Standards Institute (ANSI) ANSI IT8.7/1 (transparent) and ANSI IT8.7/2 (reflective) standards. That's a lot of jargon, we know. Just look for a reflective or transparent "IT8" target, and you'll be fine.

Most scanner profiling software products on the market include a reflective target, because most scanners purchased by consumers are flatbed scanners. If you're profiling a reflective scanner, check with the profiling software vendor to get the transparent target that you need.

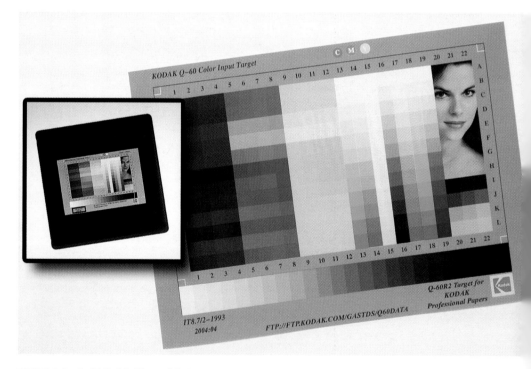

FIGURE 6-3 (Left) Kodak 35mm slide transparent scanner target. (Right) Kodak reflective scanner target.

Profiling Setup

Profiling your scanner is straightforward—easier, even, than profiling your monitor. We'll walk you through the process using the MonacoEZcolor product made by X-Rite, Incorporated (www.xrite.com).

1. Turn on your scanner and let it warm up for at least 30 minutes. If your scanner is a flatbed model, make sure that the glass is clean. If your scanner handles transparencies, make sure that the mount and detector windows are clean.

2. Exit all running programs.

3. Install the scanner profiling software according to the manufacturer's instructions.

4. Reboot if prompted to do so when the installation is complete.

5. Launch the configuration application that came with your scanner, and set the scanning resolution to at least 200 dpi and the color depth to at least 24-bit color.

NOTE
You must create a separate scanner profile for each combination of scanning resolution and color depth. Choose the settings that you plan to use most often for scanning photographs.

Profiling Process: Scan Target

1. Launch the scanner profiling software.

2. If prompted to choose between reflective and transparent targets, choose the appropriate type.

3. Position the target face down on your scanner (flatbed) or in the target mount (transparent).

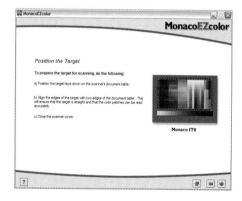

4. Follow the instructions provided by the profiling software to scan the target. The exact procedure varies between Windows and Mac systems.

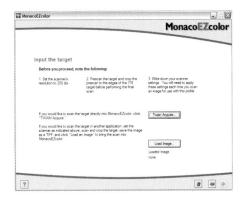

5. Confirm that the scanned target is aligned and cropped correctly.

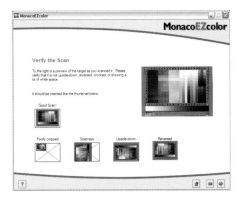

Profiling Process: Create Profile

1. Select the file containing the color data that matches the target you scanned. These reference files are specific to the target you're using. Targets are manufactured in batches; as you learned in Chapter 4, colors can vary between batches based on differences in inks, papers, and other physical characteristics of the targets.

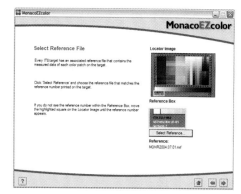

2. In this example, we're prompted to confirm the location of the crop marks on the target to ensure an accurate reading.

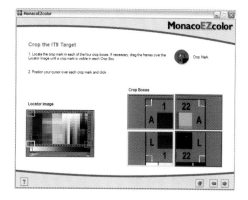

3. Save the profile to a file of your choice. Include the system, scanner, and date in the file name to help you identify this profile accurately.

4. Repeat this process for each combination of scanning resolution and color depth.

5. *Re-create the profile(s) once a month or after 60 hours of scanner use.* The settings drift as the scanner ages.

Summary

Although a scanner may seem to be an unnecessary option for digital photographers, it's a must-have tool for digitizing archives of existing prints and slides. You'll also need a flatbed scanner if you want to profile your printer yourself. Otherwise, you'll need to use a profiling service for part of the process, and that adds time and expense.

- Scanners come in two types: reflective and transparent. Reflective scanners work by reflecting light off their targets, whereas transparent scanners shine light through their targets. Most consumer scanners are reflective and are used to scan opaque targets like sheets of paper and photographic prints. Transparency scanners are specialized devices for scanning slides, negatives, and photographic transparencies.

- You must have a standardized IT8 scanner target to create a profile for your scanner. IT8 targets are available from a variety of sources and may be included with your scanner profiling tool.

- Use a commercial calibration and profiling tool to build an accurate ICC profile for your scanner, and update the profile regularly to account for changes in the device.

Profile Your Printer, Paper, and Ink

P rofiling a scanner is relatively quick and easy, but profiling a printer is a bit more tricky. There are more variables to control, and more care to be taken as you move through the steps in the process. But it's worth it. When you're finished, you can be sure that your image-editing software knows exactly how your printer renders color with the paper and ink you have chosen.

Profiling your printer is actually a two-step process. First, you print a target page using the resolution, ink, and paper combination for which you are creating a profile. Then you scan that target page so that your profiling software can evaluate your printer's output and build the appropriate profile.

The scanning step obviously requires a flatbed (reflective) scanner. If you don't own a scanner, you'll need to involve someone who does. That is typically a service bureau, which provides printer profiling services to the public for a fee. Because you need to create a profile for each combination of printer resolution, ink, and paper stock, using an outside service can quickly become expensive. If, on the other hand, you've been looking for a good excuse to purchase a scanner, then this is your lucky day! You can buy a great flatbed scanner for the cost of two or three printer profiles that you would otherwise have to purchase from a service bureau.

A service bureau may still be your best option if you're interested in creating the highest possible quality art prints for sale. A service bureau's professional-grade spectrophotometers, experience, and quality controls produce profiles that deliver the best possible results.

Printer Types

Color printers currently fall into three broad categories: ink-jet, dye sublimation, and color laser.

Ink-Jet Printers

The great majority of consumer-level color printers use ink-jet printing technology. Print heads sweep across the surface of the paper, spraying tiny dots of liquid ink. For a great brief description of ink-jet technology, see http://en.wikipedia.org/wiki/Ink_jet_printer.

Ink-jet printers are available from a wide variety of manufacturers, in all sizes, shapes, and price points. If you own a color printer, chances are good that it uses ink-jet technology.

Dye Sublimation Printers

Dye sublimation printers were introduced in the 1980s. They use heat to transfer pigments to the printing surface. The pigments typically are transferred one color at a time from ribbons or sheets.

A print from a dye sublimation printer has several advantages over the equivalent print from an ink-jet printer: higher resolution, more saturated color, longer shelf life, greater water resistance, and more rapid "drying" time. However, dye sublimation prints suffer from two major disadvantages compared with those produced by ink-jet printers: higher per-print cost and slower print speed. Because of these disadvantages, dye sublimation printers are used mostly for high-end commercial printing, archival and art prints, and other applications where cost and speed are of lesser importance than long life and high quality.

Color Laser Printers

Laser printers use an electrostatic process to transfer toner particles to the printing surface. The toner is then fixed in place by heat and pressure. Historically, most laser printers have been monochrome (black toner only), but what they lacked in color they made up for with low per-page printing cost and very high speed.

Color laser printers, however, are gaining in popularity. They use multiple drums to apply CMYK toners to the printing surface in multiple passes, much as offset printers use a separate printing plate and roller to apply each color. Because of their relative technical complexity and high cost, color laser printers are found primarily in commercial (as opposed to consumer) settings.

Paper

Paper comes in a wide variety of colors, qualities, and finishes (Figure 7-1).

- Coated or uncoated surface
- Glossy or matte finish
- Printable on one side or both sides
- Varying levels of "whiteness" (assuming the paper is white to begin with!)
- Varying levels of thickness
- Varying combinations of fibers in the paper stock (cotton, art canvas, recycled waste paper, newsprint, etc.)

All these variables have a direct and profound effect on the way the paper stock interacts with the inks, pigments, or toners that a printer applies to the surface of the paper—and thus on the colors that we perceive.

For printing digital photographs by themselves, you'll probably want to use photo-quality paper, which has either a glossy or a matte finish, allows very little "bleeding" between ink dots, is relatively rigid, and is very bright white.

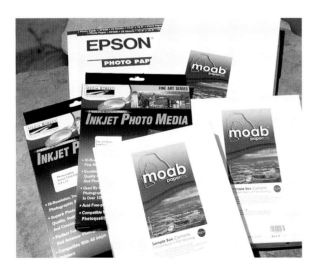

FIGURE 7-1 The selection and variety of photographic printing papers are growing daily. Invest in premium papers for consistency and high-quality results.

Ink

Like paper, ink and toner come in a wide variety of types, qualities, and prices. Some inks are designed for high speed and low cost. Others are designed for archival longevity. It all depends on what you're trying to achieve and what your printer is capable of handling.

If you use an ink-jet printer, you're well aware that the print quality can be very good. But boy, are those ink cartridges expensive! If you're serious about printing your photographs, you can quickly spend a small fortune on ink.

We love the quality and cost-effectiveness of the Niagra II Continuous Ink Flow System (shown in Figure 7-2) from Media Street (www.mediastreet.com). It's a bulk ink delivery system that you attach to your ink-jet printer. The ink reservoirs are many times larger than typical ink cartridges and are refillable. And the ink itself is top-quality. We particularly like the Generations Micro-Bright Pigmented line of inks for archival-quality art print applications. This ink has been tested and rated to last more than 100 years.

FIGURE 7-2 The Niagara II Continuous Ink Flow System

Conclusion

For the purposes of profiling your printer, it doesn't matter what kind of paper and ink you use. What does matter is that you profile the same paper and ink combination that you intend to use for printing images. The profile is specific to the paper and ink that you use when you create the profile. If you use different paper or ink later, then this particular profile won't match them and your color results may be wrong.

You must create a different profile for every combination of ink, paper, and output resolution that you use. It's even a good idea to re-create the profile when you open a new pack of paper, even if it's the same type and brand that you originally profiled. Manufacturing processes differ enough from batch to batch of paper that it's better to be safe and reprofile. And you should certainly reprofile whenever you change ink cartridges. Liquid inks age on the shelf, and their color characteristics vary from batch to batch at the manufacturing plant.

Profiling Process: Setup

Profiling your printer is a two-step process: print a target and then scan the target and build the profile. If you own a flatbed scanner that will accommodate your printed target, then you can do both steps yourself. Read on. If you don't own such a scanner, see page 172 for instructions on profiling your printer using a service bureau.

We'll walk you through the profiling process using the MonacoEZcolor product made by X-Rite, Incorporated (www.xrite.com).

1. Turn on your printer and scanner. Let the scanner warm up for at least 30 minutes. If your scanner is a flatbed model, make sure the glass is clean.

2. Exit all running programs.

3. Install the scanner and printer profiling software according to the vendor's instructions. Reboot if prompted to do so when the installation is complete.

4. Launch the scanning software that came with your scanner, and set the scanning resolution to at least 200 dpi and the color depth to at least 24-bit color.

When the setup process is complete, the next step is to print the target that you'll need to scan.

Profiling Process: Print Target

1. Launch the scanner and printer profiling software.

2. Identify the type of printer you are using if prompted to do so.

3. Print the target page on your printer. Be sure to set the printer to use the print resolution and paper type that you intend to profile.

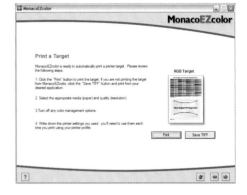

4. Remove the target page from your printer, and place it in a dark location for at least one hour to dry.

TIP

Allowing the target page to dry completely is especially important if you have an ink-jet printer. Scanning the target while the ink is wet produces inaccurate results. Professional service bureaus allow printer targets to dry for at least eight hours before scanning them, so be sure your target is completely dry before continuing.

5. When the target page is dry, attach the IT8 scanner target to the target page. Use transparent tape, and be careful not to tape over any of the color patches.

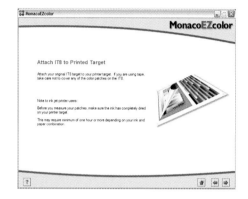

Profiling Process: Scan Target

1. Place the target facedown into your flatbed scanner. Follow the instructions provided by the profiling software to scan the target. The exact procedure varies between Windows and Mac systems.

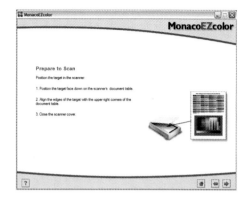

2. Confirm that the scanned target is aligned and cropped correctly.

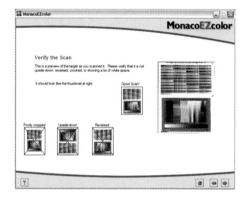

3. Select the file containing the color data that matches the IT8 target you scanned. These reference files are specific to the target you're using. Targets are manufactured in batches; as you learned in Chapter 4, colors can vary between batches based on differences in inks, papers, and other physical characteristics of the targets.

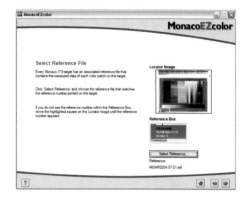

4. In this example, we're prompted to confirm the location of the crop marks on the IT8 target to ensure an accurate reading.

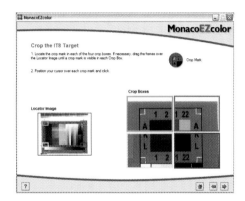

5. Confirm the location of the crop marks on the printer target to ensure an accurate reading.

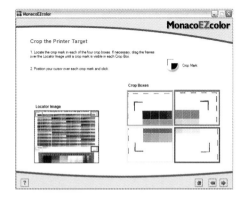

6. Save the profile to a file of your choice. Include the system, printer, paper type, and date in the file name to help you identify this profile accurately. In this example, we are also given the opportunity to save the scanner profile. We recommend saving the scanner profile with the printer profile, because they were both created in the same profiling session. If you are going to create multiple printer profiles to cover a variety of paper types, it's sufficient to save the scanner profile only once.

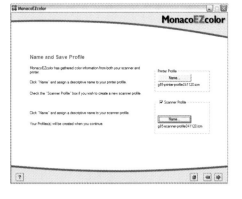

7. Repeat this process for each combination of printing resolution and paper type.

8. *Re-create the profile(s) whenever you change ink, dye, or toner cartridges, and whenever you start a new batch of paper.*

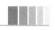

Profiling Process: Service Bureaus

If you do not own a flatbed scanner or if you want to take your work to the next level of quality without investing in high-end profiling systems, then you should consider using a service bureau to help you profile your printer.

The overall process is basically the same:

1. Download and print a target.

2. Scan the target.

3. Create the profile.

The difference is that you do only Step 1. After printing the target, you send it to the service bureau to do the scanning. The service bureau uses a high-end spectrophotometer to create your printer profile from the target you sent (Figure 7-3), then returns the profile to you by e-mail, Internet download, or disk.

Profiling services usually cost between $50 and $100 per profile. They are a great value considering the cost of high-end profiling systems and the time required to produce a professional profile.

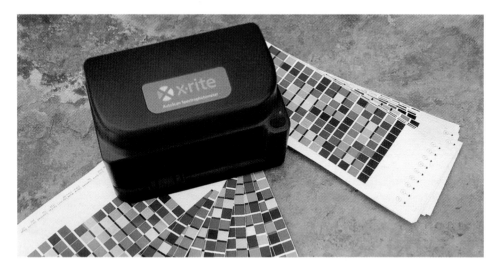

FIGURE 7-3 Professional profiling system: X-Rite DTP41 spectrophotometer and printer targets mailed in by clients

Visit PhotoGain.com for a current list of profiling services, along with competitive reviews.

Dealing with PIM

Does your camera support PRINT Image Matching (see Table 7-1)? If so, your camera may be "color managing" (i.e, altering) the image without your knowledge. For example, when you zoom in, the camera may infer that you're taking a portrait and then try to "improve" the image for you by altering the level of sharpening, boosting skin tones, and so on.

These "improvements" may or may not actually improve your photos. If your camera supports PIM, consult your owner's manual to see whether PIM can be disabled and then try some experimental shots with PIM turned on and turned off. Compare the images as they move through your workflow, from camera to computer to printer. You'll probably find that the results are more predictable with PIM disabled and you, not your camera, in control of the shot.

TABLE 7-1 Manufacturers That Support PRINT Image Matching (PIM)

Cameras & Camera Phones	Printers
Casio	Epson
NEC	
Pentax	
Olympus	
Sony	
Ricoh	
Toshiba	
Sharp	
Konica Minolta	
Nikon	
Panasonic	
Fujifilm	
Leica	
Epson	
JVC	

For the latest information about PIM, visit http://www.printimagematching.com.

Commercial Printing

Is it possible to apply color management techniques when your images are being sent out to be printed in great numbers by commercial print vendors? In other words, what do you do about managing color when the printer is not sitting on your desk? Are all bets off?

All bets *are* off if you assume that your commercial print vendor is going to take the files that you send and make them look great. Those days are over. With digital job submission, the responsibility for ensuring accurate color in the printed pieces rests squarely on *your* shoulders.

That means you must apply color management techniques to outside print jobs. Here's what to do.

1. As soon as you know that you're going to be using a commercial print vendor to print your job, start calling likely candidates on the phone. Ask to speak to the production coordinator, and then ask that person to e-mail you an ICC profile for the press or printer and paper combination that the vendor will use to print your job. If the person on the phone says, "No problem. What's your e-mail addresss?" then you're in great shape. If, as is much more likely, the person says, "What's an ICC profile?" then heave a heavy sigh and proceed to step 2.

2. Ask the vendor to tell you the following information about the press or printer that will print your job:

 – Manufacturer

 – Model and year of production

 – Paper specification for your print job

3. Visit PhotoGain.com for instructions about how to set color values "by the numbers" to match the press and paper your job will use.

Summary

Profiling your printer is a two-step process: Print a target page using the resolution, ink, and paper combination for which you are creating a profile, and then scan that target page to build the ICC profile.

- Printers come in three types: ink-jet, dye sublimation, and laser. Although each type of printer uses a different technology to create output, the profiling process is basically the same.

- Paper comes in a wide variety of colors, qualities, and finishes. All these variables have a direct and profound effect on the colors we perceive. Each ICC profile is specific to the paper that you use when you create the profile.

- You must have a standardized IT8 scanner target to create a profile for your scanner. IT8 targets are available from a variety of sources and may be included with your scanner profiling tool.

- Use a commercial calibration and profiling tool to build an accurate ICC profile for your printer, and update the profile regularly to account for changes in the device, inks, and papers (Figure 7-4).

- If you don't own a scanner, you'll need to use a commercial profiling service for the scanning step in the profiling process.

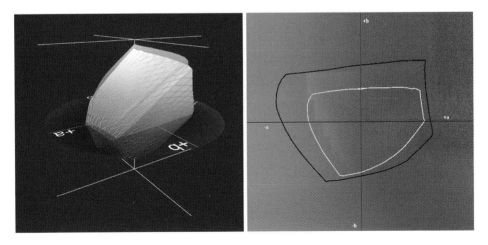

FIGURE 7-4 Gamuts of Moab Entrada 190 matte paper (outer) and Epson Semigloss photo paper (inner). Same printer, same ink, different paper. Creating a custom profile for each combination is important!

Optimize Your Images

I n Sections 1 and 2, we discuss how to shoot your best shots and prepare your environment to deal with color images in a way that lets you believe your own eyes. Now it's time to optimize your images so that they look as good as they possibly can on screen and in print.

If you were paying attention earlier, you'll realize that looking good on screen and in print are two very different things. Consequently, we devote a separate chapter to optimizing for each type of output device. Then we turn to suggestions for addressing specific issues in images themselves to make them look "better." The image-editing capabilities of products like Adobe Photoshop and Photoshop Elements are very broad and very deep—far beyond the capacity of this volume to address. So we pick a few of our favorite "fixes" to give you a sense of the potential that lies waiting within those menus and palettes.

CHAPTER 8

Optimize for the Screen

P rints are great for sharing with family and friends, but before any serious photographer (like you) entrusts a digital image to paper, the image must look great on the screen. Even if your goal is to create a great print, your digital workflow involves first manipulating the image on your computer. So before we worry about optimizing for print, we need to get the image right on the screen.

And more and more, a screen of some kind is where many of your viewers will experience your images. If you're sharing images by e-mail, posting them on the Web, using them in PowerPoint presentations, or burning them to CD or DVD and displaying them on a TV or computer, then you'll need to optimize for the screen. That's what this chapter is all about.

Before we go any further, we must make one point clear. The way your images appear on a screen—the colors, the contrast, the sharpness, and so on—depends heavily on the characteristics of that screen. The more you can understand and manage the device(s) that display your images, the better the results will be.

If you'll be displaying the images on your own computer, then you have a great deal of control over the results. Start by calibrating and profiling your computer monitor carefully and frequently (see page 143). Don't do anything else until you have a correct monitor profile.

But if your images are destined to be viewed on a screen other than your own, you may think you have no control. For instance, you may plan to e-mail your images to Aunt Betty and Uncle Bob. How can you control what they will see on their computer when they view those images? It's true that you cannot control as much as if you're viewing the image on your own computer. But getting it looking great on your own computer is a critical first step. We'll also show you how to optimize images for viewing on a PC or Mac (whichever one you *don't* use) and a TV. Read on!

Basic RAW Adjustments: Introduction

NOTE

The following discussion applies only to images shot in the RAW format. RAW files provide the greatest adjustment control. If your camera will shoot RAW, then shoot RAW. But if your images are in TIFF or JPEG format, proceed to the section "Further Optimization: Introduction" on page 194.

We'll demonstrate the basic image adjustments using Adobe Photoshop, with occasional references to Photoshop Elements. Although Photoshop is popular with digital photographers, it is by no means the only choice available in the marketplace. If you use a different tool, the dialog boxes will differ, but the principles that we're discussing remain the same. Just be sure that your tool can edit images in the RAW format.

For example, you may own Adobe Photoshop Elements, a product for casual users rather than image-editing professionals. It replaces many of big brother Photoshop's more sophisticated (and complex) image-editing features with a wealth of other capabilities:

- Cataloging features (see Chapter 11) to help you organize and manage images

- Document creation features to help you create cards, calendars, slide shows, and presentations

- Image-sharing features to help you distribute images via e-mail and the Internet

Your image toolbox may include some or all these features, too. Whatever those other features may be, we focus for now on image editing.

To begin, launch your image-editing program, and open an image to be edited. (If you encounter a warning about mismatched color spaces, choose Adobe RGB as the working color space unless you're specifically planning to use the image on a Web site. In that case, choose sRGB.)

When you bring an image into your image editor, your goal is to adjust the settings so that you keep the maximum amount of image data available for editing—without adjusting so much that you lose data at either extreme of blackness and whiteness. Once the data is lost, it's lost. Even if you can't see it on the screen, you may need it later—so hang on to it. In fact, get in the habit of editing copies of your images rather than the original files. As the technology improves over time, you'll want to have the original RAW data that you can return to. (See our digital workflow recommendations in Chapter 11.)

Photoshop and Photoshop Elements provide a histogram to help you see what's going on with your image as you make adjustments (Figures 8-1 and 8-2). The histogram is an

invaluable tool once you understand what it's telling you. We'll refer to it often as we work through the following examples. And don't forget that many cameras provide a histogram, too, that can help you judge the quality of the initial shot (page 127).

Finally, although we talk about the following adjustments in linear order (this is a printed book, after all), you'll find that all the adjustments are interrelated: For example, adjusting contrast will affect brightness. You will probably need to adjust all the settings gently and repeatedly, in various combinations, to get the best final result.

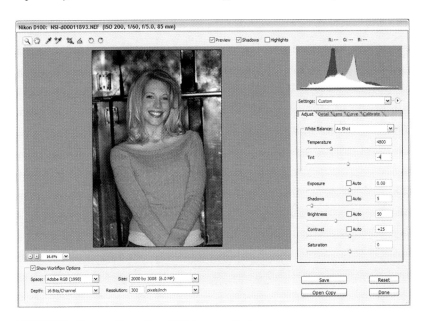

FIGURE 8-1 Opening the original RAW image in Photoshop

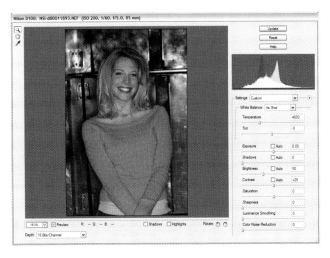

FIGURE 8-2 Opening the original RAW image in Photoshop Elements

Basic RAW Adjustments: Color Temperature

The first adjustment to make is to the white balance of the image (color temperature and tint). As we discussed on page 44, white balance defines what "white" is in a particular image. You should set the white balance correctly in the camera when you shoot the image; now you can adjust it if necessary.

1. Be sure the Preview checkbox is checked so that you can see the effect of the changes you are about to make (Figure 8-3). As you make changes, check and uncheck Preview to toggle between "before" and "after" settings and see the effect of your adjustements.

2. Set the Color Depth box to 16 bits/channel (if available) to retain the maximum amount of image data for optimization.

3. Use the Temperature slider to adjust the color temperature until the image is pleasing. Pull the slider left (decreasing values) to make the image "cooler," or more blueish. Pull the slider to the right (increasing values) to make the image "warmer," or more yellowish (Figure 8-4). (Refer to the subtractive color wheel in Figure 8-5. Blue and yellow are on opposite sides of the wheel, and that is why moving the slider increases one as it decreases the other.)

 Here's where your eye as an artist comes into play, and why it's critical that your monitor has been calibrated and profiled so that you can trust the colors your monitor is showing you. If there's a person in the shot (as in our example here), use the skin tones to judge the effect of your adjustments. We have a natural instinct for what looks "pleasing" in skin tones. If your shot is a landscape, try to find an object that should be a neutral gray, and then make it gray. Or use the sky or grass to judge the effect of your adjustments. We also have an unconscious but nearly universal sense of what color the sky and grass should be.

 You can also type a color temperature value directly into the edit box if you already know exactly the look you're trying to achieve.

4. If you don't trust your eyes, don't worry. You can use the eyedropper tool to pick a nice neutral gray pixel. In a portrait, the whites of the eyes are good choices. In a landscape shot, use a cloud. Zoom in to the image so that you can easily pick an individual pixel (this may require a zoom setting of 400% or more).

TIP
Watch the RGB value readouts in the preview window change as you move the eyedropper around. You're hunting for a pixel that's as close as possible to 128,128,128.

Once you've found a good neutral gray pixel, click the eyedropper on it to set the white balance values.

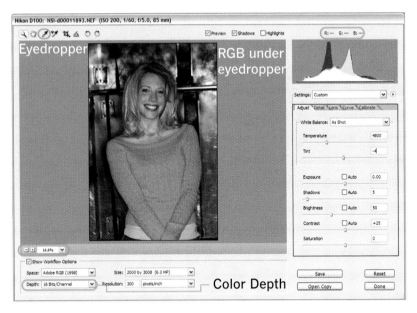

FIGURE 8-3 Original RAW image with tools highlighted

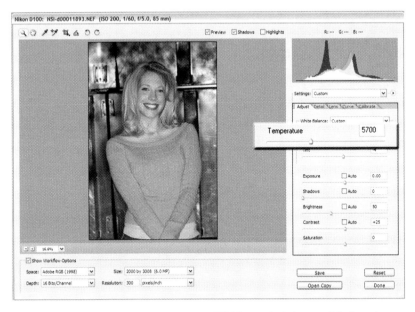

FIGURE 8-4 Color temperature increased to 5700K to make it "warmer" (yellower)

Basic RAW Adjustments: Tint

The temperature adjustment modifies blues and yellows. The tint adjustment modifies greens and magentas.

1. Once you have the color temperature close to correct, adjust the tint. Drag the Tint slider left (decreasing values) to add green. Drag the slider to the right (increasing values) to add magenta (Figures 8-6 and 8-7).

2. Refer to the subtractive color wheel again. Green and magenta are on opposite sides of the wheel, and this is why moving the slider increases one as it decreases the other.

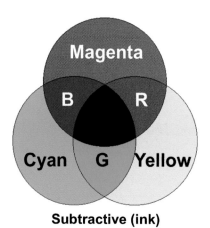

FIGURE 8-5 Subtractive primaries

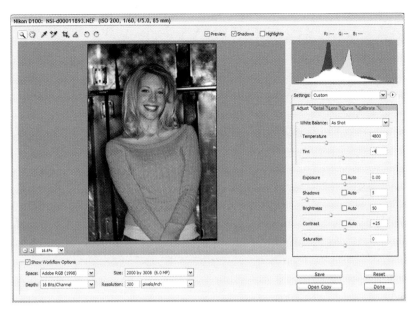

FIGURE 8-6 Original RAW image

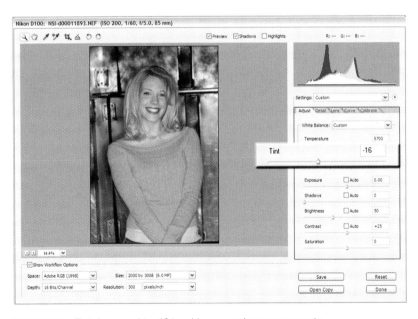

FIGURE 8-7 Tint decreased to –16 to add green and remove magenta

Basic RAW Adjustments: Exposure

Next, adjust the various exposure settings. Here's where the histogram becomes particularly useful. The histogram is a graph of the RGB data stored in the pixels in your image. It shows the distribution and intensity of the color data. The horizontal axis represents values from black (0) to white (255); the vertical axis is the number of pixels at each level.

As you make the following adjustments, watch their effects on the histogram (Figure 8-8).

1. Increase the Exposure level to expand the histogram until just before you start to lose data on the far right (watch for a sharp spike running up the right edge of the graph). The values are equivalent to f-stops on your camera: An adjustment of +1.5 would be the same as if you'd opened the aperture on your lens 1½ stops to let more light into the camera.

2. If the histogram shows data being clipped on the right before you make any adjustment, then the shot was overexposed. You may be able to improve it by pulling the exposure level down a bit, but remember: Once data is lost at either extreme, it's gone. That's another good reason to check your histogram in-camera while you're shooting!

3. In Figure 8-9, we've increased the exposure slightly. Notice that the histogram has moved to the right compared with the original image.

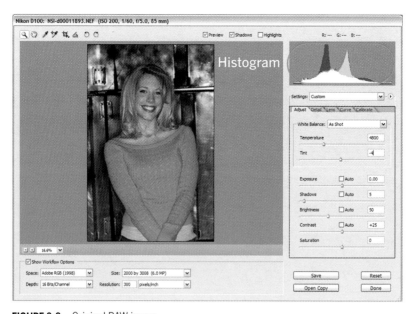

FIGURE 8-8 Original RAW image

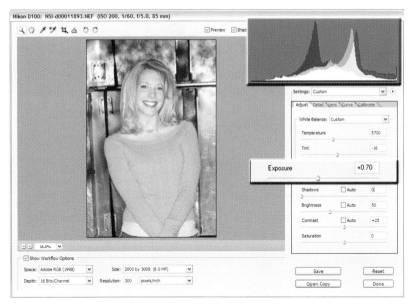

FIGURE 8-9 Exposure adjusted +0.70 to boost highlights

4. Both Photoshop and Photoshop Elements provide a handy Highlights control. Turn it on to see which pixels in the image are being clipped to white by your adjustments. In our example (Figure 8-10), we're beginning to lose data in the background metal, which is just fine.

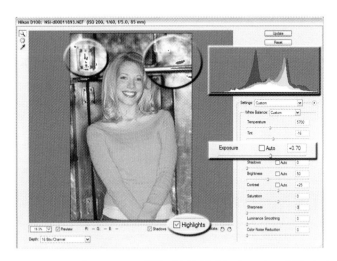

FIGURE 8-10 Exposure at +0.70, with highlights shown in red (Photoshop Elements)

Basic RAW Adjustments: Shadows

The Shadows adjustment reduces or boosts the black levels in the image. Boosting blacks can add richness and depth to a shot that might otherwise seem flat. Again, use the histogram as well as the preview image to gauge the effect of your adjustments.

1. Adjust the Shadows level to expand the histogram until just before you start to lose data on the far left.

2. If the histogram shows data being clipped on the left before you make any adjustment, then the shot was underexposed. You may be able to improve it by pulling the Exposure level up first, and then tweaking the Shadows setting. You'll have to experiment to see what works best for a specific shot (Figures 8-11 and 8-12).

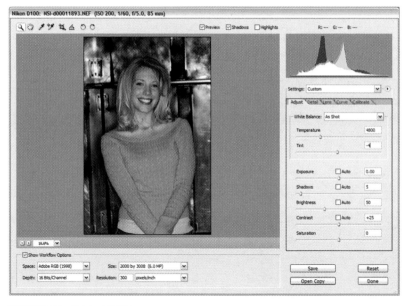

FIGURE 8-11 Original RAW image

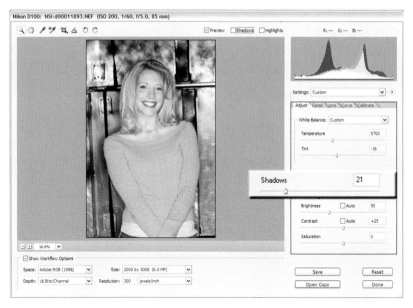

FIGURE 8-12 Shadows boosted to 21 to add richness and depth

3. As with Highlights, Photoshop and Photoshop Elements provide a Shadows control.
 Turn it on to see which pixels are being clipped to black by your adjustments. In our
 example, we're beginning to lose data in the background metal, which is just fine
 (Figure 8-13).

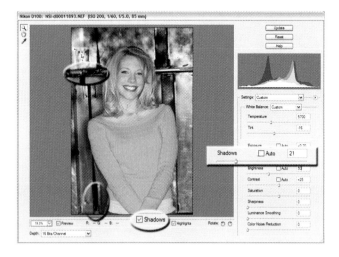

FIGURE 8-13 Shadows at 21, with Shadows shown in blue (Photoshop Elements)

Basic RAW Adjustments: Brightness and Contrast

Brightness and contrast adjust the *midtone* pixels in an image. Use these adjustments carefully, because their effects are more broad than precise.

- Brightness alters the intensity of the midtone pixels only (Figures 8-14 and 8-15). As you increase brightness, you'll see the histogram slide right. But notice that the white point (far right anchor) does not move, indicating that you're not losing data in the whites where there is no detail. This is different from increasing the Exposure, which can cause the image to "burn out" if you go too far. That's why it's important to set the Exposure and Shadow values first and then adjust Brightness.

- Contrast also affects only the midtone pixels, in this case making dark pixels darker and light pixels lighter (Figure 8-16). This has the effect of stretching or compressing the histogram. Again, the black and white end points don't move.

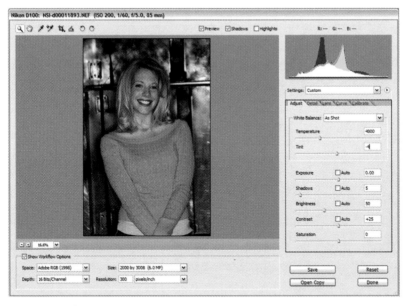

FIGURE 8-14 Original RAW image

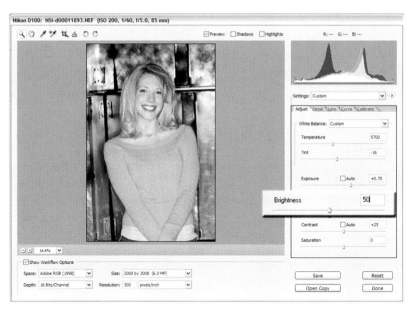

FIGURE 8-15 Brightness adjusted to 50

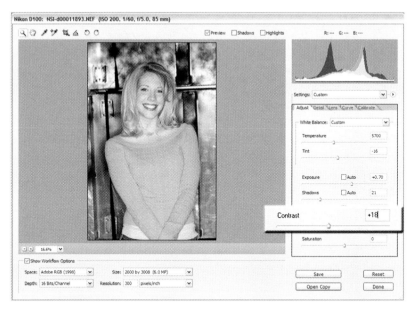

FIGURE 8-16 Contrast adjusted to +18

Basic RAW Adjustments: Saturation

Adjust saturation to reduce or boost the intensity of the colors in the image, from –100 (pure monochrome) to +100 (double the intensity). Thus, to mute the colors in an image, decrease the Saturation. To make the colors come alive, increase the saturation (Figures 8-17 and 8-18).

Summary

This completes the basic color adjustments for RAW images. As we said at the outset, all the adjustments are interrelated. You will probably need to adjust all the settings gently and repeatedly, in various combinations, to get the best final result. Just make the adjustments in the following general order.

1. Set the white balance (color temperature and tint) first to define the overall color range.

2. Set exposure and shadow levels to define the extremes of black and white.

3. Adjust brightness, contrast, and saturation to raise or lower the blacks, midtones, whites, and color levels.

Depending on which image-editing tool you use, there may be additional adjustments that you can make before proceeding to edit the image proper. For example, Photoshop offers additional tabs on its Image Import dialog box labeled Details, Lens, Curve, and Calibrate. Photoshop Elements presents most of what's found on Photoshop's Details tab in its main dialog box (see Sharpness, Luminance Smoothing, and Color Noise Reduction in Figure 8-13). If there are values in any of these fields, just set them to zero for now. Your camera may be able to apply these settings when you shoot the image, but we prefer to adjust them during the main editing session.

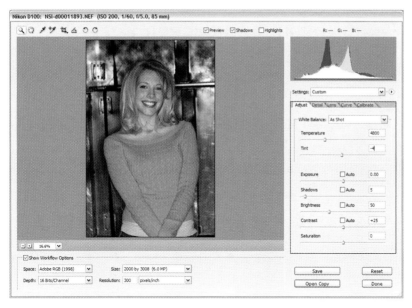

FIGURE 8-17 Original RAW image

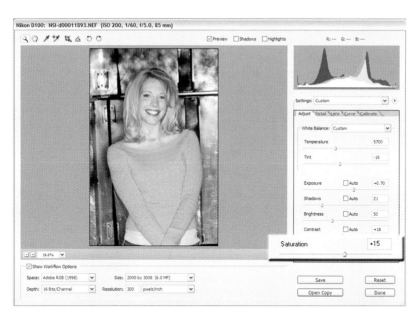

FIGURE 8-18 Saturation set to +15 to make the colors more vivid

We're finished. Our sample shot is warmer, brighter, and more vivid than the original. And don't worry about those red eyes. We'll fix them in Chapter 10.

Further Optimization: Introduction

If your camera can't store RAW images or you've chosen to shoot in a different format to save disk space, you can still optimize your images in several ways. (See "Digital File Formats" on page 121.) Just be aware that your level of control is more limited, and adjust your expectations accordingly.

Your goals in this operation are as follows. You should pursue them in the order indicated.

1. Set the optimal dynamic range (luminance levels) for the image (Figure 8-19). This involves defining the best black point and white point so that the color spread throughout the image is as great as possible. You'll do this by adjusting the Levels setting.

2. Adjust the balance and intensity of colors using the Curves setting (Figure 8-20).

3. Once the levels and curves are good, you can repair specific defects such as removing blemishes and red eye, reducing digital noise, applying selective focus, and so on. We devote an entire chapter (Chapter 10) to this topic.

4. Sharpen the image to bring out detail using the Unsharp Masking setting.

Even if you did shoot RAW and performed the basic optimizations described earlier in this chapter, it's still useful to know about Levels, Curves, and Unsharp Masking. You may not need them initially, but if you do other creative things (such as applying digital filters), you'll need to check the effect those changes have on the levels and curves before finalizing your optimization session. And unsharp masking should be applied only at the very end of your imaging workflow.

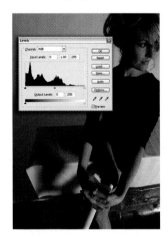 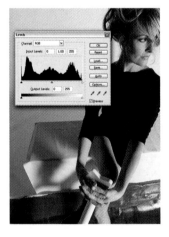

FIGURE 8-19 Before and after: Correcting an image's dynamic range using the Levels setting

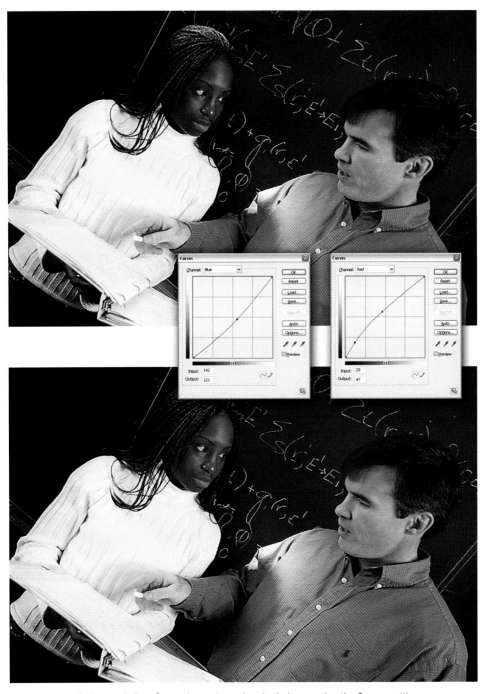

FIGURE 8-20 Before and after: Correcting an image's color balance using the Curves setting

Setting Levels

NOTE

If you adjusted Exposure and Shadow levels as described in "Basic RAW Adjustments" earlier in this chapter, then you can skip this section. However, you may need to check and readjust the levels of your image later if you apply digital filters or make other global changes.

The first screen optimization step involves defining the best black point, white point, and midtone values for the image. This allows the color spread throughout the image (or *color range*) to be as broad as possible. You optimize these values using the Levels dialog box.

We'll use Photoshop Elements to demonstrate the principle.

1. Open your image and set the image-editing mode to RGB Color if necessary. Choose Image, then Mode, and then RGB Color from the menu.

2. Confirm that the image-editing mode is 16-bit, if possible. (See page 198 for an explanation of why it's important to edit in 16-bit mode for as long as possible.) Whether or not 16-bit editing is available depends on three factors: the capture capabilities of your camera, the file format of the image (RAW versus JPEG, for example), and the sophistication of your image-editing software. If this is a RAW image, then you set the color depth when you opened the image.

 In Photoshop, choose Image, then Mode, and then 16 Bits/Channel from the menu.

 In Photoshop Elements, choose Image and then Mode. If the image is in 16-bit color, you'll see Convert to 8 Bits/Channel available on the menu. That's good; leave it alone. If that entry is disabled, then the image is in 8-bit color and you can't change it.

3. Open the Levels dialog box.

 In Photoshop, choose Image, then Adjustments, and then Levels from the menu.

 In Photoshop Elements, choose Enhance, then Adjust Lighting, and then Levels from the menu.

4. Select RGB from the Channel drop-down list.

5. Drag the black triangle below the histogram to the beginning of the data on the left to indicate where "black" is. Drag the white triangle to the beginning of the data on the right to indicate where "white" is. Finally, drag the gray triangle to adjust the midtone level until the image is pleasing.

Alternatively, you can use the three eyedroppers to pick the pixels that represent the best black, midtone, and white values. Select each eyedropper in turn and then click it inside the image to choose optimal black, midtone, and white pixels (Figures 8-21 and 8-22). (You may need to zoom the image to 400% and then pan around to identify individual pixels for selection.)

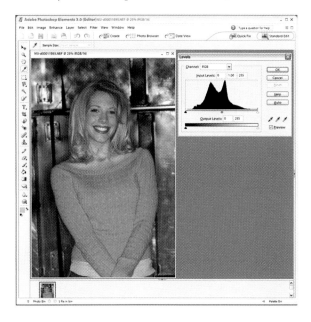

FIGURE 8-21 Original image

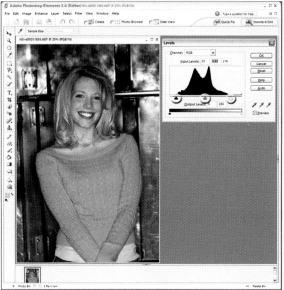

FIGURE 8-22 Levels adjusted

What's happening? By raising the black point to 23 and reducing the white point to 216, we've told Photoshop Elements to remap all dark pixels in the image with values less than 23 to 0, and to remap all light pixels with values greater than 216 to 255. The program also adjusts the values of the pixels in between those extremes proportionately to maintain the color balance. The result: darker shadows and brighter highlights for a richer and more vibrant image.

6. Click OK to set the levels to the selected values.

Color Depth: 8 Bits Versus 16 Bits

You should shoot and edit at the highest possible color depth (bit rate) for as long as possible throughout your workflow. Why is this so important? The Levels adjustment provides a great illustration.

Recall that every pixel in a digital image is represented as a triplet of values (R, G, B). When you're working with 8-bit color, each element in the triplet has 2^8, or 256, possible values (0–255). But when your image is in 16-bit color, each element in the triplet has 2^{16}, or 65,536, possible values. In other words, *16-bit images contain more than 250 times as much color data as 8-bit images.*

That's a huge difference, and the Levels adjustments in the following figures illustrate why.

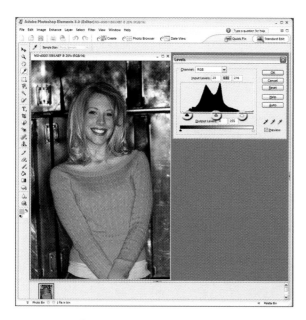

FIGURE 8-23 Original image

Figure 8-23 is in 16-bit color when we set its levels. After we apply the changes, we open the Levels dialog box again to see what happened to our histogram.

The results are shown in Figure 8-24.

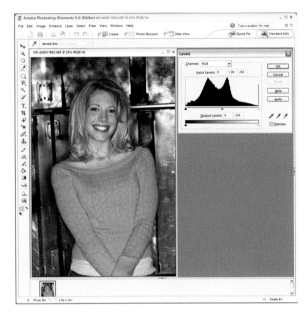

FIGURE 8-24 Levels adjustment results (16-bit)

Notice that the histrogram has widened to accommodate the new black and white points that we defined in Figure 8-23. The middle of the histogram remains filled with data as Photoshop Elements adjusted the midtone values. That's a good thing.

But what if Figure 8-23 had been an 8-bit image rather than 16-bit? Let's make exactly the same changes to its Levels and then see what happens (Figure 8-25).

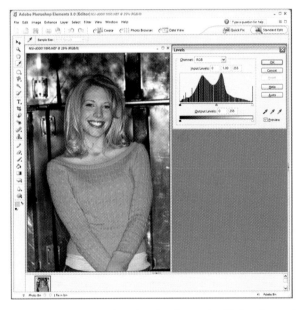

FIGURE 8-25 Levels adjustment results (8-bit)

When we reopen the Levels dialog box after changing the levels of an 8-bit image, we see something strange. The image looks fine, but the histrogram tells a different story. It has widened to accommodate the same black and white points and has the same overall shape as the histogram in Figure 8-24. But the middle of the histogram is no longer filled with data. Instead, it's filled with gaps. Because 8-bit color provides only 256 possible values for each pixel and we've "stretched" the dynamic range of the image by moving its black and white points, there are now pixel values available that no pixels in the image have.

As you can see, 16-bit images can take full advantage of the potential dynamic range that digital image-editing gives us, whereas 8-bit images cannot fully exploit that potential. There's just not enough data in an 8-bit image.

Using the Curves Tool to Adjust Colors

NOTE

Only high-end products like Photoshop provide the Curves tool. (See page 202 to adjust colors without using curves.) But the concept behind curves is universal, and it's important for you to understand it.

Photoshop provides a powerful (and to many users, mysterious) tool for adjusting colors: the Curves dialog box. Here's how to use its most basic features.

1. Choose Window and then Info from the menu to open the Info palette.

2. Choose Image, then Adjustments, and then Curves from the menu to open the Curves dialog box (Figure 8-26). Toggle the Preview checkbox to preview changes.

 Everything that happens inside an image-editing program like Photoshop boils down to one thing: mathematical changes to R, G, and B values. A pixel starts with a value like 128,128,128; then the program applies a mathematical function to the pixel, and the pixel ends up with a different value like 255,255,255. It's all about the math.

 The Curves dialog box presents a graphical picture of a mathematical function and allows you to change the math by changing the graph. The horizontal axis shows the starting (input) values of pixels, and the vertical axis shows the ending (output) values of pixels after the math is performed. Values range from 0 at the lower left, to 255 at the upper right. The "curve" begins as a straight diagonal line when you open the dialog box: There's no math happening, so the input and output values are identical and unchanged. We'll change the curve to change the math.

 Because every pixel comprises three color values (RGB), the Curves dialog box lets you do math on each of the three color "channels" individually. This channel isolation is extremely important and powerful. This dialog box also provides a combination channel that applies the math to all three color values in pixels simultaneously, but that's of lesser interest. With Channel set to RGB, the Curves dialog box actually produces the same results that the Levels dialog box does. But the Levels dialog box shows a histogram that makes it easy to see where the black and white points should be. And Levels lets you set only three control points: black (0), midtone (128), and white (255). Curves lets you change everything in the 0–255 range.

3. Set the Channel to Red. Now changes that we make to the curve affect only the R values in pixels. The G and B values remain unchanged (Figures 8-27 and 8-28). The eyedropper tool and the Info palette confirm what's happening to the pixels in the image. (In Info, the first number is input; the second number is output.) You can

also click on the curve to place anchors that "lock" part of it and change the underlying mathematical function. We've placed an anchor on the curve in Figure 8-29 so that only reds in highlights are being adjusted.

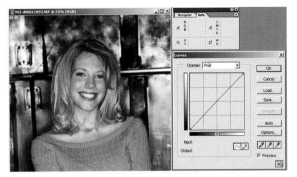

FIGURE 8-26 The Info palette and the Curves dialog box (Photoshop). The RGB Channel provides the same control as the Levels dialog box, but with more control and without the histogram.

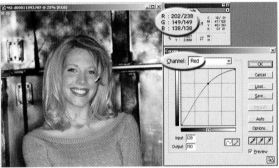

FIGURE 8-27 Red channel increased. Notice that only the R value of the pixel under the eyedropper has increased, from 202 to 238. G and B are unchanged. The curve shows what's happening to all the R values in the image.

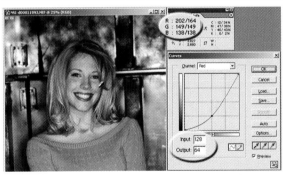

FIGURE 8-28 Red channel decreased. Now R values are decreasing. Values of 128 will drop to 64. Other R values drop proportionately until we reach the ends of the curve.

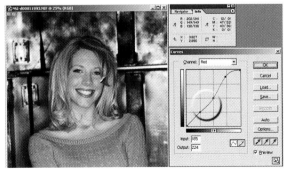

FIGURE 8-29 Red channel highlights only increased (using anchors). Now only pixels whose R values are greater than 128 are being modified!

Adjusting Colors without Using Curves

Many image-editing programs provide color adjustment tools that are less sophisticated than Photoshop's Curves dialog box. Here are a couple of examples. No matter what the user interface looks like, however, remember that they are all doing exactly the same thing: changing the mathematical function that the program applies throughout the image to the R, G, and B values of every pixel.

Photoshop Elements

Photoshop Elements provides the Color Variations dialog box for adjusting colors. It puts a different user interface on exactly the same functions that you find in Photoshop Curves.

1. Choose Image, then Mode, and then 8 Bits/Channel from the menu to switch to 8-bit editing mode. Color Variations (at the time of this writing) works only on 8-bit images.

2. Choose Enhance, then Adjust Color, and then Color Variations from the menu. The Color Variations dialog box appears (Figure 8-30).

3. Click the radio button Select Area of Image to Adjust. In Figure 8-30, we've chosen to adjust Highlights. This has the same effect as "locking" the curve in Figure 8-29. Only pixels with values greater than 192 (i.e., the highlights) will be affected by our changes. If we had clicked Shadows, then only pixels with values less than 64 would have been affected.

4. Don't bother with the Adjust Color Intensity slider. Because there's no numeric indication on the slider to indicate how great the changes will be, there's little value in moving the slider. Just take the default "middle" value, and change it only if trial and error gives you a reason to change it.

5. Click repeatedly on one of the thumbnail buttons to increase or decrease a single color channel. Each click is like pushing the curve up or down a bit. If you click on either the Lighten or the Darken buttons on the far right, you change all three channels at once (just like choosing the RGB Channel setting in Curves).

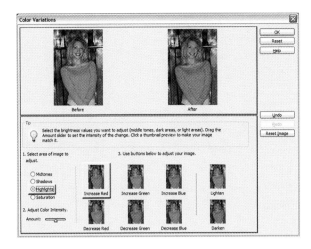

FIGURE 8-30 Color Variations dialog box (Photoshop Elements)

Figure 8-30 shows the results from selecting Highlights and then clicking the Increase Red button four times. Compare the "After" version with Figure 8-29.

Nikon View

Nikon View is typical of the simple image editor that ships with many digital cameras. Its Color Balance dialog box provides basic color manipulation controls. This type of feature is more limited than Color Variations in Photoshop Elements.

In Figure 8-31, we've increased the red channel. But you can't lock the curve to limit the effects to highlights, midtones, or shadows. The change affects red values throughout the 0–255 range. So the steel background, for example, has gotten pinker; compare with only the highlights reddening in Figure 8-29.

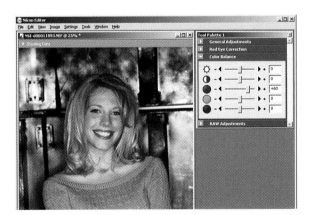

FIGURE 8-31 Color Balance dialog box (Nikon View)

Because there's no way to limit the changes to one segment of the "curve," the red values in every pixel have increased. Compare this with Figures 8-27 and 8-29.

Applying Unsharp Masking

Unsharp masking is a technique for sharpening an image that comes from the traditional world of film compositing. It's very useful for reducing the blurring effects caused by poor focus,[1] repeated scanning or image compression, or printing.

> **TIP**
> You can sometimes improve the apparent "sharpness" of an image just by increasing the overall contrast. If that's not enough, then unsharp masking is the tool of choice.

Blur occurs when adjacent pixels are too similar for our eyes to differentiate them. Sharpening involves adjusting pixels so that they are less similar. There are many ways to do this programatically; unsharp masking works by analyzing pixels to identify where the edges of objects occur and adjusting the contrast of pixels at those edges to differentiate them more from their neighbors. You control three characteristics of this analysis and adjustment process.

- The amount of contrast adjustment that the filter applies

- The distance outward from each edge pixel (the *radius*) that the filter sharpens

- The contrast *threshold* that must be crossed between pixels before the filter considers the pixels to be edges and applies the sharpening

The amounts you must specify to produce the best results for each of these three characteristics vary widely among images and output targets (i.e., screen or print). You'll need to experiment to find out what works best for each image, although we can provide some general recommendations. The apparent impact of the filter decreases as the image resolution increases. So if your target output is a high-resolution print, you'll need to use filter settings that are bigger than you would for images intended for on-screen viewing.

> **TIP**
> Unsharp masking should be the last thing you do to your image, and you should do it only once. Repeated applications of this filter can quickly cause unpleasant distortions. One exception to this rule applies when you resize an image, particularly when you downsize (shrink) it. Downsizing often makes an image blurry. You may be able to get better results by downsizing in small steps and unsharp masking at each step.

1. Don't forget the "garbage in, garbage out" rule. There's no substitute for getting your shots in focus to begin with!

Follow these steps to perform unsharp masking in both Photoshop and Photoshop Elements.

1. Set the zoom level to 100% so that you're viewing the image at real size. The effects of this adjustment are difficult if not impossible to see if the image is zoomed out.

2. Choose Filter, then Sharpen, and then Unsharp Mask from the menu. Make sure that the Preview option is selected. Note that you can also click inside the preview window to see how the image looks without the sharpening. Drag in the preview window to see different parts of the image, and click + or − to zoom in or out.

3. Adjust the three filter values as needed to produce the desired results. All the values are interdependent, so you'll need to go back and forth, changing them in various combinations to see what works best.

 - Set the Amount value to specify how much to increase the contrast of sharpened pixels. For high-resolution printed images, an amount between 150% and 200% usually works pretty well. For low-resolution on-screen viewing, try 100% to 150%.

 - Set the Radius value to specify the number of pixels surrounding the edge pixels that get sharpened. For high-resolution printed images, a radius between 1 and 2 is usually OK. A lower value sharpens only the edge pixels, and a higher value sharpens a wider band of pixels.

 - Set the Threshold value to specify how far different pixels must be from their neighbors before they are considered edge pixels and sharpened by the filter. To avoid introducing noise (in images with flesh tones, for example), experiment with Threshold values between 2 and 20. The default Threshold value (0) sharpens all pixels in the image.

WARNING
Watch the preview image closely as you change these values. If you start to see white or black "halos" or oddly sharp color transitions at the edges of things, the sharpening has gone too far. Back off on one or more of the three filter values until the halos go away.

QUANTUM LEAP (PHOTOSHOP ONLY)
If halos begins to appear before you can get enough sharpening, convert the image to Lab mode and apply unsharp masking to the Lightness channel only. This sharpens the image without affecting the color components that cause the halo effect.

Targeting PCs Versus Macs

You may have heard someone say, "Images look different on an Apple Mac than they do on a Windows PC." That's true. The reason lies in the computers' operating systems, though, rather than in any intrinsic differences in the monitor hardware. In fact, if you plug the same monitor in to a PC and a Mac and use it to display the same image file, the image will look darker on the PC (Figures 8-32 and 8-33). That's because the QuickDraw component of the Mac operating system applies *gamma correction* functions when it renders graphics on the screen. This gamma correction boosts the apparent brightness of the screen. The Microsoft Windows operating system applies no such gamma correction, so equivalent images appear darker.

This has two implications:

- **If you are a PC user and your viewers are likely to be Mac users,** *decrease* the Brightness setting approximately 10 units as the final step before saving the Mac version of the image. The image will look too dark to you, but it will look fine to your Mac users.

- **If you are a Mac user and your viewers are likely to be PC users,** *increase* the Brightness setting approximately 10 units as the final step before saving the PC version of the image. The image will look too bright to you, but it will look fine to your PC users.

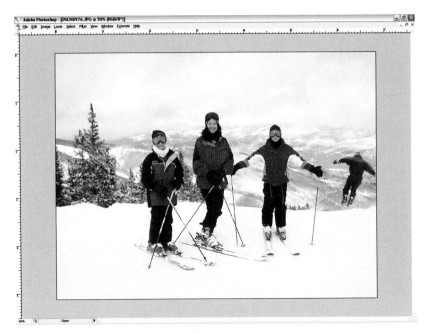

FIGURE 8-32 An image displayed on a PC monitor

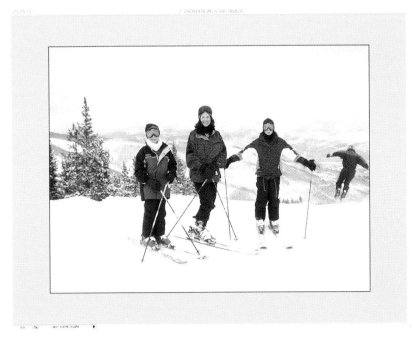

FIGURE 8-33 The image in Figure 8-32 displayed on a Mac monitor

Targeting a TV

Broadcast television viewed on a conventional color TV is designed with a specific set of viewing conditions in mind, in particular a "dim surround." This means that the TV set is assumed to be sitting in a moderately dark room as you watch it. Also, the conventional TV tube is capable of displaying only 480 lines of vertical resolution, equivalent to the lowest-quality computer monitor (VGA).[2]

Many DVD players will display CD-ROM and DVD disks that contain JPEG image files. This is a great way to distribute lots of images in a format that viewers can browse without the need to use a computer. If you intend for your images to be enjoyed to their fullest when played on a DVD player and viewed on a conventional TV, make the following adjustments.

1. Download the industry-standard SMPTE (Society of Motion Picture and Television Engineers) target image for TVs from PhotoGain.com (Figure 8-34).

FIGURE 8-34 SMPTE color bars

2. Place the image (a JPEG file) as the first image on the disk. The image includes instructions that explain how to adjust the TV's brightness, color, and hue settings to get the best results. Encourage the people playing your disk to follow these instructions.

3. In your image-editing program, adjust each image's levels, curves, and unsharp masking to get the images looking as good as possible on the computer screen.

2. High-definition TV (HDTV) monitors make the TV viewing experience closer to that of a computer, although the resolution is boosted only to 720 lines of vertical resolution. Under these conditions, if you get your images looking great on your computer, they should look fine on the new TVs.

4. When you're happy with the way each image looks on your comupter, adjust the overall contrast of the image down approximately 10 percent. The image will look slightly flat on your computer screen.

5. Resize each image so that the vertical dimension is 480 or less, and the horizontal dimension is 640 or less. Although some DVD players will automatically downsize large images to fit the TV, that feature is not universal. And you have more control over image quality if you do the downsizing yourself.

6. Save each image in JPEG format at the highest possible quality setting (i.e., the least possible amount of compression). Because you've taken the trouble to get the images looking great, there's no point in letting the JPEG compression algorithm mess things up.

7. Burn the SMPTE color bar image and the rest of your image files to CD-ROM or DVD (Figure 8-35).

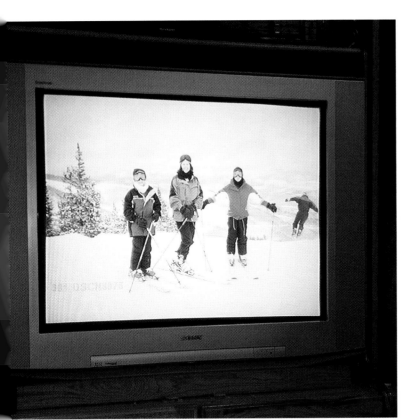

FIGURE 8-35 A DVD player displaying a slide show of JPEG images on a TV

Targeting the Web

Web browsers (and e-mail programs that use Web formats for e-mail messages) use three predominant file formats to display images: JPEG, GIF, and PNG. Your images will look best if you choose the best output format for them. Which one is "best"? That depends on the nature of the image and your intended use for it (Table 8-1).

Workflow

Follow these steps to create your output files in whatever format you choose.

1. Optimize the image at full size so that it looks its best using the techniques described in this chapter.

2. Downsize the image to the dimensions that you need for the Web. See page 204 for a tip about using unsharp masking to sharpen downsized images. Note especially the tip about downsizing and unsharp masking in steps if the end result will be dramatically smaller than the original (for example, if you're creating thumbnail images).

3. Export the image to the appropriate output format. If you choose JPEG, export the image into separate files using high, medium, and low compression settings so that you can compare the results and determine the best balance between quality and file size.

TABLE 8-1 Choosing the best image file format for the Web

Issue	Best Format	Discussion
Image has continuous tones with smooth full-color transitions.	JPEG, PNG-24	JPEG was designed to deliver good-looking photographs in the smallest possible file size.[a] You can vary the compression strength as needed to get the optimal balance between image quality and file size. Typically, compression of 10 to 1 is possible without any discernable loss of quality on screen. Higher compression settings begin to cause pixelation.
		PNG files with 24-bit color are also suitable for photographs; however, the file size will be much larger than a JPEG version of the same image that looks just as good.

TABLE 8-1 Choosing the best image file format for the Web (cont.)

Issue	Best Format	Discussion
Image is vector (line) art or contains significant areas of solid colors.	GIF, PNG-8	GIF is best for images with a limited color range and sharp boundaries where colors change. Consequently, GIF is typically better suited to line art illustrations than to photographs. Ditto for PNG-8 files; there's not enough color depth to create good results with most photographs.
Colors in the image must be locked to specific color values.	GIF	Suppose you want the blue in the sky to match exactly the blue in your company's logo whenever anyone views the image on the company Web site. In this special case, GIF's ability to define a specific color palette for each specific image can guarantee that the colors match.
Images are being archived for long-term storage.	PNG	The PNG format was defined from the outset to be a standard for Web-based images. It is currently unencumbered by patent disputes that hang over the GIF and JPEG formats, and seems to us to be destined for a long and happy life.
Images contain areas that must be transparent, allowing Web page backgrounds or other design elements to show through.	GIF, PNG	These two formats support transparency. JPEG does not.
You desire the best compatibility across devices.	JPEG	If you want people to be able to view your images on more than just their computers (i.e., TVs, handheld PDAs, cell phones, etc.), JPEG is currently the most widely supported format.

[a]Not all JPEG generators are created equal. For example, you can create a better-looking JPEG image with a much smaller file size using Macromedia Fireworks MX 2004 than you can with Adobe Photoshop CS. If you have more than one image-editing program, experiment with them to see which one produces the best results for your images.

Summary

Optimizing images begins with the screen. If your creative goal is for your images to be viewed on the screen, then that's as far as you need to go. If you want great-looking prints, then optimizing for the screen is still an important first step.

1. Shoot your images in the RAW format if your camera and image-editing software support it. If not, then shoot TIFF. If that's not available, then shoot JPEG as a last resort. Shoot at the maximum resolution and color depth that your camera supports. Don't be a cheapskate. Memory is cheap compared with settling for images that have been degraded by compression algorithms in your camera.

2. Archive a copy of the original file, unchanged, so that you can start fresh in the future when your creative goals are different.

3. If you're optimizing RAW shots,

 - Adjust the white balance settings (color temperature and tint).

 - Adjust the black and white points using the Exposure, Shadows, and Highlights settings.

 - Adjust the midtone pixels using the Brightness and Contrast settings.

 - Adjust the color intensity using the Saturation setting.

4. If you're optimizing TIFF or JPEG shots, or for further optimization of RAW images,

 - Use Levels to fine-tune the black, white, and midrange pixels.

 - Use Curves (or Color Balance if Curves is unavailable) to fine-tune individual color channels.

5. Apply Unsharp Masking to sharpen the image.

6. Resize the image to fit your output format. See page 204 for tips about downsizing, and see page 238 for tips about upsizing.

7. Tweak contrast and brightness if necessary to target specific viewing devices (other computer platforms, TVs, etc.).

8. Export the image in the appropriate output file format.

When all is said and done, what's important is that your shots look great. Once you're comfortable making adjustments to things like levels and curves, then adjust away. Don't get hung up on the numbers and the shapes of the graph lines. Get obsessed with making great images.

Optimize for Print

R eady to print? We thought so. Let's do it. We'll look at two scenarios for making prints from your digital images, and we'll explain how to get the best results in each case.

- **Personal printing on your own printer.** This gives you the most control and immediate gratification. Of course, you need to own a computer and printer to make this happen.[1] Costs for ink and paper are relatively high, so if you're making several copies of each print, you may want to choose another option. But for small numbers of prints and the most control over the final results, this is the way to go.

- **Local and online printing services.** This scenario removes the need to have your own equipment. Just take your camera or memory card to local retailers and let them make your prints. There are also online services that let you upload or e-mail your image files; the services then ship your prints back to you. Of course, you sacrifice all the optimization control that we've spent so much time teaching you, so you'd better be sure you shot the images right to begin with!

1. Many consumer printers offer direct connections to your camera or memory card readers that allow you to print without using a computer at all. Although this setup gives quick results, you must rely on the built-in printer drivers to produce the best print possible. That's fine for snaphots. For more professional results, follow the guidelines in this chapter.

Personal Printing: Introduction

When we talk about "personal color printing," we're referring to ink-jet printers. Color laser printers are steadily improving output quality and dropping in price, but they cannot yet match ink-jet printers in terms of image quality and dollar value. Now, with the proper selection of inks and papers, ink-jet printers offer archival-quality output that rivals conventional photographic prints.

TIP

One of the criticisms of ink-jet printing is the high cost of ink cartridges. Third-party ink tank add-ons for high-volume printing offer a cost-effective solution. If you own a Canon or Epson printer, check out the Niagara Continuous Ink Flow System at www.mediastreet.com

Direct Printing

You may be able to print straight from your camera, a great option for checking the initial quality of a shot or for casual sharing with friends and family. To take advantage of this capability, you'll need a printer that offers at least one of the following options:

- **Cable or wireless connection to your camera**. The Camera & Imaging Products Association (CIPA)—a consortium of camera and printer manufacturers—has defined the PICTBRIDGE standard for connecting cameras and printers via a USB cable (Figure 9-1). A small number of Kodak and HP brand cameras and printers offer camera docking stations that are another way for the camera to communicate directly with the printer. Finally, wireless communication links between cameras and printers are starting to appear on the market as we go to print with this book. Visit PhotoGain.com for the latest news.

- **Memory card reader(s)**. Because there are many different kinds of memory cards being used in digital cameras,[2] printers that print images straight from memory cards typically support multiple card formats. Just be sure that the printer you purchase supports the type of card your camera uses (Figure 9-2).

Direct printing requires total reliance on the default image optimization that is built into your printer driver. If you shot a great image to begin with—using the correct lighting, exposure, focus, and color balance—then your direct-to-printer experience should be fine for creating small-format, snapshot-style prints (5×7 or smaller).

2. CompactFlash, Secure Digital (SD), Mini-SD, Smart Media, Sony Memory Stick, xD-Picturecard, MultiMediaCard, and Reduced Size MMC—to name a few.

But to ensure that you get the best possible results at any size, transfer the image to your computer and then optimize it for your target printer.

FIGURE 9-1 A camera communicating directly with a printer via PICTBRIDGE

FIGURE 9-2 This printer reads a variety of memory cards to print images straight from the cards.

TIP (FOR INK-JET PRINTING)

Save paper, ink, and time by running an initial nozzle check and print head cleaning operation before beginning to print. This is especially helpful if your first print is a large one. There's nothing more frustrating, and costly, than printing 95 percent of an image and then having a nozzle clog up.

Personal Printing: Photoshop Elements

Remember, it's critical to profile to your printer accurately to get the best possible results. If you can't do this process yourself (Chapter 7), then take advantage of one of the many online printer profiling services that are available. Visit PhotoGain.com for a current selection.

To optimize for personal printing using Photoshop Elements, follow these steps.

1. Calibrate and profile your monitor (Chapter 5).

2. Profile your printer (Chapter 7).

3. Disable color management in your printer driver. This is typically found in the printer's Properties dialog box in the Control Panel (Windows) or the Color Management Preset of the Print dialog box (Mac). This prevents the color management built into the printer driver from conflicting with the color management that you're doing yourself.

4. Optimize the image for the screen (Chapter 8).

5. Choose File, then Page Setup, and then Printer from the menu and select your printer.

6. Choose File and then Print from the menu. In the Print Preview dialog box, click the Show More Options checkbox to reveal the color management options (Figure 9-3). *Note that the preview image is not color managed, so don't rely on it to represent the printed colors accurately.*

7. Select your printer profile from the Print Space drop-down list.

8. Select either Perceptual or Saturation from the Intent drop-down list (Figure 9-4). You may want to print the image using each setting to see which one produces the best results. *Do not leave this setting at its default value (Relative Colormetric).* The default value is there for consistency with Adobe's vector-based applications (Illustrator, etc.) and usually is inappropriate for printing photographs.

9. Click Print to send the image to the printer.

FIGURE 9-3 Print Preview with Show More Options checked

FIGURE 9-4 Selecting the Print Space and Intent settings

Personal Printing: Photoshop, Phase 1

To optimize for personal printing using Photoshop, begin with these steps.

1. Calibrate and profile your monitor (Chapter 5).

2. Profile your printer (Chapter 7).

3. Disable color management in your printer driver. This is typically found in the printer's Properties dialog box in the Control Panel (Windows) or the Color Management Preset of the Print dialog box (Mac). This prevents the color management built into the printer driver from conflicting with the color management that you're doing yourself.

4. Optimize the image for the screen (Chapter 8).

5. Before you apply ink to paper, it's important to perform one final optimization to ensure that the blacks and whites in the image are as close to neutral (equal amounts of red, green, and blue) as possible. Good neutral blacks and whites make the image pop off the page. Unless your creative intent is specifically otherwise, spot-check the values of blacks and whites as follows.

6. Choose the Color Sampler tool by clicking and holding on the eyedropper until the rollout menu appears (Figure 9-5). The Color Sampler allows you to select up to four pixels in an image and display information about those pixels in the Info window. This is an extremely useful and frequently overlooked feature of Photoshop.

FIGURE 9-5 Color Sampler (eyedropper) tool. You can change the sample area from a single pixel to either a 3×3 or 5×5 averaged area using the Sample Size drop-down list at the top of the Photoshop window.

7. Zoom in on the image until it's easy to identify individual pixels; then pan around to find a black pixel. Watch the Info palette as you move the eyedropper over the image. You're looking for a pixel whose RGB values are close to 0,0,0. When you find it, click the eyedropper on it. The click point is marked "#1."

8. Locate a white pixel (RGB close to 255,255,255) and click it with the eyedropper. This click point is marked "#2." Notice that the Info palette has grown to show information about the two click points (Figure 9-6).

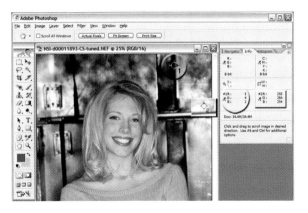

FIGURE 9-6 Black (#1) and white (#2) pixels being sampled

9. Open the Curves dialog box (Figure 9-7) and adjust the red channel until the black point is neutral. To do this, lock the three quartertone points so that the curve moves only at the end points. In our example, the black sample (#1) was 5,4,2. Figure 9-7 shows the red channel adjusted at the bottom (lower left) to change the R value from 5 to 0. Make similar adjustments in the green and blue channels to bring the G and B values to 0, too.

10. Now adjust the top (upper right) of the curve in each channel until the white point is as close as possible to 255,255,255.

11. Click OK to close the Curves dialog box. The blacks and whites are now perfectly neutral.

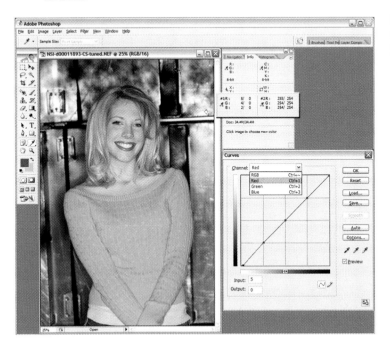

FIGURE 9-7 #1 and #2 points adjusted to neutral

Personal Printing: Photoshop, Phase 2

Now that the blacks and whites are balanced and neutral, you're ready to print. First, create a *soft proof* to see what your printer will produce. We do this because the Print Preview dialog box does not show a true, color-managed preview. The soft proof is also useful for seeing how your print will change if you switch between printers, papers, and so on.

1. Choose View, then Proof Setup, and then Custom from the menu (Figure 9-8).

 - Choose your printer profile from the Device to Simulate drop-down list.

 - Choose either Perceptual or Saturation from the Rendering Intent drop-down list. You may want to print the image once with each setting to see which one produces the best results. *Do not leave this setting at its default value (Relative Colormetric).* The default value is there for consistency with Adobe's vector-based applications (Illustrator, etc.) and usually is inappropriate for printing photographs.

 - Check the Black Point Compensation and Simulate Paper Color checkboxes.

 - Click OK. Now when you click the View menu, the Proof Colors entry is checked to indicate that you are viewing the printer proof colors.

2. Now print the image.

 - Choose File and then Print with Preview from the menu (Figure 9-9).

 - Choose Color Management to display the appropriate controls in the lower area of the dialog box.

 - Click Document in the Print group.

 - In the Options group, choose Let Photoshop Determine Colors from the Color Handling drop-down list. (Be sure that color management is disabled in your printer driver, too.)

 - Choose your printer profile from the Printer Profile drop-down list.

 - Choose either Perceptual or Saturation from the Rendering Intent drop-down list to match the setting you made in Step 1.

 - Check the Black Point Compensation checkbox.

 - Set the print size options as desired.

 - Click Print to send the image to the printer.

FIGURE 9-8 Customize Proof Condition dialog box

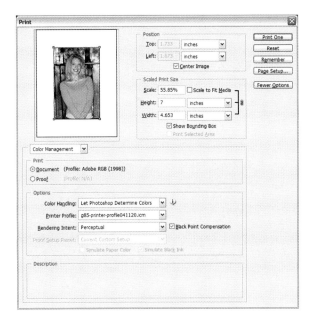

FIGURE 9-9 Print with Preview dialog box. Note that the preview image is not color managed, so don't rely on it to represent the printed colors accurately. Use the soft proof technique to see what the printer will produce.

TIP

If you are optimizing your image in Photoshop for use in another application (such as Quark or Fireworks) and intend to print from there, you should assign the correct printer profile to the image before importing it into the other application. Choose Edit and then Convert to Profile; then pick your printer profile from the Profile list. Save the image to a new file name that indicates the profile that it uses, and then import that file into the next application. It should print beautifully, even if the other application does not understand color management and the image looks odd on screen.

Local and Online Printing Services

It used to be that getting prints made involved taking your exposed film to a photofinishing service at a neighborhood retailer, or shipping the film to a processing house by mail. With the rapid expansion of digital photography, these traditional businesses have been scrambling to offer new lines of service to replace the loss of film processing. As a result, many retailers now offer "digital photofinishing" services and self-service kiosk print stations. Rather than submit film, you submit digital image files on memory cards or CD-ROM, and the retailer creates prints to your specifications.

The obvious advantage of such services is that you don't have to fool with using a computer and printer to get your prints. The experience is much closer to the old days of point-shoot-print photography. The obvious disadvantage—for serious photographers, anyway—is that you relinquish all control over the printing process. What you get is what they give you.

If you choose to use a local printing service, follow these guidelines to get the best possible results.

- Capture the best possible image, one that is in focus, white balanced, exposed correctly, and in TIFF or JPEG format[3] at the highest possible resolution.

- If you're using a local service, burn the images to CD-ROM and submit that rather than risk losing expensive memory cards. Otherwise, ask the retailer to download the images from your memory card while you wait; then retrieve the card before you leave the store.

Self-service kiosks support limited changes to images, such as cropping an image to fit the desired print size or combining multiple images into a montage. More sophisticated kiosks may also offer brightness, contrast, and saturation adjustments, and various "automatic" repair features like red eye removal and noise reduction.

Online services provide the widest range of options, from simple upload-my-files-and-mail-me-my-prints for snapshot consumers to full-service photofinishing services for professional shooters in specialty markets (i.e., wedding photography).

3. JPEG is the most widely supported image format for retail and online printing services.

Color RIP Software

If you really want to control the quality and color integrity of your printed images, consider investing in a raster image processing (RIP) product such as ColorBurst RIP from Color-Burst Systems (www.colorburstrip.com). RIP products sit between an image-editing application like Photoshop and the printing device that will produce the printed image. If you're sending images out for professional offset printing, the printing company will require your images to be expressed in terms of CMYK color data in order to create the printing plates. If you deliver RGB files, the printing company will convert them using a RIP application. If you own the RIP, then you get creative control over one more aspect of the production process.

RIP products offer high-end CMYK color matching via the industry-standard Pantone libraries and support custom ICC profiling for devices throughout your creative workflow.

Even if you are targeting your own ink-jet printer rather than a commercial press, you may still be interested in investing in a RIP product. Consumer ink-jet printer drivers interpret RGB data almost exclusively. That invariably leads to changes as images move from RGB to CMYK to RGB during your shoot, edit, and print workflow. If you want full control over the way ink is deposited on paper by your ink-jet printer—perhaps to create fine art prints for sale or for collecting and archiving—then you should consider owning a color RIP application.

Summary

Optimizing for print is critical to get the best possible output on paper. Although you may be able to print directly from your camera using a cable or wireless connection, your prints will be far better if you take the time to optimize them first and then print using custom profiles.

1. Capture the best possible shot, stored in RAW format.

2. Calibrate and profile your monitor using color calibration hardware and software.

3. Profile your printer, ink, and paper combination or let a professional service bureau build custom profiles for you. If you decide to use a service bureau, choose one that caters to professionals and will provide you with ICC profiles.

4. Disable color management in your printer driver.

5. Optimize the image for the screen.

6. Assign the appropriate printing profile to your optimized image.

7. For ink-jet printing, you can save paper, ink, and time by running an initial nozzle check and print head cleaning operation before beginning to print. This is especially helpful if your first print is a large one.

Fix Specific Problems

Now let's talk about making repairs. Sometimes, despite your best intentions, shots just refuse to be perfect. With film, about all that most of us could do was to shred our mistakes. But we're talking digital imaging now. With a decent image-editing tool, you can fix almost anything.[1]

In this chapter, we'll examine fixes for several common problems you're likely to encounter. We also look at a couple of more specialized "repairs" to give you a taste of the amazing things that are possible. We discuss the following:

- Removing red eye
- Removing blemishes using two techniques
- Repairing keystoning
- Upsizing images while minimizing jaggies
- Reducing digital noise
- Eliminating banding in prints
- Adding selective (limited) focus
- Creating a black and white effect
- Replacing the sky

We'll continue to use Photoshop and Photoshop Elements as our tools for demonstrating techniques. However, you should be able to accomplish most of these same feats with any reasonably capable image-editing application.

1. Assuming, of course, that there's image data in the file.

Image-Editing Basics

If you spend much time at all working with your image-editing application, you'll find it worth your while to set it up correctly and to learn how to use some of its time-saving features.

Here are our favorite tips and techniques for working in Photoshop and Photoshop Elements.

- Always work on a copy of the original image file so that the raw shot is available later for other work. This is especially important if you're using the image for multiple purposes, such as the Web and print. Save all the variants in separate files.

- Use the History palette to undo a range of previous actions. Photoshop lets you make the history list nonlinear, meaning you can undo individual previous actions selectively without also undoing all the steps in between.

- Increase History States to at least 50. More is better, provided that your computer has enough memory to support a deeper history list. If your computer's performance drops noticeably or you notice the hard drive working overtime, shorten the history. Choose Edit, then Preferences, and then General from the menu. When you start using tools like the Clone Stamp, you'll appreciate having a long history list if you need to fall back to a meaningful prior state.

- Set up your cursor to provide the best feedback by choosing Edit, then Prefs, and then Displays & Cursors from the menu. We recommend the following:
 - Painting Cursors = Full Size Brush Tip
 - Show Crosshair in Brush Tip = checked
 - Other Cursors = Precise

- Learn a few of the most useful keyboard shortcuts for common functions. Our favorites for Photoshop and Photoshop Elements include these:
 - Ctrl+spacebar : Zoom in
 - Alt+spacebar : Zoom out
 - Spacebar: Pan or drag image
 - [(left bracket): Decrease pen size
 -] (right bracket): Increase pen size

- Use selection tools to isolate portions of an image to be changed. This allows you to make much more precise corrections in specific places without altering the entire

image. Photoshop and Photoshop Elements offer several selection tools that are increasingly "smart" about identifying the areas or objects that you intend to select, including these:

- Marquee tool (rectangular and oval selections)

- Lasso, Magnetic Lasso, and Polygonal Lasso tools (arbitrary shape selections)

- Magic Wand (selects adjacent pixels that match the target pixel's luminance within a specified range of values)

- Color selector : Choose Select and then Color Range from the menu (selects pixels within the image or selection area that match specific color values)

• Right-click on a selection and choose Transform Selection to make slight adjustments to it instead of redrawing it.

• Use layers to hold changes that you make to the image. By showing and hiding layers, you can easily toggle back and forth between "before" and "after" versions of your image. Adjustment layers are also handy for applying software filters. Using separate layers for each filter is a great way to manage multiple effects.

The Ethics of Image-Editing

Throughout this book, we assume that you own the rights to the images you are editing, and that your image-editing goals are creative or artistic. Of course we recognize that there are other motivations for altering images—some less honest than others. The technologies that make image-editing easy and often undetectable have no intrinsic ethical stance. It's up the people who use those tools to use them responsibly.

Artists have always struggled to find their own unique balance between realism and vision; between truth and beauty (however those may be defined). Digital photographers are no different. Image-editing tools offer great power to many people to do amazing things with their photographs. We encourage you to wield those tools wisely, in the service of work that makes all of us proud.

Removing Red Eye

Red eye in portraits is caused by light from your camera's flash unit bouncing straight off the capillaries at the back of the eye. The red is actually blood (gack!). You can avoid red eye to begin with by having your subject look away from the lens or by moving the flash source slightly off-axis to the camera.[2] Of course, that can also weaken the dramatic impact of the shot.

Because this is such a common problem with portraits illuminated by a flash, almost every image-editing application provides a red eye removal tool. The tool works by identifying any pixels in a target area that you define that have the characteristic red color, and then minimizing the R(ed) channel values for those pixels. Be careful to select only the pupils that need correcting; otherwise, you may wind up reducing the R channel in other parts of the image, too.[3]

In Photoshop and Photoshop Elements, follow these steps:

1. Zoom the image until the eyes that you need to fix are big enough to click on easily.

2. Choose the Red Eye Removal Tool from the toolbar.

3. Click inside the red area of each eye to reduce the R channel values in adjacent pixels.

As you can see in Figure 10-1, that's all there is to it!

2. Some consumer cameras attempt to minimize the red eye effect by flashing their strobes several times before the shot to constrict your subject's pupils, thus creating a smaller target. This technique is of limited usefulness.

3. One more reason to be grateful for Undo.

FIGURE 10-1 Using the Red Eye Removal tool (Photoshop Elements)

Removing Blemishes: Healing Brush

Blemishes take a variety of forms. In a portrait, blemishes might be imperfections in skin tone, shiny hot spots that reflect too much light, wrinkles or creases on a face or neck—the list is endless. But to an image-editing application, pixels are only pixels and everything is subject to manipulation.

Photoshop and Photoshop Elements offer a couple of great tools that you can use to correct blemishes: the Healing Brush and the Clone Stamp. The Healing Brush samples the pattern or texture of pixels in one area of an image and then blends that pattern into the pixels in the target area while preserving the light and dark characteristics of the target (Figure 10-2). Actually, it's more complicated than that, but we're hitting the highlights here.

Let's try the Healing Brush in Photoshop Elements. The effect is like using makeup concealer, but applied to the image rather than to your subject!

1. Choose the Spot Healing Brush from the toolbar.

2. Set the brush size so that the brush is larger than the target blemish and includes clean, unblemished skin.

3. Click on a blemish to blend it into the surrounding pixels.

FIGURE 10-2 (Left) Original image in Photoshop Elements. (Right) Using the Spot Healing Brush tool to correct forehead blemishes and a hot spot on the nose (upper target shows selection).

The Healing Brush can remove large blemishes, too. After all, it's only sampling one area of an image and blending those pixel values into the target area. As long as the sampled background pixels are relatively uniform, you can effectively "erase" large objects with the Healing Brush.

In Figure 10-3, we've removed the tree that seems to be protruding from the car's hood by using the Healing Brush to blend the background foliage into the foreground.

FIGURE 10-3 Removing large objects with the Healing Brush (Photoshop Elements)

Try varying the brush size, the hardness and softness of the brush edges, the opacity or transparency of the brush, and the shape of the brush to get the best results for your problem area. All those controls are available on the Brush pull-down list at the top of the edit window when the brush is active.

Removing Blemishes: Clone Stamp

Sometimes the Healing Brush doesn't produce the right effect to correct a problem perfectly. Photoshop and Photoshop Elements also offer the Clone Stamp tool, which may be more appropriate. Unlike the Healing Brush, the Clone Stamp exactly duplicates (or "clones") the pixels in the sample area and then uses them to overwrite the pixels in the target area. It's sort of like copy and paste, although you can alter the fidelity of the pasting by adjusting opacity, edge softness, and other properties of the tool.

Figures 10-4 and 10-5 demonstrate the repeated application of the Clone Stamp tool to remove dark areas under the model's eyes and to minimize the wrinkles on her neck. While we were fixing things, we also used the Red Eye tool to color-correct her pupils, and then whitened her teeth using a selection mask and the Selective Color dialog box to reduce yellow and magenta within the masked area.

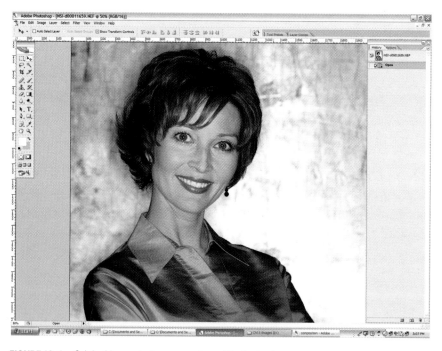

FIGURE 10-4 Original image before corrections (Photoshop)

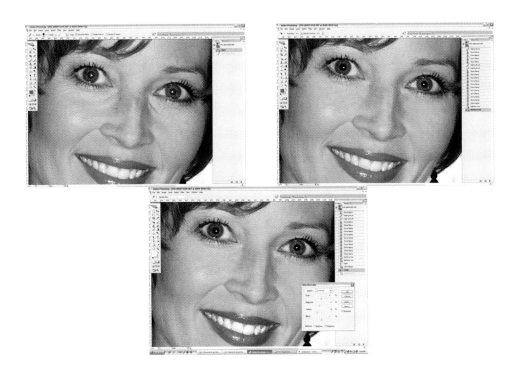

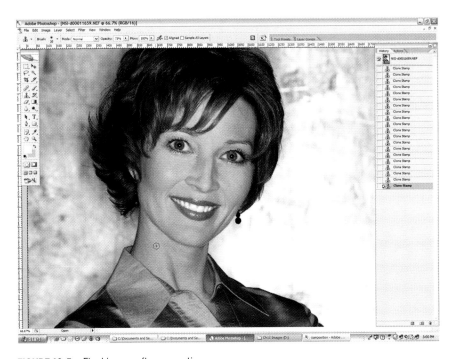

FIGURE 10-5 Final image after corrections

Repairing Keystoning: Narrow to Wide

Builders of stone arches call the stone at the top of an arch that holds everything together the "keystone." The distinctive trapezoidal shape of a keystone gives its name to a common photographic problem caused by extremes of perspective. The problem is most noticeable in shots with strong vertical features shot from below or above.

In Figure 10-6, the foremost vertical column of the building frame appears to bend and twist toward the center of the image. That's keystoning. Let's use Photoshop to correct that vertical element so that it's parallel to the vertical edges of the image.

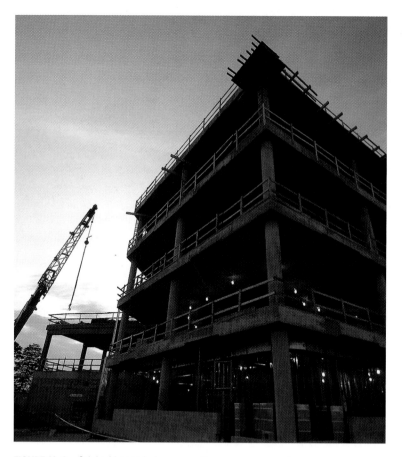

FIGURE 10-6 Original image before correction

1. Zoom the image out so that you can see all four of its edges.

2. Select the entire image (Ctrl+a).

3. Choose Edit, then Transform, and then Skew from the menu (Ctrl+t).

4. Click the vertical ruler and drag a guide over the image to give you a visual reference for the next step (Figure 10-7).

5. Press and hold the Ctrl key, then click and drag one or more corners of the image as necessary to correct the shape.

6. Press Enter when you are finished (Figure 10-8), or press Esc to abandon the correction.

7. If you can't get good results by skewing the entire image at once, you can select half the image, correct it, and then invert the selection and correct the other half.

FIGURE 10-7 (Left) Adding a guide. (Right) Using Skew to correct keystoning.

FIGURE 10-8 Final image after correction

Repairing Keystoning: Wide to Narrow

Buildings, trees, and telephone poles are not the only objects that fall prey to keystoning. A similar effect can happen when you're shooting with a wide-angle lens setting, but the results are opposite: Rather than appearing pinched at the top or bottom, objects appear to swell in the middle and/or flare out at the corners. If your subject includes people, they won't appreciate that (Figure 10-9). You can use tools like Skew in Photoshop to correct that, too.

1. Zoom the image out so you can see all four of its edges.

2. Select the entire image (Ctrl+a).

3. Choose Edit, then Transform, and then Skew from the menu (Ctrl+t).

4. If you need horizontal or vertical guides to give you a visual reference for the next steps, click the appropriate ruler and drag the guide(s) over the image.

5. Press and hold the Ctrl key, then click and drag one or more corners or middle control points of the image as necessary to correct the shape (Figure 10-10).

6. Press Enter when you are finished (Figure 10-11), or Esc to abandon the correction.

7. If you can't get good results by skewing the entire image at once, you can select half the image, correct it, and then invert the selection and correct the other half.

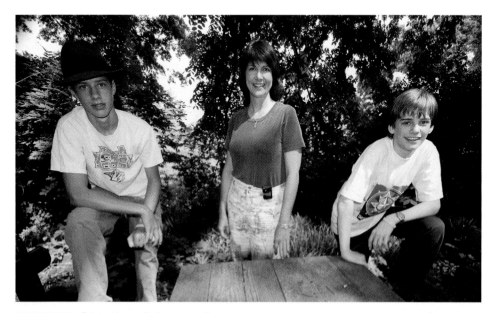

FIGURE 10-9 Original image before correction

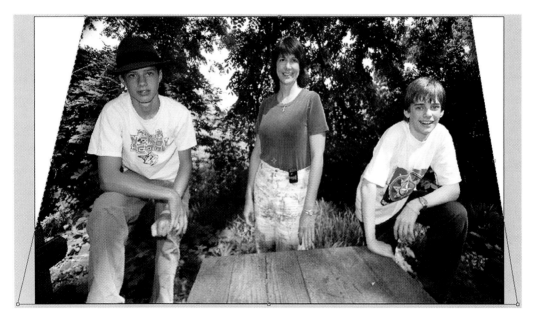

FIGURE 10-10 Using Skew to correct keystoning

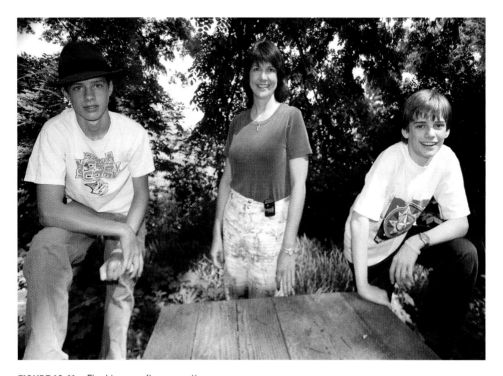

FIGURE 10-11 Final image after correction

Upsizing Images

It's much easier to make images smaller than it is to make them larger while maintaining an acceptable level of quality. When you downsize an image, your image editor evaluates the pixels in the image and figures out the best way to compress the data while preserving quality. Depending on which compression algorithm you choose (JPEG, TIFF, etc.), some data may be lost during compression. That's usually not a problem, though, because as the image gets smaller, it becomes harder for viewers to perceive details. When in doubt, shoot the highest possible resolution with the least in-camera compression.

But if you do find it necessary to make an image bigger, you face a very different problem. If you simply grab the corner of an image and pull to make it bigger, you quickly begin to see *pixelation*, also known as the *jaggies*, as the image degrades.

Try this *step method* to upsize images with minimal pixelation (Figure 10-12). Our technique should work with almost any image-editing program that supports unsharp masking. Depending on the image, you may be able to double its size before the quality begins to suffer noticeably. The idea is to upsize in small steps, and apply unsharp masking every so often to reduce blurring and pixelation.

1. Optimize at normal size for screen or print.

2. Open the dialog box that allows you to resize the image. (In Photoshop and Photoshop Elements, choose Image and then Image Size from the menu.)

3. Set the units of measure to Percent and lock the aspect ratio. (In Photoshop and Photoshop Elements, check Constrain Proportions.)

4. Increase either the width or the height to 110%. If the aspect ratio is locked, the other dimension will change proportionally.

5. Click OK.

6. Repeat steps 2–5 another two or three times, increasing the image size by 10 percent each time.

7. When the image begins to look blurry, apply a little unsharp masking to enhance detail.

8. Keep upsizing in 10 percent increments and use unsharp masking as needed. Watch for the jaggies, and stop when they become too severe.

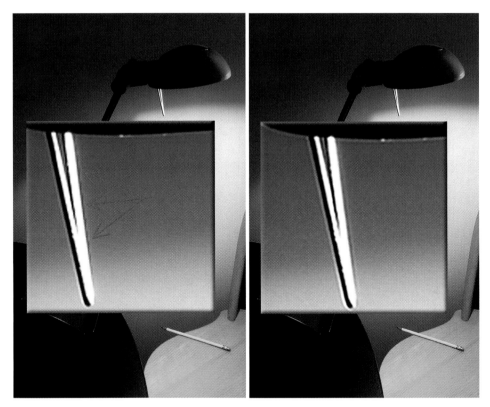

FIGURE 10-12 An image upsized 200 percent in one step (left) and in several steps (right). The step method significantly reduces pixelation.

Resampling

Another method for upsizing images is to use a tool that does image resampling.. There are plug-ins for Photoshop and Photoshop Elements that sample the original image and store its brightness and color information in a mathematical equation. They then scale the image and apply the equation to the new image. If you're upsizing, they interpolate pixels to fill the gaps between the original pixels as the image grows, and apply the original brightness and color information to the new pixels, too. Depending on the characteristics of the original image, such tools can help you upsize images by several hundred percent with no discernable loss in print quality.

Reducing Digital Noise

Digital noise is the accumulation of errors in image detail that degrades image quality. When you zoom into an image, you can see noise as bright, colored, or dark specks that don't seem to match the surrounding pixels. Noise often occurs when you shoot in low light or save images with JPEG compression. It can also occur when you increase the ISO rating in your camera to shoot in low-light situations.

If your target output is the screen and the image is small, then noise may not be noticeable. But if you're printing the image (especially at larger print sizes), noise can become much more troublesome.

Whether or not an image contains noise depends on many factors, including your camera's image sensor and capture settings, the lighting, the amount of detail in the shot—the list is long. You'll need to examine each shot closely to determine whether or not noise reduction is necessary.

Some cameras provide their own noise reduction settings, but we recommend that you disable or minimize them if you intend to edit the images on your computer. In-camera noise reduction discards image detail; it's much better to capture as much detail as possible and then reduce noise yourself, if necessary, later. To get the best results,

- Turn off (or minimize) in-camera noise reduction.
- Turn off (or minimize) in-camera image sharpening.
- Use a flash in low-light situations. More light means less noise.
- Avoid saving in JPEG format. JPEG compression tends to create noise. Instead, shoot RAW or TIFF.

Both Photoshop and Photoshop Elements contain built-in noise reduction filters that you can apply to an image as a whole or to one or more selections within the image. Choose Filters, then Noise, and then Reduce Noise from the menu. Photoshop also lets you reduce noise in individual color channels, providing even greater control.

Our favorite tool for reducing noise is the Dfine plug-in from nik Multimedia, Inc. It works with both Photoshop and Photoshop Elements. Dfine supports downloadable profiles for specific cameras, control over both luminance and chrominance noise, and great algorithms for removing artifacts created by JPEG compression. The Dfine Selective palette offers time-saving tools that allow you to "paint" content-specific noise reduction onto an image, with predefined controls for skin, sky, shadows, hair, and so on. We highly recommend adding this tool to your image-editing arsenal.

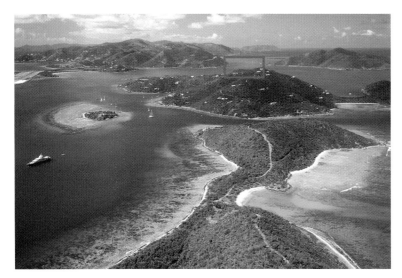

FIGURE 10-13
Original image (detail area highlighted). The blue channel is more prone to noise than other channels. Keep a close eye on it.

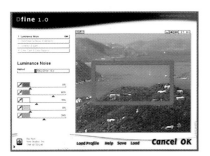

FIGURE 10-14 Dfine 1.0 adjustments. To hold detail in the mountains and houses in Figure 10-14, we've used the eyedroppers to sample green, white, and tan. Those colors have noise reduction set low (0%–18%). We've also sampled two blue values (sky and water) and applied much more noise reduction to those colors. Figure 10-15 shows the before-and-after results.

FIGURE 10-15 Composite view: Original (highlight) and noise reduction in blues (right)

Eliminating Banding in Prints

Consider the smooth color gradient typical of a daylight sky in Figure 10-16. Gradients like this give digital devices fits. Remember that a digital image is a collection of individual pixels, each with a discrete color value. When the values of adjacent pixels change too uniformly and abruptly, you begin to see visible boundaries, or *bands*, of color. The problem is caused by an image having insufficient color data to represent all the subtle colors in the gradient. It's worse when you're working in CMYK color space, but it can happen in RGB, too. Remember, CMYK devices have a smaller gamut than RGB devices, and this means that you have less color data to work with (Figure 10-17).

TIP
Keep a sharp eye out for banding in gradient fills when you convert from RGB to CMYK color.

You can reduce banding by boosting the color depth of the image (for example, from 8 bits to 16 bits), but only if the original image contained enough data to begin with.[4] Otherwise, you can add a bit of noise to the image to make the banding disappear.

As you saw in the preceding section, noise is just random image data. Usually noise is bad; but to remove banding, a little bit of randomness is just what we need.

FIGURE 10-16 A typical "sky" gradient (RGB)

4. Did you remember to shoot RAW?

FIGURE 10-17 Gradient converted to CMYK color, causing banding

FIGURE 10-18 The Add Noise dialog box (Photoshop)

In Figure 10-18, we add a small amount of noise by choosing Filter, then Noise, and then Add Noise from the menu in Photoshop. It doesn't take much—about 2 percent in this case. Figure 10-19 shows the results.

FIGURE 10-19 CMYK file with noise added to reduce banding

Adding Selective (Limited) Focus

Focus and blur direct the viewer's eye. Here's a Photoshop technique for adding selective focus to draw the viewer's eye to a particular point in the image.

FIGURE 10-20 Original image

1. Duplicate the image onto a new layer. This will make it easy to toggle back and forth between layers to view the effects of your changes.

2. Use the Lasso or other selection tools to select the area that you wish to be in focus. In the example in Figure 10-20, we selected the pipette and the red drop. We feathered the edges of the selection area around the drop to soften the focus gradient and create a halo effect and left the edges around the glass pipette nice and crisp.

3. Choose Select and then Save Selection from the menu. This creates an alpha channel in the Channels palette. Rename it something meaningful (Figure 10-21). This alpha channel serves as a mask that we'll use to control the lens blur effect.

FIGURE 10-21 The selection area, saved as an alpha channel named "Dropper"

4. Make sure the image layer is highlighted in the Layers palette, and then choose Filter, then Blur, and then Lens Blur. Adjust the settings in the Lens Blur dialog box as needed.

- Check Preview Faster to speed up preview rendering.

- Set Depth Map Source to the alpha channel that you created (i.e., "Dropper").

- Check Invert. Now Lens Blur affects everything *except* the Dropper mask.

- Adjust the remaining settings until the preview results are pleasing.

- Set Noise to 1 or 2. Adding a little noise helps the blurring. If you are working in 16-bit mode, you won't need much noise. If you are working in 8-bit mode, you may need a little more.

5. Click OK. Do you see how applying selective focus draws your eye straight to the part of the image that is in sharp focus (Figure 10-22)?

FIGURE 10-22 Final image

Creating a Black and White Effect

There are several ways to convert color images to black and white. Not surprisingly, some produce better results than others. Here are our favorite techniques.

Quick and Dirty

The fastest way to create a black and white effect is to convert the image to Grayscale mode. This works in both Photoshop Elements and Photoshop, but the results tend to be flat (Figure 10-23). The conversion discards color data and sets each pixel to a gray level based on the original luminosity of the pixel.

FIGURE 10-23 Image produced by choosing Image, then Mode, and then Grayscale from the menu (Photoshop)

More Refined

You can get better results with the Channel Mixer tool in Photoshop. Rather than discard color data, you can adjust the R, G, and B channels separately to get more pleasing results (Figure 10-24).

FIGURE 10-24 Image produced by choosing Image, then Adjustments, and then Channel Mixer

1. Select Gray in the Output Channel drop-down list. Then check Monochrome.

2. Adjust the Red, Green, and Blue sliders as needed to get a richer black and white image.

Third-party plug-in filters are also available and produce great results. Check out the black and white filters in nik Color Efex Pro 2.0 from nik Multimedia. We particularly like BW–Dynamic Contrast.

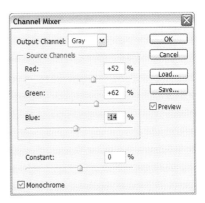

Replacing the Sky

Shooting outdoors puts you at the mercy of the elements. Scouting and planning the date and time of day can help, but if the sky is overcast when you're ready to shoot, what can you do? Here's a technique for replacing that dull sky with a much more interesting sky to liven up the shot.

FIGURE 10-25 Original image before correction

Figure 10-25 shows an architectural shot that's lit well, but the sky is flat, slightly hazy, and profoundly uninteresting. Let's apply an image of a blue sky with clouds using Photoshop to give the shot some pizzazz.

1. Use the Lasso tool to isolate the sky area at the upper right. Don't worry about following the contours of the building perfectly. Just make a rough outline that includes all of the sky.

2. Choose Select and then Color Range from the menu. In the Color Range dialog box, choose the left eyedropper, and then pick the upper-right (darkest) corner of the sky. Now choose the middle eyedropper and pick several lighter points in the sky. Watch the selection preview until the entire sky appears to be selected. Use the Fuzziness slider to adjust the sensitivity of the selection area. When the selection looks right, click OK.

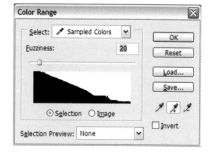

3. Choose Select, then Modify, and then Expand and expand the selection by 3 pixels. Choose Select and then Feather and set the feather radius to 2. This softens the selection so that you don't get an artificially hard boundary between the new sky and the roof line.

4. Choose Edit and then Cut to cut the selection, leaving a hole for the new sky.

5. Create a new layer beneath the layer containing the building.

6. Copy and paste a suitable new sky shot from another image into the lower layer. Choose a shot in which the perspective and angle of sunlight match the original shot (Figure 10-26).

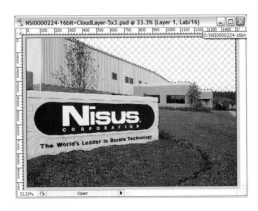

7. Save the results to a new file name.

FIGURE 10-26 Final image with new sky

TIP

Build up your own collection of stock images containing interesting skies. They will come in handy whenever you need to replace a flat or boring sky.

Summary

With enough patience, practice, and skill, it's possible to fix almost any problem in a digital image. That's no excuse for shooting bad shots, of course. You can save huge amounts of time and disk space just by shooting well.

The power and sophistication of today's image-editing tools may seem overwhelming. In this chapter, we have only scratched the surface of the changes that such tools make possible. And we hardly touched on issues of creativity.

But don't be discouraged. By taking small steps toward improvement, you'll soon be far ahead of where you began.

Optimize Your
Workflow

Work smarter, not harder. Sounds familiar, doesn't it? If only life were that simple. Every photographer has a workflow. You shoot; you edit; you print. Sounds simple enough. But there's more. You archive; you search; you reedit; you repurpose. Over time, things become more complicated. Your tools change. Your hard drive fills up. Your memory falters. Where was it you stored that shot of Grandpa and little Suzie sitting on the porch swing a couple of summers ago? What printer were you using when you spent so much time trying to get the holiday cards looking just right? Why does everything have to be so complicated?!

If you're like most of us, your workflow consists of random bursts of energy followed by forgetfulness and quiet desperation. In this section, we try to help you get better.

CHAPTER 11

Manage Your Assets

A sset management is like surfing. Life is good as long as you stay on top of the wave and in control of your board. But if you let your attention wander and the wave gets away from you—look out. You're soon drowning in a flood of images, and the waves just keep coming.

PROFOUND THOUGHT FOR THE DAY

The purpose of filing is not storage; it's retrieval. If you can't find it tomorrow, you might as well go ahead and throw it away today.

Need to locate a particular shot of the family standing at the edge of the Grand Canyon during last year's vacation? Chances are, it's buried somewhere inside one of dozens of folders on your computer's hard drive that look like Figure 11-1.

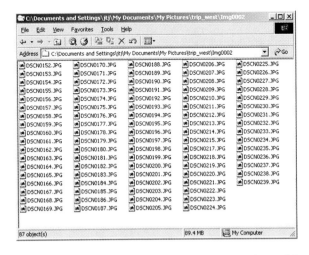

FIGURE 11-1 The asset management problem

You know it's in there somewhere, but which file is it? You can display thumbnails for the files, sure. But if you're looking through hundreds, even thousands, of files, a visual search is just too hard.

In this chapter we'll show you tools and techniques to fix this problem and transform your digital images from drive-killing data into truly useful assets. All you need are a few basic digital asset management (DAM) tools, and a little DAM discipline in using them.

Buying Good Media

Buying cheap media is like buying cheap film or cheap photofinishing. You've worked hard to take great shots. Don't risk spoiling them just to save a few dollars on storage.

Memory Cards

Memory cards are the heart of your camera. If a card fails, you're in big trouble. There's nothing more disheartening than seeing your camera or computer report "Card unavailable" and knowing that all those shots are suddenly irretrievable.

We've used all the name-brand memory cards on the market and have found considerable variation in quality. As we move over time to cards with larger capacity, this purchase decision becomes even more important. Based on our experience, we recommend Lexar media for its quality and reliability (Figure 11-2).

FIGURE 11-2 Lexar CompactFlash memory cards

Optical Disks

The quality, durability, and reliability of CD and DVD media vary widely, too. Buy from a name-brand company that handles its own manufacturing and quality control. This includes Fuji, Kodak, Maxell, Mitsui, Taiyo Yuden, TDK, and Verbatim, to name a few.

Avoid rebranded "store" disks, because there's no way to know who made them or how good they are.

The key to quality in optical disks lies in the reflective and photoreactive dye layers.

The reflective layer can be gold, silver, or a combination of both. Silver is the most reflective and was specified in the original disk standard. Gold, however, tends to be more stable over time because it is less reactive with dyes and therefore less prone to corrosion. Top-quality gold disks offer an archival life span of up to 300 years.

The photoreactive dye layer varies more between manufacturers than the reflective layer does. The official CD standard specifies TDK's Azo dye, which is dark blue. However, a number of other dyes have been developed, such as the lighter blue cyanine. Companies use these alternatives to avoid paying royalties and licensing fees to TDK.

Dye formulas are constantly changing, so we recommend using disks with a good gold reflective layer from a well-known company that has a good reputation for quality. The bottom line is to "go for the gold" and do your research. Don't be misled by tricky advertising slogans and bargain-basement pricing.

DISK CARE TIPS

Protect your disks from direct sunlight and temperature extremes. A jewel case that floats your disk in the air is better than a paper sleeve, which eventually can cause problems from direct contact. Note, too, that the surface that carries the label is far more delicate than the polycarbonate "bottom" surface. The data is actually written on the back of the label surface. If you write on the disk face with a marker pen, be aware that the ink can eventually seep through and corrupt the data!

Shooting and Archiving

If you're shooting and saving RAW images as we recommend, then you're giving yourself the most flexibility and creative control in the digital darkroom. But RAW files are big: A 5-megapixel camera uses more than 7MB of memory to store a single RAW image. That means a 256MB memory card will hold roughly 33 images, or about the same number of images as a 36-shot roll of film. The good news is that unlike film, memory cards are reusable, and they get faster and cheaper with each passing day. If you're headed out for a day trip and would normally expect to shoot a couple of rolls of film, a 512MB memory card for a 5-megapixel camera will be fine.

Get the fastest memory cards that you can afford, too. Read-write speed affects how long you wait while your camera saves an image to the card, and again when the image moves from the card to your computer. Faster is always better. As we write this, we use top-of-the-line 80X cards. If you're an average shooter, we recommend carrying at least 512MB cards with at least a 40X read-write speed.

FIGURE 11-3 You can never have too much storage!

Purchase enough memory cards to complete one full day of shooting, however many shots that may be (Figure 11-3). When the day is done, burn the files onto a good-quality CD-ROM or DVD-ROM before reformatting the cards for the next day's shooting.

You may be tempted to copy the files to your computer's hard drive and leave them there without going to the trouble of burning a CD. Resist that temptation. CDs and DVDs are cheap and durable. It's alarmingly easy to drag and drop image files onto a hard drive and accidentally overwrite existing data. If you do, it's gone. It's far better to carry enough memory cards to hold a full day's shoot and then burn disks at your leisure when the pressure to return to shooting has passed. There are also new portable CD-ROM and DVD burners that run on battery power and require no computer. They can burn directly from your memory cards in the field and are a great option.

Here's our suggested shoot-archive workflow:

1. Shoot until a memory card is full and then switch to a new card.

2. At the end of the day, transfer images to your computer (preferably onto a mirrored drive). Then burn the images to a CD-ROM or DVD data disk, depending on storage requirements.

3. After burning the disks, delete images from the memory card(s) when you need them for fresh shooting. If you have sufficient memory cards, it's a good idea to leave the images on the cards as one more level of backup until you need the card again. You never know when disaster may strike, and too many backups are better than too few. When you are ready to clean a card for reuse, we recommend reformatting the cards using your camera's built-in reformatting command. This is the best way to ensure clean and complete byte rewriting.

Dual-Format Images

Some cameras, such as the Canon 20D, can save images in both RAW and JPEG format simultaneously. The RAW image is for editing; the JPEG is for low-resolution applications such as contact sheet thumbnails and Web page use. If your camera offers this feature, take advantage of it. It can save a lot of time that you would otherwise spend creating JPEGs yourself.

When Disaster Strikes

You've just discovered that your hard drive has failed, and you've deleted the images from the camera memory cards. If you don't have a CD or DVD backup, what can you do to recover your images from a failed hard drive? All is not lost. To be honest, two 160GB drives full of images failed on us as we were writing this book. We shipped the failed drives to Vioplex Inc, (www.vioplex.com). Vioplex is a leader in data recovery and business continuity services. They have performed thousands of successful data recovery operations on all sorts of media: failed hard drives like ours, RAID disk arrays, flash memory and all tape formats. They also offer some innovative data storage services with advanced compression and encryption technologies to keep your data safe and secure. We can testify that their customer service rocks.

Adopting a Naming Scheme

The first step down the asset management path is to organize your images in a meaningful folder hierarchy and to name each image in a way that conveys useful information. Even if you do nothing else, this will help a lot.

Your camera applies a default name to each image when it stores the image on the memory card. This naming varies by manufacturer but likely includes at least a couple of letters followed by a string of numbers that increment by 1 for each subsequent shot.[1] On a PC, the file name also includes a three-character *extension* that identifies the file type (.jpg, .tif, .nef, etc.). Whether or not that extension is visible to you depends on how your computer is configured to display file names, but it's there nonetheless.

When you copy image files from a memory card to your computer, copy them into the appropriate folder and rename them immediately. Applications like Photoshop Elements and Extensis Portfolio allow you to rename the files automatically as you copy them and place them in the new folder. This capability is typical of image cataloging tools. Use it!

FIGURE 11-4 Image import (Photoshop Elements)

In Figure 11-4, we've created a folder whose name is the date and time that we imported the images. You may prefer to name the folder based on the content of the images instead. As you'll see in a moment, Photoshop Elements offers several easy ways to organize and search images by date, so using the date in the folder name may be redundant. It all depends on how you choose to organize your files and folders.

The file-naming scheme that we use begins with the photographer's initials to identify who took the shot, followed by -d (for *digital photo*) or -s (for *scan*), followed by a sequential number, ending with an extension that identifies the image file format.

In Figure 11-5, we are using a different tool to create an image catalog. Extensis Portfolio remembers image sequence numbers from session to session so that you always have

1. Many cameras let you set them up to increment image numbers continuously across shooting sessions and multiple memory cards. Check your manual for this feature.

unique numbers. It also watches folders to see when new files appear and catalogs them automatically and performs a host of other cataloging tasks like adding pertinent keywords. More on this in a moment.

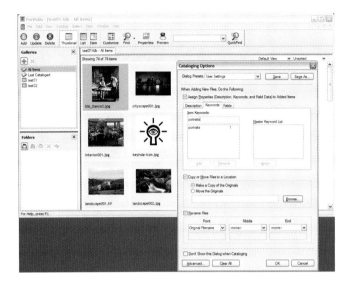

FIGURE 11-5 Image import (Extensis Portfolio)

Of course, assigning meaningful file and folder names is only the beginning . . .

Keywording Your Images

Assigning keywords that describe an image is the most important asset management step you can take. It can also be the most tedious and time-consuming in some applications. Fortunately, software vendors have been investing considerable effort in making the process easier, with encouraging results.

You assign keywords to images now so that you can search for them later. Your goal is to describe, as succinctly as possible, the subject matter of the shot. Keywords may be obvious, such as the name of the person in a portrait or the location of an outside shot. Keywords may be more generic: "blonde female age 36." Keywords may be abstract: "happy" or "loneliness." In all likelihood, the best keywords may be a combination of such terms. Don't be shy about assigning the most obvious keywords, and supplement them with increasingly arcane terms as time and energy allow.

Photoshop Elements has one of the best interfaces for keyword assignment and searching that we've found. You assign keywords to images using *tags*. You can create a hierarchy of tags, drag and drop them onto one or more images, and then filter a catalog to show images that you've marked with a combination of tags (Figures 11-6 and 11-7).

FIGURE 11-6 A catalog displaying all images (Photoshop Elements)

FIGURE 11-7 The catalog in Figure 11-6, this time showing only images tagged with the "Other shots" and "Screenshots" tags in the DigiPhoto Book tag set (Photoshop Elements)

Every asset management application that's worth considering lets you assign keywords to images and then search, although the user interface may vary (Figure 11-8).

FIGURE 11-8 Keyword search (Extensis Portfolio)

In Figure 11-8, we're about to begin a search for images that have the keyword *female*. You can combine several keywords to narrow the search.

Using EXIF and Other Image Metadata

Most digital cameras store several pieces of information about an image along with the actual pixel data. This *metadata* (or data about the data) is saved in the image file and can be extremely useful for asset management.

There are several image metadata standards. The most common are the Exchangeable Image File Format (EXIF) and International Press Telecommunications Council (IPTC) standards.

EXIF
The EXIF metadata tags record a wide range of information about an image, including these:

- Date and time when the image was captured

- Camera settings: camera model and make, camera orientation, aperture, shutter speed, focal length, metering mode, ISO speed, and so on

- Location data provided by a global positioning system (GPS) receiver

- Text descriptions and copyright information

IPTC
IPTC data fields are designed to store information useful to news organizations, including contact information about the photographer, copyright and description fields, headline and story details, and so on. Many high-end cameras allow you to preset much of this data in the camera so that it gets saved with each image. Lexar offers a line of memory cards that store IPTC data on the cards and apply the data automatically to all images written to the cards.

Using Metadata
If an image contains metadata, your image asset management tools can put it to good use.

For example, the date and time when an image was shot make it possible to create graphical, calendar-based views of your image catalog (Figures 11-9 and 11-10). If you're looking for an image from your vacation in August, then date-based sorting can identify the relevant images quickly and easily. Figure 11-11 shows how Photoshop Elements uses the date information to create a time line at the top of the Photo Browser view.

You can also use the metadata to construct more complex searches and catalog filtering. For example, if the EXIF data includes GPS coordinates, you might search for all shots taken at a specific location.

FIGURE 11-9 Using EXIF date information, Year view (Photoshop Elements)

Dates containing shots are high-lighted in the calendar.

FIGURE 11-10 Using EXIF date information, Month view (Photoshop Elements)

Dates containing shots are still highlighted but now contain thumbnails of the day's first image. You can use the controls above and below the preview box to scroll through the day's shots.

FIGURE 11-11 Using EXIF date information, time line in Photo Browser view (Photoshop Elements)

The time line provides visual clues about how many shots were made each month. Dragging the Time Line indicator scrolls the thumbnail view to that month.

Protecting Your Images

It's ridiculously easy to copy digital images. If you're the copier, the ease of making copies represents one of the greatest benefits of the digital age. If you're the one whose work is being copied, the blessing is more bittersweet. But it's a fact of digital life.

If you want other people to see your digital images, you should expect that those images will be copied at one time or another. It's as simple as that. The issue is not how to prevent copying; rather, it's to explore how much you care about the copying and what steps you are prepared to take in response.

If you are not selling the image (and thus are not losing any money when the image is copied), then you may not care at all—and that's great. For the vast majority of images floating around in cyberspace, the more sharing, the better. Still, we recommend including your name and a copyright notice in the comments attached to the image as a matter of principle, so that the image can be attributed to you as its creator. Your asset management product should embed such information in the image file for you automatically.

If your images have sufficient monetary or artistic value, you may also want to *watermark* them to alert viewers that they belong to you (Figure 11-12). This makes it harder (though still not impossible) for someone to use your image without your permission. A watermark alters the pixels in the image so that a semitransparent mark is visible (typically a graphical logo or text message). Because the watermark appears as part of the image's pixel data, it's difficult to remove and thus offers some visible protection.

We offer a free *action* (or prerecorded macro) that automates the process of adding a watermark to an image with Photoshop. It's available for download at PhotoGain.com. Check the members' download area.

In addition to visible watermarking, there are several companies such as Digimarc Corporation that offer invisible (or *covert*) watermarking tools and usage tracking services that scan the Internet on your behalf to provide you with reports about illegal use of your images (Figure 11-13). Such technologies do not prevent illegal use, but they do help you pursue offenders if that's important to you.

FIGURE 11-12 A digital watermark from Noël Studios, Inc., protects this image.

FIGURE 11-13 An image by photographer Don McGowan, protected by Digimarc

Adding Audio Attachments

Does your camera record audio? Many do. If your camera can shoot brief video clips, then the microphone is there primarily to record sound with the video. But it can do more than that. If your camera records audio, you can use it to create audio attachments for images. Imagine the things that you might say as you shoot that could be invaluable later:

- "This shot shows, from left to right, Aunt Mary, Uncle Bill, their children Buffy and Sam, and the two puppies they just saved from the animal shelter."

- "This is a macro shot of a lichen-covered stone shot in the creek at Newfound Gap. Part of the nature workshop taught by Don McGowan. Focal distance: about four inches. I'm using my new tripod."

- "This is one of five similar items that I plan to sell via online auction. If I need to shoot the others, don't forget to use the same lighting and scrim setup."

Audio attachments can store all sorts of information that is unknown to the camera. And best of all, you can talk while you shoot. No need to worry about interrupting the creative process to write notes in a journal. And the data stays with the image, so it never gets lost.

TIP

If you rename image files during import and cataloging, be sure to make the same naming changes to the audio attachments so that you don't lose track of them.

Digital Asset Management Tools

Most digital cameras come with some sort of tool for managing your images. We recommend checking out the following products, which are currently best of breed for this important task.

- **Photoshop Elements (Adobe Systems, Inc.).** The Photo Organizer makes basic to intermediate asset management easy and painless. Makes simple tasks simple, and complex tasks possible. Limited support for automation and customization.

- **Photoshop CS Bridge (Adobe Systems, Inc.).** Greater automation for large batch cataloging than Photoshop Elements, but less intuitive for novice users.

- **Picassa (Google.com).** Sophisticated cataloging and simple image editing from a leader in Web innovation. The good news: It's a free download. The bad news: It doesn't run on a Mac (at least as we write this).

- **iMatch (Photools.com).** Great support for many camera RAW formats; powerful and feature-rich.

- **Portfolio (Extensis, Inc.).** Highly customizable and powerful for intermediate and advanced users. Great CD-ROM and Web publishing tools. Automated cataloging and assisted intelligent keywording. Excellent control of file importing and renaming. Free browser application for distributing your images to clients and friends on CD-ROM with automatic slide show launch. Runs on PCs and Macs.

- **Photo Mechanic (Lexar Media, Inc.).** Another great choice for photographers managing a high volume of images. Lots of automation, plus support for parallel operations to speed up your workflow (dual-processor computers, multicard card readers, etc.).

- **Cumulus (Canto Software, Inc.).** Targeted at professionals and organizations, with simplified tools for advanced amateurs and individuals.

Digital asset management tools are evolving rapidly. Who knows what the future may hold? For example, as we write this we're hearing talk of adding GPS capabilities to cameras so that location information can be stored in the image metadata automatically, just as time and date are stored today. You could search for shots by place as well as time.

The future is bright! Please visit PhotoGain.com for the latest reviews and user feedback.

Summary

The key to successful digital asset management is to adopt a basic set of good behaviors and then stick to them.

- Always use high-quality media throughout your workflow, from memory cards to hard drives to archival disks.

- Create a meaningful naming scheme for folders and files, and then use it.

- Promptly archive image files to high-quality nonvolatile media like CD-ROM or DVD data disk.

- Assign meaningful keywords faithfully.

- Take full advantage of the metadata capabilities of your camera and asset management software.

- Take reasonable steps to protect your images from unauthorized use.

- Use audio attachments (if available) to record additional information that the camera cannot store automatically. If you rename image files during import and cataloging, be sure to make the same naming changes to the audio attachments so that you don't lose track of them.

CHAPTER 12

Think Digitally

igital photography is not a craze, a phase, or a passing trend. It's a profound and fundamental realignment of the image-making enterprise (Figure 12-1). If you started taking pictures using digital techniques, you've been thinking digitally from the start (even if you didn't realize it). But if you've been shooting film and are making the switch to digital, your expectations and shooting habits may no longer be appropriate. It's time to adjust your thinking.

FIGURE 12-1 An art-quality digital print. Moab Entrada 190 bright white matte paper; MediaStreet G-Chrome ink; Illinois Watch Co. watch, circa 1905. Quality lasts!

A Personal Reflection (Rip Noël)

I've been shooting images for more than 30 years. I've won my fair share of awards as a professional photographer, have gotten to see the world, and have grown to be serious about creating great images. Here's a bit of my own experience in making the transition from conventional to digital photography.

Alessandro Volta must have felt a shock (of amazement and current!) when he put two metal wires in his mouth in 1800. What he felt was the world's first steady electrical discharge from the wet cell battery, or "voltaic pile," that he had invented. I felt a similar thrill 35 years ago as I crouched on the floor of the linen closet in my first makeshift darkroom and saw an image appear—as if by magic—in my developer tray. It's amazing to me that the forces behind these two events have merged in digital photography.

FIGURE 12-2 My first camera, shot with my current camera. (If you look closely, you can see my inverted reflection in the flash bulb reflector.)

We've talked a lot about technology throughout this book, and in many ways photography has always been a technology-driven art. Camera bodies, lenses, film, paper—from the earliest days, there have always been plenty of ways to get your hands dirty. The advent of digital imaging has done nothing to change the basic principles of great image making. You still need to light your shots well and pay attention to composition. You still need to focus on the main subject and tell a clear story. No matter how much technology improves, there will never be a replacement for the artist's eye and imagination.

But digital photography is also fundamentally different in many ways. How you deal with these differences can have a profound impact on your final results, not to mention the amount of fun you have. That's why it's important that you think digitally from now on.

You may be wondering whether digital photography really is better than film-based photography. Frankly, the answer is yes. Not, perhaps, in the earliest days of the technology. But as I write this, in mid-2005, the quality of digital photography has surpassed that of film-based photography.[1] In fact, digital imaging is actually driving the art of photography in new directions.

Always seek out the best tools and master them. Only then will you truly free yourself enough to reach your creative potential. The rapid pace of change in digital imaging makes it hard to keep up, I know. I feel the same pressures. But you must make a commitment to mastering your tools, whatever they may be. As you grow in mastery, you'll discover the creative power of digital photography that makes it all worthwhile.

"Quality" Shoot-out: Digital Versus Film

A lively debate has been raging for several years about which is better: digital or film. Like most debates that involve passion and opinion as well as facts, this one is not likely to stop any time soon.

There's no question that the quality of digital images, measured in technical terms by raw density of pixels per unit area, is constantly improving. Rapid advances in sensor and memory technologies create the same increasing performance and declining cost curves that have been typical of computers and most consumer electronics over the past few decades. Similar improvements in printing technologies are occurring, too.

Whatever the perceived quality gap may be between digital and film, that gap is closing rapidly. The only question really is, can the gap close completely? And will the quality improvement curves of digital and film ever cross?

In our opinion, the quality of digital images has surpassed that of film for all applications that matter to the majority of photographers—amateurs and professionals alike. Digital's clear advantages over film in areas other than raw pixel density make it even more of a winner. Those advantages include

- Immediate feedback
- Editability
- Asset management
- Archiving and storage
- Ease of transfer and reuse

Some audiophiles will always contend that they can hear a difference between digital and analog audio and that record albums will always sound better than optical disks. But for most listeners, the day has long passed when they were able truly to hear any difference.

The same is true for digital imaging. It's far more than "good enough" for the vast majority of users and uses.

1. Hart, John. *Resolution Issues in Scientific Photography: Resolution Tests Film, Nikon CP5000, Slide and XGA Projectors*, University of Colorado. http://www.crystalcanyons.net/Pages/TechNotes/FilmVsCP5000.shtm

Master Your Tools

Digital tools are powerful—in many ways, more powerful than the analog tools that they replace. But digital tools are not magical. They can make great shots fabulous, and mediocre shots pretty darn good. But they cannot make bad shots anything more than a little less bad—and sometimes, even that is asking too much.

We said it on the opening page, and we'll say it again in the closing chapter: The only way to create great work on a consistent basis is by mastering your tools. Digital cameras are complex instruments. Study your owner's manual carefully, and carry it with you into the field so that you can refresh your memory when necessary. There's no shame in referring to the manual. The shame is in shooting a bad picture because you misunderstood or misused the camera's controls.

Practice, practice, practice. Shoot a dozen shots of the same subject using different exposures, focal lengths, and lighting. Then delete the shots and shoot a dozen more. All you're spending is a bit of battery life; what you're gaining is comfort with the camera's controls. Your ultimate goal is to be able to operate the camera without thinking about it. Only then will you be free to start capturing great images. (See "Expanding Your Vision" on page 283 for more ideas.)

It doesn't stop with the camera. Computer programs like Photoshop have feature sets that are broad and deep. Invest in a good book, and take an online tutorial or a live class. Swap tips with other users. Whatever you do, learn to do it a little better each time. You're investing in your art by growing as an artist. It's worth it.

Data Longevity

Improvements in software tools make it possible to improve shots taken with earlier generations of digital cameras. You don't have to discard lower-resolution images from yesterday. And further technology advances will improve today's shots tomorrow. So please, be conservative about deleting images.

But you can fix old images only if you can open them. Guarding against data obsolescence is as important as guarding against data decay. Just think of all the data storage devices that have appeared on the scene, only to fade quickly from popularity, making the data stored on them inaccessible. Do you still have a system that will read floppy disks? How about the original 8-inch floppies that really were floppy?

RAW images are great, for example, and we encourage you to use them. But as we write this, every camera manufacturer's RAW format is proprietary and not publicly documented. This means that the formats can change at the manufacturers' pleasure, and your old RAW files may become unsupported.

Adobe's DNG file format is an attempt at RAW unification and standardization. But that format, too, is under the control of a single corporation. An open-source movement called OpenRAW has emerged to bring RAW formats out into the open and protect their longevity. We endorse this effort and encourage you to do so, too.

The OpenRAW Web site states,

> The goal of OpenRAW is to encourage image preservation and give creative choice of how images are processed to the creators of the images. To this end, we advocate open documentation of information about how the raw data is stored and the camera settings selected by the photographer.

> If the current practice of hiding data and dropping support for older models of cameras continue countless images will be unreadable with no software to decode them. Only openly documented RAW formats will make it possible to decode RAW files in the future.

Visit http://www.openRAW.org for more information.

There's No Free Lunch: Get the Exposure Right

One of the biggest differences between film and digital photography relates to your approach to exposure. Although you can recover from modest exposure miscalculations, you can do only so much. If you're used to compensating for exposure problems on film, you'll need to rethink your assumptions in the digital realm.

We have repeatedly encouraged you to "shoot RAW." Indeed, the RAW format does allow for some fairly wide exposure control when you edit your images on the computer. But there is no free lunch.

Don't Overexpose

Beware: You cannot "fix" a digital photograph that is overexposed. With film, overexposure can be a process of gradual degradation that you can sometimes correct by altering the film processing. But with digital imaging, overexposure means that there simply is no data to work with in the overexposed region. You cannot fix what isn't there.

As a digital shooter, you will quickly learn that the histogram on your camera is your friend—a friend you should get to know very well. Once you are able to interpret your histograms, you are well on your way to good digital exposures (page 127).

FIGURE 12-3 Histogram showing proper exposure

The histogram in Figure 12-3 shows a good distribution of values throughout the exposure range. There is some data clipping in the highlights (far right edge of histogram). That means we're losing detail in the white lab coats. But that's not a problem for this shot.

FIGURE 12-4 Histogram showing overexposure

The histogram in Figure 12-4 also shows data loss in the whites. In this shot, the biomedical engineer at left is holding a bone in his hands. *We don't want to lose detail in that important object.* The histogram provides a warning that the exposure is incorrect.

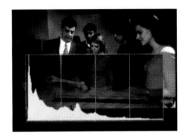

FIGURE 12-5 Histogram showing exposure correction

In Figure 12-5, we have reduced the exposure by half an f-stop. The histogram now shows no clipping in the highlights. We can be confident that we have good detail in the white bone that is critical for the shot.

Remember, data lost to overexposure is lost for good. Even though the exposure in Figure 12-5 appears dark when we view it in the camera's monitor, the histogram reassures us that there's plenty of data in the image. Because we're shooting a 16-bit RAW file, we will have lots of latitude to adjust the midtone range with our image-editing program for best results. And we'll still be able to hold all the detail we need in the highlight areas.

Beware of Excessive Underexposure

When a shot is very underexposed, it presents a different set of problems. You can often boost the exposure values during postprocessing, but this causes excessive noise in the shadows and loss of shadow detail. You'll want to apply noise reduction filters to the shadow areas to improve the final results.

But it's best to get the exposure right to begin with. Remember, the histogram is your friend!

Digital Versus Film: The Good News

Digital photography offers many dramatic advantages over film. We think the following are most significant.

- **Instant feedback.** It's much easier to know immediately whether or not a shot is what you had in mind. No more waiting for days or weeks to get film processed, only to discover that you missed the shot. However, don't be too hasty with the Delete button (see page 278)!

- **Power and control.** Processing film takes so much expensive equipment, technical expertise, and time that most photographers simply could not or would not do it themselves, especially when photography moved from black and white to color. Digital has changed that completely. Today's cameras, image-editing software, and printers give even the most casual photographer profound power and creative control. Just be sure there's image data in the file to work with (see page 272).

- **Task automation.** Many routine, repetitive tasks can be automated to save time and effort. Programs like Photoshop offer scripting languages and macro capabilities that you can use to do all sorts of useful tasks on many files with minimal effort. Consider the Photoshop *action* (or macro) at right. It implements the repetitive steps of our step method for upsizing an image (page 238). Why do these tasks manually with dozens of tedious clicks, when you can do the entire job with a single click? You can download scripts from Web sites like PhotoGain.com to get started with common tasks. Later, you can write your own scripts to automate tasks that meet your own unique requirements.

- **Archival-quality prints.** It is now possible to create art-quality prints that will last up to 100 years yourself, provided you purchase the correct inks and papers. For archival paper, we recommend that you consider the wide variety of matte and glossy papers from Moab Paper Co. (www.moabpaper.com). Then visit MediaStreet (www.mediastreet.com) and consider its G-Chrome pigmented inks and the Niagara Continuous Ink Flow System for high-volume ink-jet printing (Figure 12-6). You'll get outstanding results and lower your ink costs at the same time. Visit PhotoGain.com for more product reviews

and tutorials on archival-quality printing. And don't forget that it's important to profile your printer, too (Chapter 7).

- **Ease of sharing and duplication.** Web publishing, e-mail, camera phones, and other innovations make it easy and quick to share your shots with the world. No more waiting for days or weeks to share prints and slides. The gratification is global and virtually instantaneous.

FIGURE 12-6 The Niagra II Continuous Ink Flow System installed on an Epson Stylus Photo 2220 ink-jet printer

Digital Versus Film: The Bad News

There is no free lunch, of course. Digital photography has its downsides, too.

- Because there's no effective "cost" for taking a digital shot, the tendency is not to think before shooting. But it's more important than ever to consider what you're trying to accomplish with a shot. Is there visual tension? Are you telling a story? What's your artistic intent? When you were paying for film, processing, and paper, you tended to be more deliberate when taking a shot. Don't lose that now.

- "Am I a photographer, or a computer geek?" We've heard some photographers lament that they spend more time in front of their computers than behind their cameras shooting. That's really a question of personal work style. Compared with film photography, digital photography may require more time in post-production to achieve the results you seek. Film photographers have commercial processing labs that they have grown to trust. They hand off their film to the lab and keep on shooting.[2]

 But consider what the time spent in digital postproduction gives you: power and control—especially when you shoot RAW. That's why most digital photographers prefer to handle their own image optimizing. You gain enormous control over exposure, contrast, color balance, sharpening—the list is almost endless. Of course, exercising that control means spending the time required on the computer to "get it right." You need to know how to master issues like color management and digital workflow, in addition to the software and hardware. That is indeed a lot of stuff to master, in addition to knowing how to use your camera.

- Beware the lure of the Delete button on your camera and the Delete key on your keyboard. The monitor on your camera is tiny—too tiny to see clearly exactly what you've shot. You can get a general idea of whether or not your subject is in the frame, but fine details are invisible. We recommend that you *never* delete shots in-camera if you can avoid it. We can't count the number of times we've opened what we thought were worthless shots in Photoshop, only to discover gems. So don't delete until you see the whites of their eyes.

PROFOUND THOUGHT FOR THE DAY
"The camera is an instrument of detection. We photograph not only what we know, but also what we don't know." —Lisette Model

2. Of course, if you develop your own film and prints, the labor comparison is quite different.

- You must take care to avoid image overload. If you don't adopt good digital asset management behaviors and then stick to them, you'll quickly be overwhelmed by the sheer volume of data. Discipline is good for you (see Chapter 11). Pulling together the right toolset and establishing a good digital workflow from the start may well mean the difference between a modestly painful and an extremely enjoyable digital photography experience.

CCDs and Focal Length

Many high-end digital camera bodies have the same lens mounts as their film camera counterparts. This allows photographers who have substantial investments in lenses for film cameras to use those same lenses on their digital cameras. If you are using your film camera lenses with your digital camera body, be aware of the *focal-length multiplier effect* (Figure 12-7).

The physical dimensions of CCD sensors in consumer and "prosumer" digital cameras are typically smaller than a frame of 35mm film. A smaller CCD capturing the light from a lens effectively crops the image, and this causes the apparent focal length of that lens to increase compared with that of a film camera.

The amount of the increase varies, depending on the size of the CCD in the camera (Figure 12-8). In general, you'll find that your film camera lenses are now 1.5 to 2.5 times as "long" as they used to be (see Table 12-1). For example, a 50mm lens mounted on a Nikon D-series digital body creates an image that you'd get using a 75mm lens on a Nikon film body.

This focal-length multiplier effect is typically good news, because it's nice to have what amounts to longer telephoto lenses with no reduction in aperture or speed. But it can be an issue at the low end of the focal length spectrum. If you like to shoot very wide (for example, 24mm landscapes), your first digital lens purchase will probably be a new wider-angle lens, because your existing wide-angle lenses will be less wide when mounted on a digital body.

FIGURE 12-7 This CCD sensor measures 23.7mm x 15.6mm, compared with a 36mm x 24mm frame of film. This results in a focal-length multiplier of 1.5.

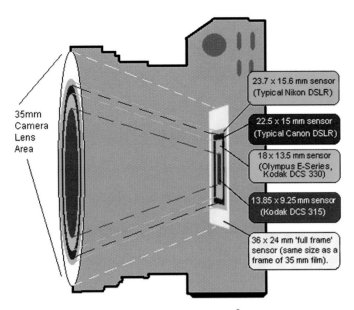

FIGURE 12-8 Various CCDs versus a frame of film[3]

TABLE 12-1 Focal-Length Multipliers for Various CCDs

Camera Type	Sensor Size	Horizontal View Multiplier Factor (Rounded Off)	Physical Area (mm²) of Sensor Compared to a Full Frame
Kodak Pro 14n, SLR/n, SLR/c, Canon 1Ds and 1Ds Mk II, 35mm film camera	36mm x 24mm	N/A (full frame)	100%
Nikon D1, D1H, D1X, D2H, D2X, D100, D70	23.7mm x 15.6mm	1.5	42.8%
Canon D30, D60, 10D, 20D, Kodak DCS 5xx, 6xx, 7xx	22.5mm x 15mm	1.6	39.1%
Olympus E1, E-300, Kodak DCS 330	18mm x 13.5mm	2.0	28.1%
Kodak DCS 315	13.85mm x 9.25mm	2.6	14.8%

3. Illustration and table courtesy of John Cowley, www.lonestardigital.com

Winning the Digital Rat Race

To stay competitive, professional photographers must constantly upgrade their gear and software. You may not be running that same race—but you're competing with yourself to be the best photographer that you can be. Owning—and knowing how to use—the correct gear is critical (Figure 12-9).[4]

We like to envision the "race" more in terms of a marathon than a treadmill. A marathon, although grueling, offers the allure of constantly changing scenery and the company of other runners. Who knows what wonders lie just over the next rise or around the next bend in the road? The key is to enjoy the run.

FIGURE 12-9 Tools evolve rapidly—just like your skills. Be prepared to upgrade and retool as technology improves.

If you're in the race for the long haul, join us at PhotoGain.com. This online community, produced by photographers for photographers, offers a wealth of learning and sharing opportunities. We hope you'll take a few minutes to check it out and join in the fun.

4. Our digital gear bags in Appendix A provide a glimpse of the tools that we carry ourselves.

Expanding Your Vision

When you're shooting film, you're consuming film. That costs money—for the film and for the processing to see what you shot. But when you're shooting digital shots and viewing them on a computer, there is no cost for consumables. That means there's no longer a cost barrier to creative exploration. No more excuses. It's time to find out how great a photographer you can be.

Here are some suggestions for stimulating your creativity and expanding your vision.

- "I just don't know what to shoot." It's a common lament. Try this: Search your feelings. What mood are you in? Sleepy? Hungry? Bored? Happy? Pick the strongest emotion that you're experiencing right now and write it down. Now find objects around the house that you can arrange to illustrate that feeling in some way and shoot them. Shoot them again with different light. Shoot them again from a different angle. Then save your shots and play them as a slide show on your computer a couple of days later, when your mood has changed. Do your shots tell the emotional story effectively? Why or why not?

- Pick one of the fundamental design elements that we covered in Chapter 2 (light, line, shape, form, pattern, texture, and color), and then compose and shoot specifically for that element. See how many subjects you can find that illustrate that element. Repeat the "visual push-ups" with other elements, and then with combinations of elements.

- After you've spent time composing a shot, shoot the subject at least once more using some variation that you would not normally consider. Vary the exposure. Change the focus or composition. Get vertical. Kneel or lie down. Whatever you choose, push your own limits.

- Keep up with what others are doing, creatively and artistically—not so that you can copy them, but so that you can learn from them.

TIP

After you've mastered your tools and techniques, don't be afraid to break the rules.

It's Your Turn

Digital photography encourages a new way of shooting, a new way of seeing, and a new way of thinking.

The fundamentals have not changed, it's true. Lighting, exposure, composition, and storytelling remain critical. And you must still master your tools if you hope to grow beyond being a rank amateur and really set your artistic talents free.

But new technologies invite new techniques . . . and new-found creative power. Never before have so many innovations been within the reach of so many people. You don't have to be rich, or a genius, or a prodigy to produce truly wonderful art. And we mean "wonderful" in the broadest sense: images that create a sense of awe and wonder.

There has never been a more exciting time to be a photographer. Digital photography offers truly unlimited creative potential to those who are ready for greatness.

Spring into it!

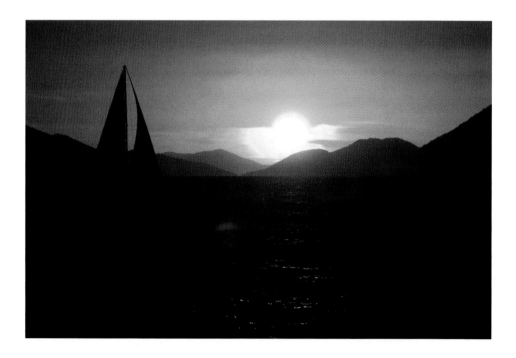

 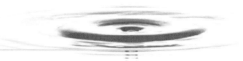
Digital Gear Bags

D igital gear can seem overwhelming. Cameras, lights, computers, software, printers, scanners, accessories, inks, batteries, filters, cables . . . how do you make sense of it all? What really works when you're down in the trenches and out in the field?

We present our own "digital gear bags" for your consideration as one way to confront the chaos. Although our gear probably won't fit your needs exactly, it works well for us and should give you a good place to start in considering your own requirements.

These gear bags are both literal and figurative. In addition to the bags, cameras, lenses, lights, and accessories that we carry to a shoot, we list the computer hardware and software that we use to produce finished images.

Joe is a writer first and a photographer second. He's been shooting digitally for about five years for personal pleasure. His "serious amateur" gear bag is where we think most readers will want to start.

Rip is a professional photographer and videographer. Not surprisingly, his "pro" gear bag is quite different from Joe's. In fact, its scope is huge. His "gear bag" includes, for instance, a 25-foot dual-axle trailer for transporting gear to location shoots! We offer it as one illustration of why professional-level shots look the way they do. Very few people will ever need (or even want) all this gear. However, most will need, and want, some of it. We show you all of it to stimulate your imagination and let you know what's possible.

Creative growth is important. Consequently, we offer three potential growth paths to help you plan purchases wisely as you improve your skills and talent and upgrade your gear over time. These growth paths reflect three areas of photographic interest: people and portraits, nature and landscape, and editorial and action. No one can afford everything all at once, so we suggest some ways to make smart purchasing decisions by considering the question, "What should I buy next?" The answers vary, depending on the type of subjects that you like to photograph.

Serious Amateur Gear Bag

Camera System

- Camera: Nikon CoolPix 5700 with 5MP CCD and 8X optical zoom (Figure A-1)

- Batteries: (2) Lithium ion camera batteries and AC charger; Powerex POWERBank external Li-ion battery pack with AC and DC chargers for extended shooting sessions

- Memory: (2) Lexar 1GB 80X CompactFlash

- Filters: Tiffen Sky 1-A UV haze; Circular Polarizer; Soft/FX 2 soft focus; 52mm snap-on thread adapter (Figure A-2); LowePro filter case

- White balance card (included with this book)

- Camera user guide

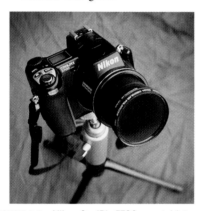

FIGURE A-1 Nikon CoolPix 5700 on a tabletop tripod

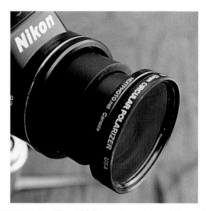

FIGURE A-2 The 5700 lens barrel is not threaded for filters; a snap-on thread adapter solves the problem.

Lighting

- Vivitar 285HV strobe unit

- Chimera Mini Bank and Maxi Bank (Silver) softboxes (Figure A-3)

- 2-ft. × 3-ft. white fill card (cardboard or foam core)

FIGURE A-3 (LEFT) Mini Bank & (RIGHT) Maxi Bank softboxes for handheld flash units

Grip and Support

- LowePro Omni Traveller equipment bag, and LowePro Traveller Extreme hard case for waterproof impact protection in the field (Figures A-4 and A-5)

- Tripod, tabletop tripod

- Super clamps, alligator clips

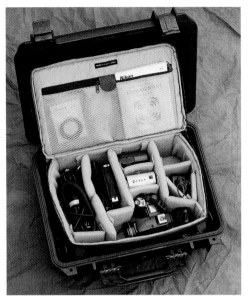

FIGURE A-4 Serious amateur gear bag. LowePro Omni Traveller bag inside a Traveller Extreme waterproof shell.

FIGURE A-5 A front panel gives fast access to the camera without the need to open the entire bag.

Computer Hardware and Software

- Dell Inspiron 5150 laptop, 1GB RAM, 60GB hard drive, DVD-ROM/CD-RW, multiformat USB card reader, Windows XP Pro

- Adobe Photoshop; Adobe Photoshop Elements; nik Dfine with Nikon CP5700 profile; nik Color Efex Pro

- Extensis Portfolio

- MonacoOptix color management and Monaco OptixXR monitor colorimeter

- Nero Burning ROM 6

- Canon PIXMA iP6000 ink-jet printer

Pro Gear Bag: Camera and Containers

Camera System

- Camera: Nikon D100 with 6MP CCD (Figure A-6)

- Lenses: Nikon 50mm f/1.8, 180mm f/2.8; 12–24mm f/4, 85mm f/1.8; 105mm f/4 macro; 24mm f/2.8 (Figure A-7)

- Batteries: Nikon multifunction battery pack MB-D100

- Memory: (5) Lexar 4GB 80X CompactFlash; (1) Lexar 512MB 40X CompactFlash

- Tiffen Filters: Pro-Mist 2; Black Pro-Mist 3; Circular Polarizer; 2-stop neutral density; Low Contrast 3; Ultra Contrast 2; graduated neutral density; No. 87 (infrared); step-up rings; LowePro filter case (Figure A-8)

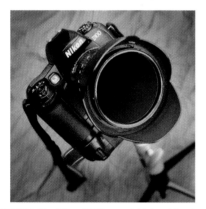

FIGURE A-6 Nikon D100 on a tabletop tripod; 12–24mm zoom lens

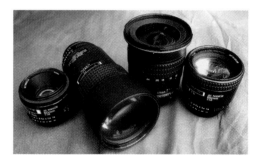

FIGURE A-7 (L to R) Nikon 50mm f/1.8, 180mm f/2.8; 12–24mm f/4, 85mm f/1.8

FIGURE A-8 Filters and filter case

FIGURE A-9 A camera level plugs in to the hot shoe to provide precise leveling.

- Camera level (Figure A-9); great when you're shooting panoramas that will be stitched together later

- White balance card (included with this book)

- Camera user guide

Containers

- 25-ft. grip trailer. Transports gear and serves as an on-location production studio.

- Bags: LowePro Road Runner AW (Figure A-10). Excellent for travelling to a location and setting up. Offers a tow handle and wheels, plus a full-suspension backpack harness. LowePro Commercial AW shoulder bag (Figure A-11). Great for working journalistically, on the go, straight from the bag. In addition to the shoulder strap, the bag includes a hip strap to distribute the weight and control movement. Both bags meet airline regulations for carry-on luggage.

- Lighting containers (shown in Figure A-12)

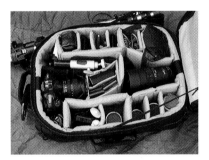 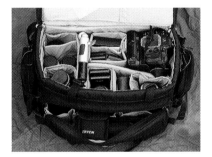

FIGURE A-10 LowePro Road Runner AW wheeled backpack bag

FIGURE A-11 LowePro Commercial AW shoulder bag

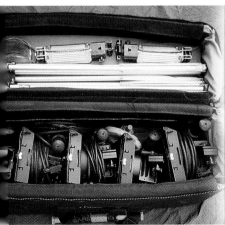 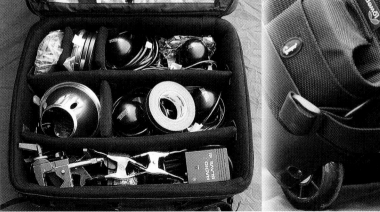

FIGURE A-12 (L) Rhino bag with Lowel lights and stands. (C) LowePro Pro Roller 3 with AlienBees strobes, grid spots, slaves. (R) Wheels and tow handle make traveling easy.

Pro Gear Bag: Strobe and Constant Lights

Strobe Lights

- Vivitar 285HV strobes. Good for journalistic and editorial shooting.

- AlienBees B400 and B800 units (Figure A-13). Good for light to heavy commercial shooting. Continuously variable output and built-in light slaves; can run on battery power.

- Norman 800 and 2000D strobe packs with LH2000 heads. Good for lighting large venues like basketball arenas.

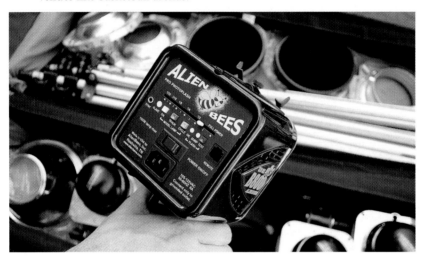

FIGURE A-13 AlienBees B800 strobe

Constant Lights

- Lowel Rifa-Lite (Figure A-14). Good for soft on-camera fill.

- Lowel L-Lights and Pro-Lights. Small and easy to position in tight spaces.

- Lowel DP lights (1,000 watt). Workhorse lights for a variety of applications. You can place up to four units in some high-heat softboxes (Figure A-15).

- Lowel Tota Lights (100–500 watts). Good for backlight, hair light, and room fill where more punch is needed than L-Lights and Pro-Lights provide.

- Strand 5K (5,000 watts with Fresnel lens). High-powered and focusable. When used with a compatible softbox, provides a good main light for large subjects. Can also be used as a fill light outdoors under some conditions.

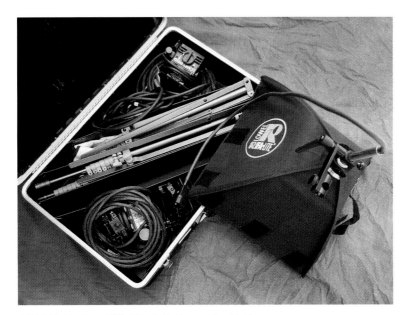

FIGURE A-14 Lowel Rifa-Lite, L-Lights, and Pro-Lights

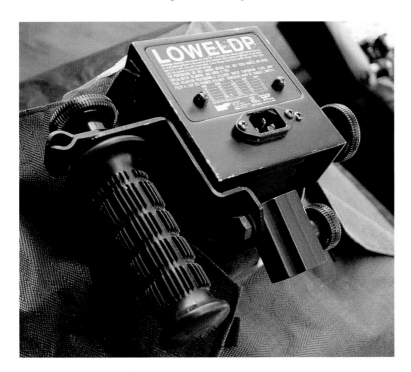

FIGURE A-15 Lowel DP light mounted in a softbox

Pro Gear Bag: Lighting Modifiers

Chimera Softboxes
- Mini Bank (Silver) for on-camera or handheld flash units

- For use with strobes: Super Pro Plus (small), Super Pro Plus (medium), Super Pro Plus Strip (medium), Octaplus 5-ft. diameter with 7-ft. extension (Figure A-16)

- For use with constant or high-heat lights: Video Pro Plus (medium), Video Pro Plus Strip, (medium), Quartz Plus (Figure A-16)

- (See Figure A-18 for a clever softbox accessory.)

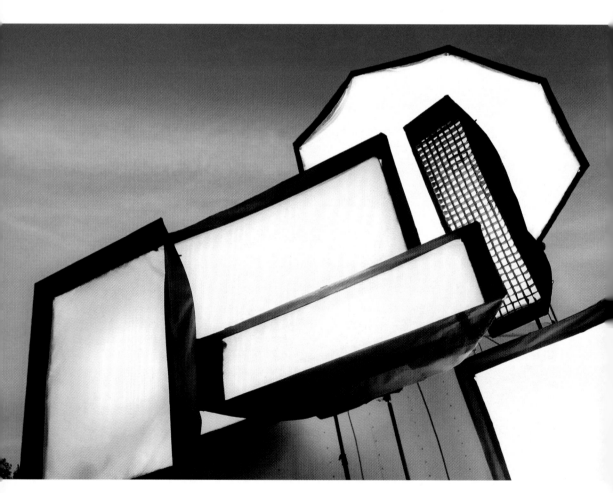

FIGURE A-16 (Left) Video Pro softboxes lit with high-heat tungsten (warm) lights. (Right) Super Pro Plus softboxes lit with daylight strobes.

Other Modifiers

- Grid spots for strobes to narrow the light's "throw" (Figure A-17)

- Barn doors for softboxes and DPs to control and shape light output

- 40-degree fabric egg crate grids for softboxes to narrow the light's "throw"

- Chimera Pro Panel ("gobo") lighting kit to create light patterns on surfaces and backgrounds such as dappled light, clouds, and so on.

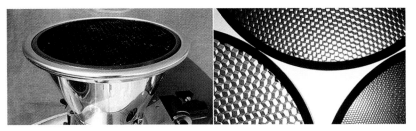

FIGURE A-17 Grid spot mounted in reflector on AlienBees strobe

Lighting Accessories

- 7-ft. × 10-ft. and 20-ft. × 20-ft. lighting scrims

- Flexi-fill cards: gold/white, silver/white in small, medium, and large sizes. Good for reflecting light to provide soft fill.

- Light meter: Minolta Flash Meter III

- Remote radio slaves and remote light slaves

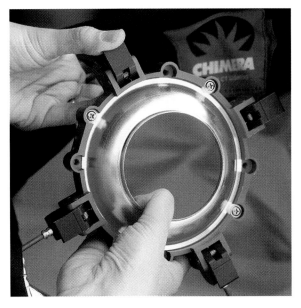

FIGURE A-18 The small things in life can make a big difference. Chimera's softbox quick-release speed ring makes setup and teardown quick and easy. You can get a lot more shooting done in a day when mundane tasks like swapping softboxes between lights are streamlined by clever accessories.

Pro Gear Bag: Grip and Support

- A variety of tripods with ball heads and quick-release camera mounts (Figure A-19)

- Tabletop tripod

- Video monitor and cables. Good for reviewing shots with clients on location. It's also a good way to lure groupies and hangers-on into another room so that you can get your shooting work done.

- CCD cleaning kit (Figure A-20)

FIGURE A-19 Tripod with ball head; tabletop tripod

FIGURE A-20 CCD cleaning kit

- C-stands of varying heights to support lights and softboxes; boom stands; high-roller stand for hanging large lights and scrims.

- Super clamps and alligator clips (Figure A-21); grip tape; Vise-Grips; tool bag with common hand tools; gloves for handling hot lights; steel-toed boots (no joke!)

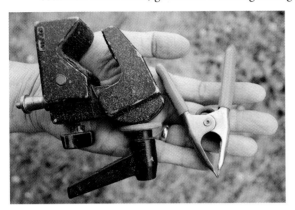

FIGURE A-21 Super clamps and alligator clips are invaluable for attaching objects to stands and serving as an extra pair of hands.

- Model release forms (Figure A-22). You must get model releases from people who appear in any shot other than journalistic shots taken in a public place. Carry spare forms in your bag! The Advertising Photographers of America (APA) and American Society of Magazine Photographers (ASMP) are great resources for learning more about doing business as a professional photographer.

FIGURE A-22 Model release forms

Pro Gear Bag: Computer Hardware and Software

- Custom-built, on-location computer (Figure A-23). AMD 64-bit dual processors; 4GB RAM; 400GB mirrored hard drive space (expandable to 2 terabytes of internal mirrored storage); Firewire and USB2 ports for fast file transfer; dual-layer DVD burner; USB card reader; ganged Firewire CompactFlash card readers; Windows XP Pro

- Adobe Photoshop; nik Dfine with Nikon D100 profile; nik Color Efex Pro; Extensis Mask Pro and PhotoFrame

- Extensis Portfolio

- Complete color management workflow with custom profiles for all devices produced by Monaco Profiler and Monaco OptixXR monitor colorimeter. Additional printer control provided by Colorburst RIP.

- Monaco GamutWorks color management utility for graphing and evaluating ICC-compliant profiles

- X-Rite DTP41 autoscanning spectrophotometer for scanning printer output targets

- Nikon Super CoolScan 8000 transparency scanner

- Microtek ScanMaker 8700 flatbed scanner

- Epson StylusPHOTO 2200 ink-jet printer

- Niagra II Continuous Ink Flow System with Generations G-Chrome archival inks

- Moab papers: Entrada Fine Art, Kokopelli Photo Gloss, Kayenta Photo Matte

- MediaStreet Fine Art Series papers: G-Chrome Gloss, Photo Matte

- Nero Burning ROM 6

 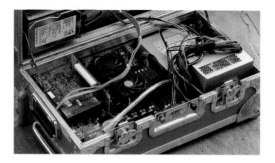

FIGURE A-23 Custom-built, on-location computer

Growth Path 1: Portraits and People

Here are our suggestions for building your gear bag if your primary subject matter is portraits and people shots. The items appear in the order of priority within each section.

Camera System

- 85mm–105mm zoom lens. Portraits are best shot at slight telephoto.
- 12–24mm wide-angle zoom lens. Portraits are more dramatic at wide angle.
- Soft-focus filters

Lighting

- Medium box softbox and AlienBees B800 strobe
- Medium strip softbox and AlienBees B400 strobe
- 40-degree fabric egg crate grids for softboxes
- Lowel Tota Light for mixed-media lighting effects (combined strobe and constant)

Grip and Support

- Two super clamps
- Three light stands, then a C-stand, then a boom stand
- Radio slaves for strobes
- Backdrops (Just rent them when you need them. They are inexpensive to rent and you won't have to store them between shoots.)

Computer Hardware and Software

- Digital asset management software
- Dual-layer DVD burner for archiving
- Photo-quality printer
- Color management that supports custom printer profiles for inks and papers
- Niagra II Continuous Ink Flow System
- External mirrored hard drives for backup

Growth Path 2: Nature and Landscapes

Here are our suggestions for building your gear bag if your primary subject matter is nature and landscape shots.

Camera System
- Lots of memory cards. You don't want to run out of storage space in the field.

- 12–24mm wide-angle zoom lens. Landscapes are more dramatic at wide angle.

- Medium telephoto lens (180mm)

- Long telephoto lens (300mm)

- Filters: circular polarizer, then graduated neutral density, then neutral density in various strengths, then infrared

- Rugged, waterproof, backpack-style gear bag. If you have a fabric gear bag, use spray-on waterproofing to improve performance.

Lighting
- A compass, to figure out where the sun is going to be. Remember that the sun changes position with the seasons.

Grip and Support
- Heavy-duty tripod. Wind wreaks havoc with long-exposure nature shots.

- Cable release or remote shutter control or self-timer

- 12-volt DC inverter to power AC devices in your vehicle

Computer Hardware and Software
- Epson P2000 image storing and viewing device. Stores and displays images easily in the field.

- High-end laptop computer usable in the field

- External hard drive for external storage, preferably mirrored

Growth Path 3: Editorial and Action

Here are our suggestions for building your gear bag if your primary subject matter is editorial (journalism, magazines, etc.) and action shots.

Camera System

- Lots of memory cards. You don't want to run out of storage space in the field.

- 12–24mm wide-angle zoom lens

- Medium telephoto lens (180mm)

- Long telephoto lens (300mm) and monopod for support when you're on the move

- Filters: circular polarizer, then neutral density in various strengths

- Comfortable shoulder-slung gear bag that you can work from without having to set it down

Lighting

- Multiple handheld strobes with radio slaves. You can light an amazing variety of shots with multiple small strobes, and they are easy to pack and carry.

- External battery packs and chargers for rapid recharging. Use nickel metal hydride (Ni-MH) batteries for fast recycle times between shots.

Grip and Support

- Tabletop tripod. Also works great as a chest support for low-light shooting on the go.

- Photographer's vest with lots of pockets. But get organized: Too many pockets may mean you can't find anything. ("Where are my car keys?")

- 12-volt DC inverter to power AC devices in your vehicle

Computer Hardware and Software

- High-end laptop computer usable in the field

- External hard drive for external storage, preferably mirrored

- Mobile phone with data transmission capability for image uploads from the field

▮▮Index ▮▮

Numerics

16-bit color mode
 defined, 198
 working in, 196
2000D strobe unit, 290
25-ft. grip trailer, 289
285HV strobe unit, 286, 290
5K, Strand, 290
800 strobe unit, 290
8-bit color mode
 defined, 198
8-bit *versus* 16-bit color, 198

A

action, growth path for shooting, 299
Add Noise dialog box, 243
additive colors, 133
Adobe Gamma applet, 146
Adobe RGB
 as default color space, 180
 defined, 138
Advertising Photographers of America
 See APA
alligator clip, 287, 295
alpha channel, 244
ambient light
 effects on color perception, 145
 effects on digital projector, 150
American Society of Magazine
 Photographers
 See ASMP
angle of incidence, 12
angle of reflectance, 12
angle, for composition, 92

ANSI scanner targets, 156
APA, 295
aperture, 107
 for asset management, 262
Aperture Priority exposure mode, 109, 128
archival-quality prints, 276
artificial light source, 40
ASA, 120
ASMP, 295
aspect ratio, locking, 238
asset management
 aperture, 262
 audio annotations, 266
 automatic image numbers, 258
 camera orientation, 262
 cataloging tools, 258
 copy protection, 264
 copyright, 262
 EXIF data, 262
 file naming, 258
 focal length, 262
 GPS data, 262
 in portraits growth path, 297
 IPTC data, 262
 ISO data, 262
 keyword tags in Photoshop
 Elements, 260
 keywords, 260
 metadata, 262
 metering mode, 262
 practices of news organizations, 262
 products, 267
 shooting and archiving, 256
 shutter speed, 262
 watermarking, 264
audio annotations, for asset
 management, 266
Automatic Exposure mode, 108
automobile, lighting, 32

H

hair light, 290
hard drives
in action growth path, 299
in landscapes growth path, 298
in portraits growth path, 297
recovering from failure, 257
head shot, 30
Healing Brush tool, 230, 231
high-contrast lighting, 90, 117
highlights, 10, 22, 30
adjusting when opening file, 186
avoiding overexposure, 274
preview when opening file, 187
high-roller stand, 295
histogram, 180, 186, 198
in-camera, 127, 274
History palette, 226
History States, 226
hood, monitor, 145
horizon, placement of, 75
hot mirror filter, 124

I

ICC, 139
ICC Profile, 139
creating for monitor, 148
creating for printer, 167–171
via service bureau, 172
creating for scanner, 157–160
graphing tool, 296
sources of an, 140
image cataloging tools, 258
image numbers, 258
image size, changing, 238
iMatch, 267
incandescent light, 46, 48
incidence, angle of, 12
incident highlights, 18
infrared filter, 288
in landscapes growth path, 298
infrared shot, 51, 95, 124
ink, types of, 166

ink-jet printer
bulk ink delivery system, 166, 214, 277
color space of, 136
controlling color with RIP, 223
defined, 164
for personal printing, 214
PIXMA iP6000, 287
profiling, 167–171
via service bureau, 172
StylusPHOTO 2200, 296
Intent
in Photoshop Elements, 216, 217
International Color Consortium
See ICC
International Press Telecommunications
Council
See IPTC
IPTC, 262
ISO equivalency, 120
for asset management, 262

J

jaggies, 238
jewelry, lighting, 34
JPEG format, 121, 180, 210, 257
and digital noise, 240

K

Kayenta Photo Matte paper, 296
keyboard shortcuts, 226
keystoning
defined, 234
repairing, 234–237
keywords, for asset management, 260
Kokopelli Photo Gloss paper, 296

Model release forms, 295
MonacoEZcolor, 157, 167
MonacoOptix, 146
 in gear bag, 287
monitor
 types of, 144
 white point of, 149
monitor calibration, 143
monitor hood, 145
monitor profiling, 143
monopod
 in action growth path, 299
Month view, in Photoshop Elements
 calendar, 263
Morro Rock, 21
motion blur, 112, 115, 126
MultiMediaCard (MMC) memory card, 214

N

natural light source, 40
nature, growth path for shooting, 298
Nero Burning ROM, 287, 296
neutral black, 218, 219
neutral density filter, 52, 288
 in action growth path, 299
 in landscapes growth path, 298
neutral gray, 182, 183
neutral white, 218, 219
news organizations, asset management
 practices of, 262
Niagra II Continuous Ink Flow System, 166,
 277, 297
 in gear bag, 296
noise
 adding to create blur, 245
 adding to reduce color banding, 242
 chrominance, 240
 digital, 120
 defined, 240
 from underexposure, 275
 luminance, 240
 reducing, 120, 240
noise reduction filter, 240, 275

O

obsolescence of data, 273
Octaplus softbox, 292
Omni Traveller gear bag, 287
online printing services, 213, 222
OpenRAW, 273
optical disk, 254
optical zoom, 81, 286
OptixXR colorimeter, 287, 296
orientation of camera, for asset
 management, 262
out of gamut, 137
overexposure
 causing loss of data, 275
 using histogram to avoid, 274

P

Pantone, 223
paper, types of, 165
pattern, for composition, 66
PC monitor gamma, 149
people, growth path for shooting, 297
Perceptual Intent
 in Photoshop, 220
 in Photoshop Elements, 216
personal printing, 213, 214
 from Photoshop, 218
 from Photoshop Elements, 216
perspective, for composition, 96
Pfeiffer Beach, California, 124
Photo Matte paper, 296
Photo Mechanic, 267
Photo Organizer, in Photoshop
 Elements, 267
PhotoFrame
 in gear bag, 296
photoreactive dye layer, 255
Photoshop
 action for upsizing an image, 276
 action for watermarking, 264
 Bridge, 267
 in gear bag, 287, 296
 keyboard shortcuts, 226

RAW formats, list of, 122
rear curtain synch, 126
Red Eye Removal tool, 228, 232
red eye, defined, 228
reds
 adjusting using Curves, 200
 adjusting without using Curves, 202
reflectance, angle of, 12
reflection, law of, 12
reflective dye layer, 255
reflective scanner, 154
reflective surface, lighting, 32, 34, 36
Relative Colormetric Intent
 in Photoshop, 220
 in Photoshop Elements, 216
remote shutter control
 in landscapes growth path, 298
Rendering Intent
 in Photoshop, 220
resampling tools, 239
resizing an image, 238
resolution, digital *versus* film, 271
retail printing, 213, 222
RGB channels, 196
RGB color
 converting to CMYK with RIP, 223
 defined, 133
RGB Color mode, working in, 196
RGB data
 range of values, 134
 viewing with histogram, 127, 186
Rhino lighting bag, 289
Rifa-Lite, 290, 291
RIP, 223, 296
Road Runner AW gear bag, 289
rule of thirds, 74, 102

S

saturation
 adjusting when opening file, 192
Saturation Intent
 in Photoshop, 220
 in Photoshop Elements, 216
ScanMaker 8700 scanner, 296
scanner

ANSI targets, 156, 296
flatbed, 154
 in gear bag, 296
opaque target, 154
profiling
 See profiling a scanner
ScanMaker 8700, 296
transparency (film or slide), 155, 296
transparent target, 155
types of, 154
uses for, 153
scrim, 36, 293
 building your own, 38
 stand for, 295
Secure Digital (SD) memory card, 214
selection mask, 232, 244
selection tools, 226, 244
Selective Color dialog box, 232
self-timer, camera
 in landscapes growth path, 298
shadows, 10, 22, 30
 adjusting when opening file, 188, 192, 196
 preview when opening file, 189
shape
 creating with light, 8
 for composition, 64
sharpener Pro, 54
sharpening an image, 204
shiny metal, lighting, 33, 34, 36
shortcuts, keyboard, 226
shot within a shot, for composition, 82
Shutter Priority exposure mode, 112, 128
shutter speed, 107
 for asset management, 262
silver dye layer, 255
Simulate Paper Color, 220
Skew, 235, 236
skin tones, as color temperature gauge, 182
sky, replacing, 248
slave, remote lighting, 289, 290, 293
 in action growth path, 299
 in portraits growth path, 297
slide scanner, 155
 in gear bag, 296
Smart Media memory card, 214
SMPTE, 208
SMTPE color bars, 208

Society of Motion Picture and Television
 Engineers
 See SMPTE
soft focus filter, 52, 286
soft proof, in Photoshop, 220
softbox, 26
 barn doors, 26, 27, 293
 Chimera Lighting brand, 26, 286, 292
 egg crate grid, 26, 27, 293
 in portraits growth path, 297
 for handheld strobes, 286, 292
 in portraits growth path, 297
 low heat *versus* high heat, 26, 292
 Maxi Bank, 286
 Mini Bank, 286, 292
 Octaplus, 292
 Quartz Plus, 292
 quick-release speed ring, 293
 stands for, 295
 Super Pro Plus, 292
 Video Pro Plus, 292
softbox lightbank
 See softbox
soft-focus filter
 in portraits growth path, 297
software filters, 54
spectrophotometer, DTP41, 296
speed ring, quick-release, 293
sphere
 lighting examples, 20–21, 28, 30
 lighting for shape, 18
spot focus, for composition, 91
Spot Healing Brush tool, 230
spot metering, 106, 128
sRGB
 as default color space, 180
 defined, 138
step method to upsize images, 238
step-up rings, 288
stop action, 113
stop-down, 110
storage devices, obsolescence of, 273
strobe unit, 289
 2000D, 290
 285HV, 286, 290
 800, 290
 B400, 290
 B800, 290

in action growth path, 299
StylusPHOTO 2200 ink-jet printer, 296
subtractive colors, 133, 184
super clamp, 287, 295
Super Pro Plus softbox, 292

T

tabletop tripod, 286, 287, 288, 294
 in action growth path, 299
tags, keyword, in Photoshop Elements, 260
telephoto effect of CCDs on lenses, 280
telephoto lenses
 in action growth path, 299
 in landscapes growth path, 298
 in portraits growth path, 297
texture, for composition, 68, 102
thirds, rule of, 74, 102
thread adapter, for filters, 286
threshold, unsharp masking, 204
TIFF format, 121, 180, 240
time line, in Photoshop Elements, 263
tint
 adjusting when opening file, 184, 192
tonal range, 119
 expanding and compressing, 119
toner, types of, 166
tools, mastering, 272
top-back lighting, 36
Tota Light, 26, 290
 in portraits growth path, 297
trailer, grip, 289
Transform Selection, 227
transparency scanner, 155
Traveller Extreme hard case, 287
triplet, color values, 135, 198
tripod, 287, 294
 in landscapes growth path, 298
tungsten light, 26
 softbox for, 292
TV, for viewing images, 208